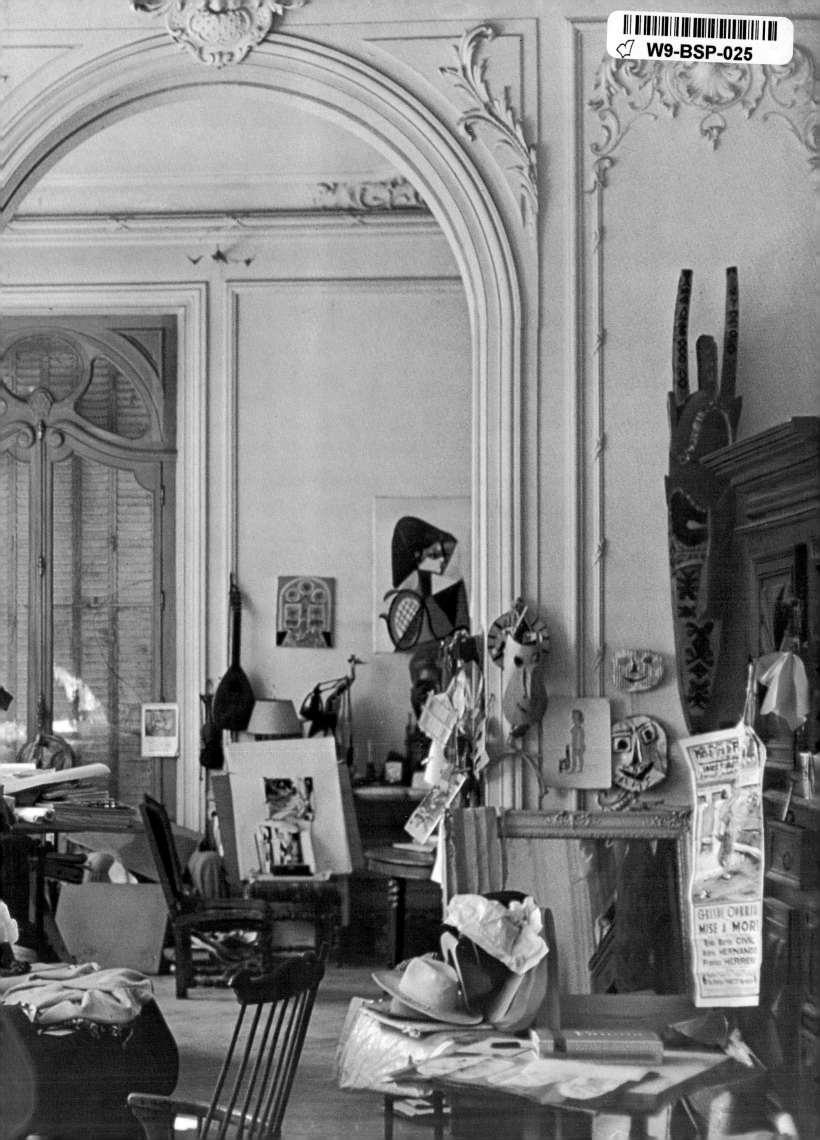

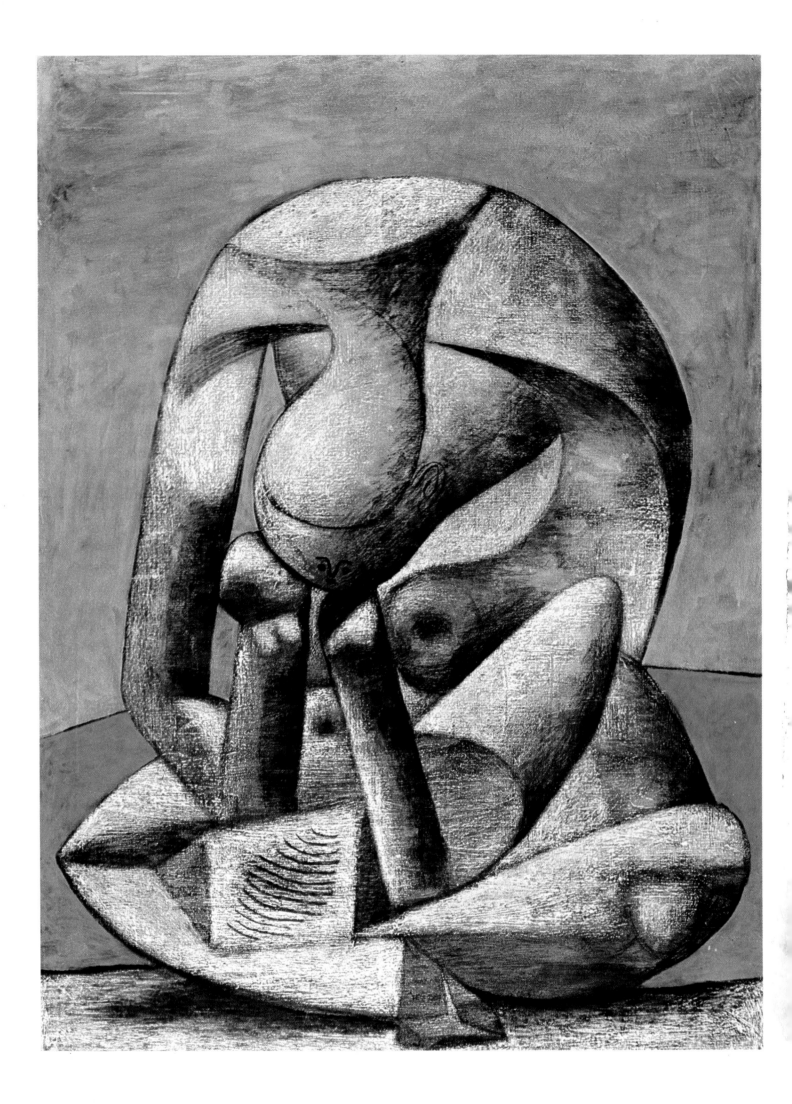

Viva Picasso

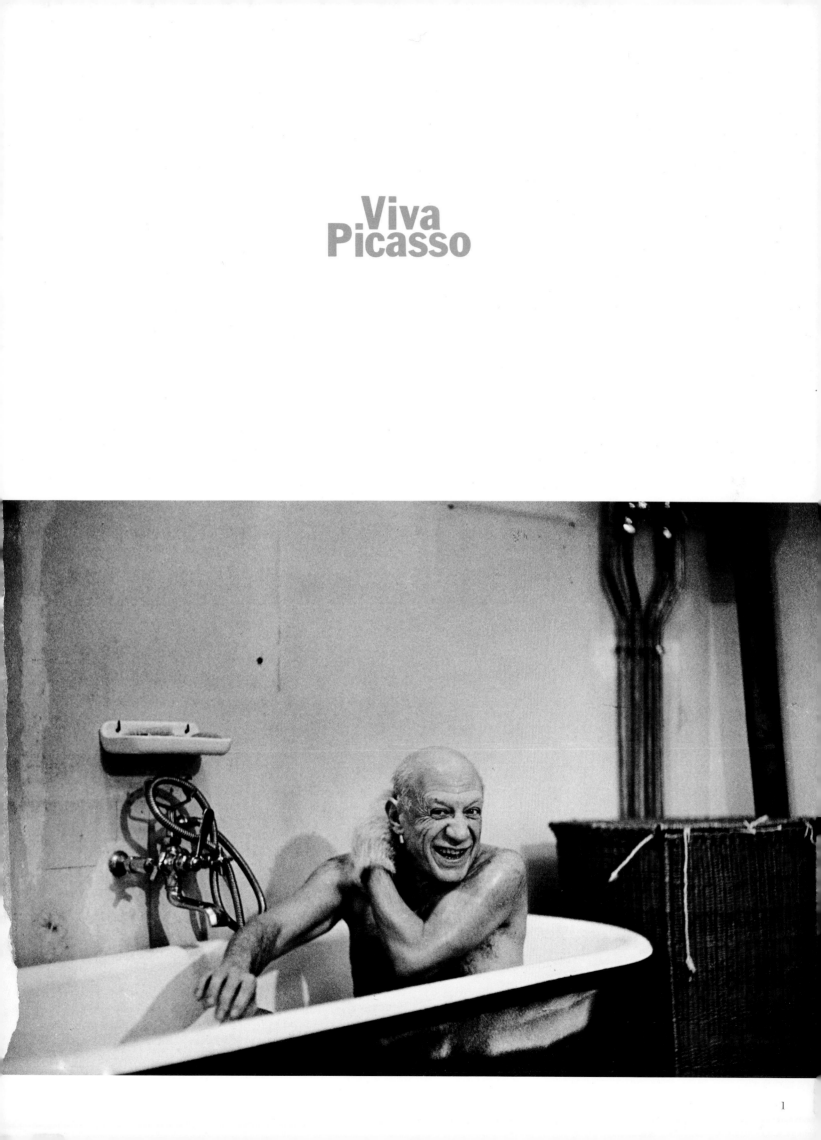

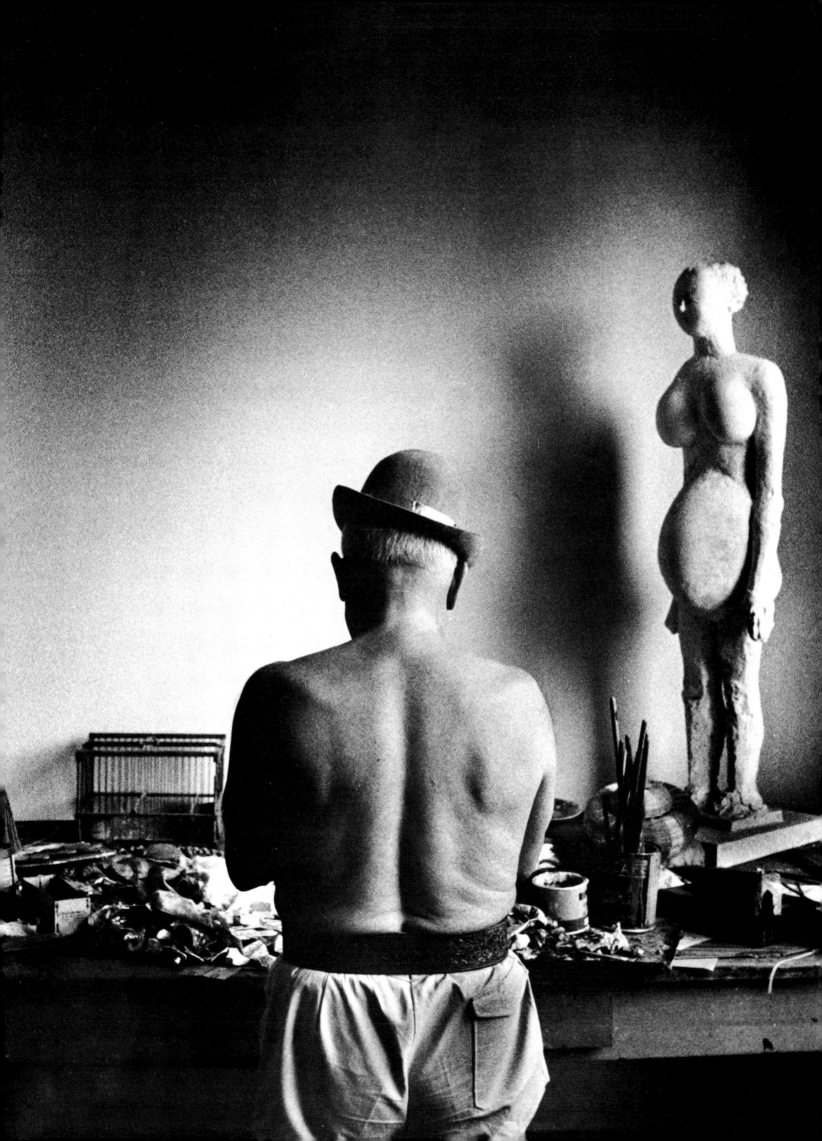

Viva
Picasso

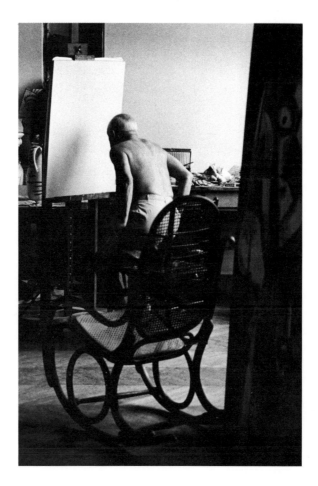

a Centennial Celebration
1881 - 1981

David Douglas Duncan

a Studio Book
The Viking Press
New York

Photography - Text - Design - Production
David Douglas Duncan

Printing and Binding
Dai Nippon-Tokyo

Copyright © 1980
David Douglas Duncan

Picasso's Picassos
reproduced
by permission SPADEM

a Studio Book
The Viking Press
625 Madison Avenue
New York, N.Y. 10022

ISBN 0-670-74737-8
Library of Congress
80-5168

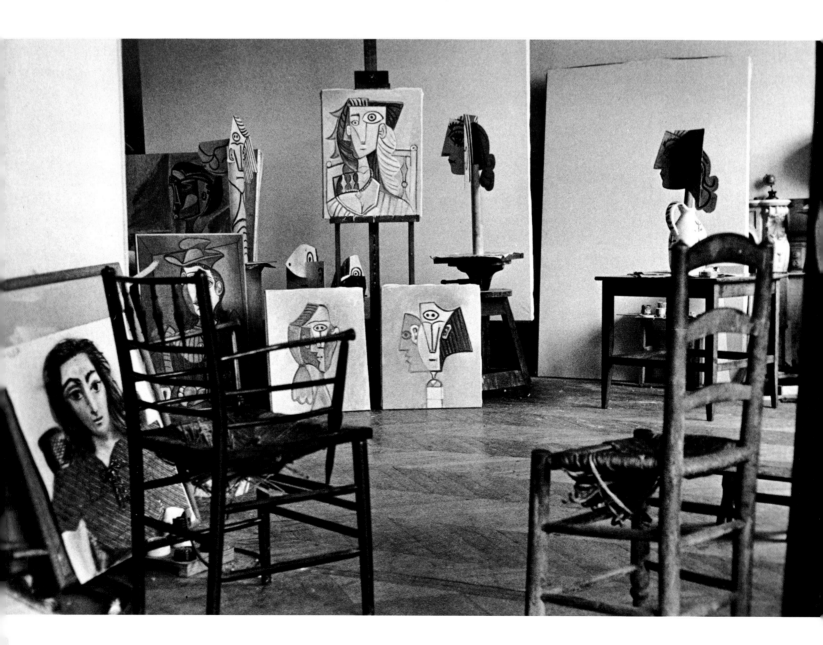

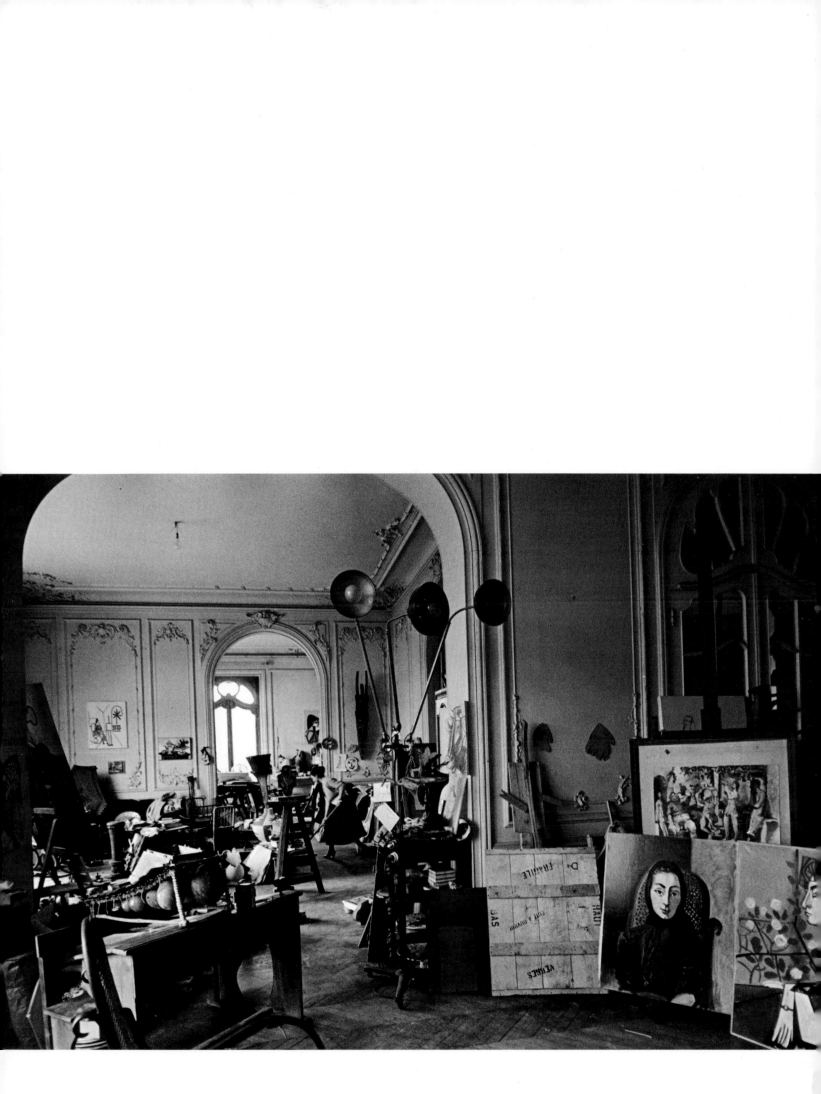

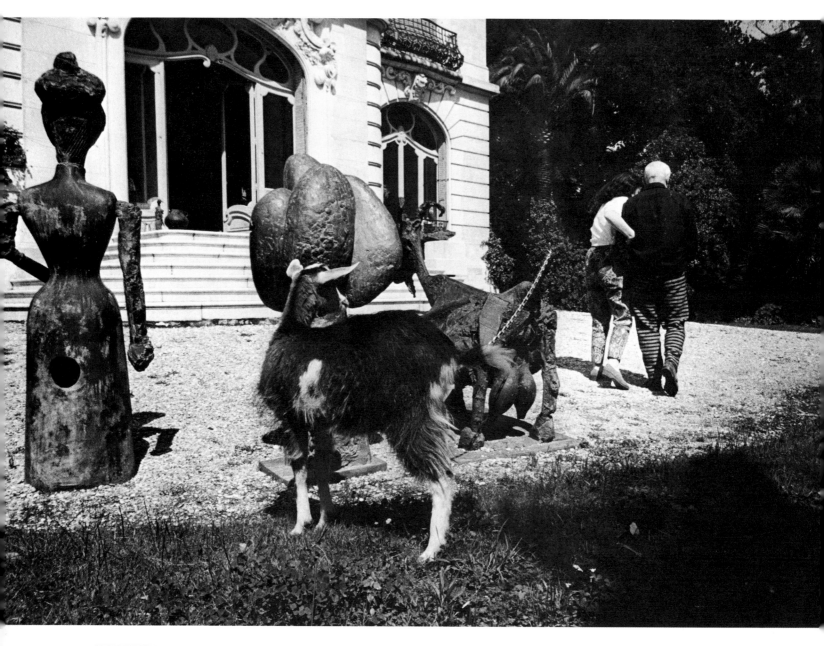

Seventeen Years of Friendship
with Pablo and Jacqueline

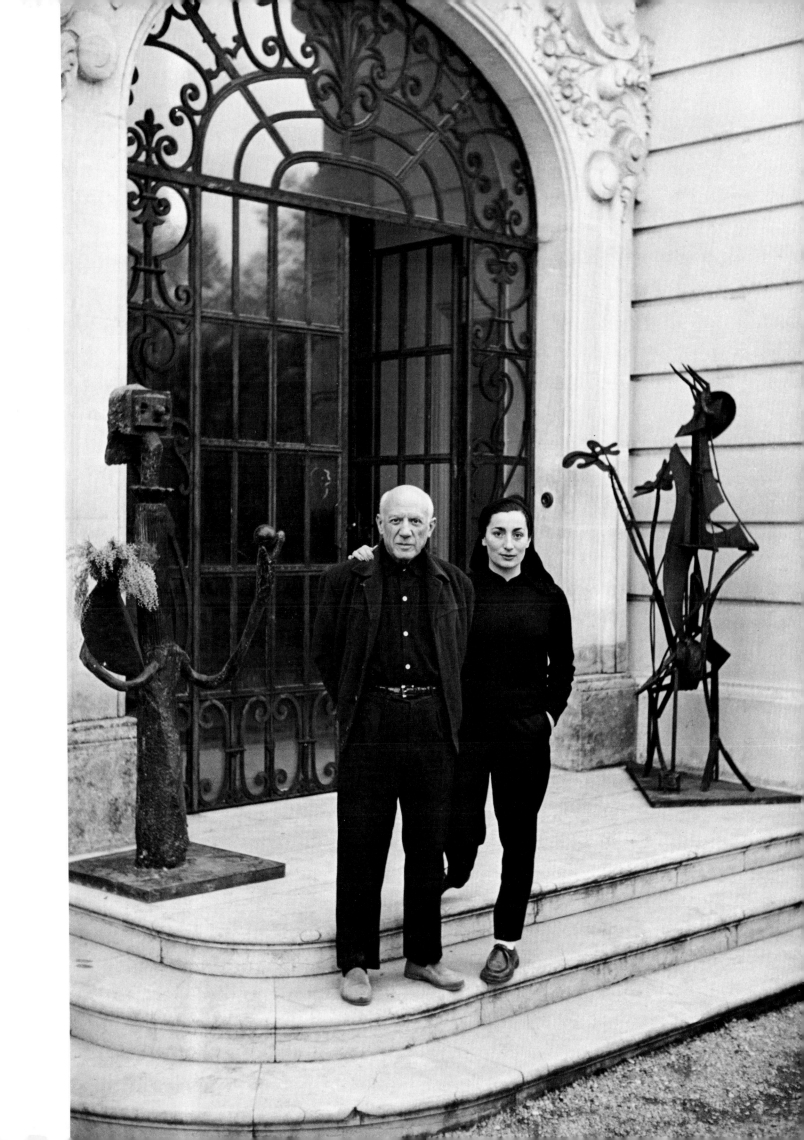

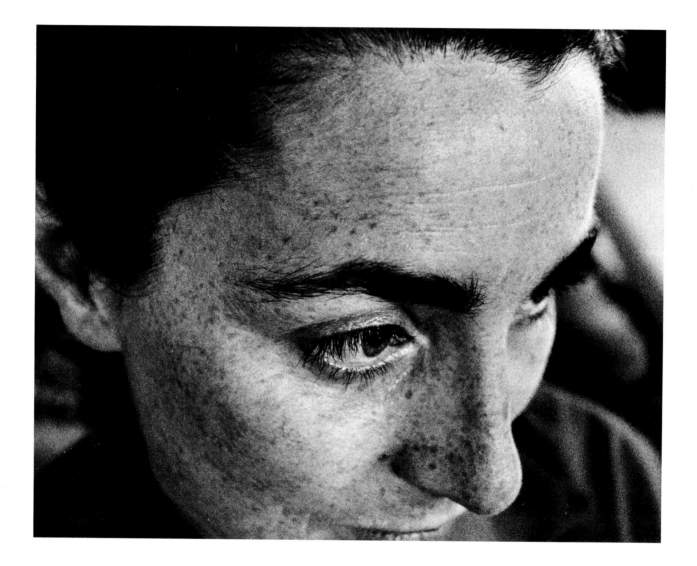

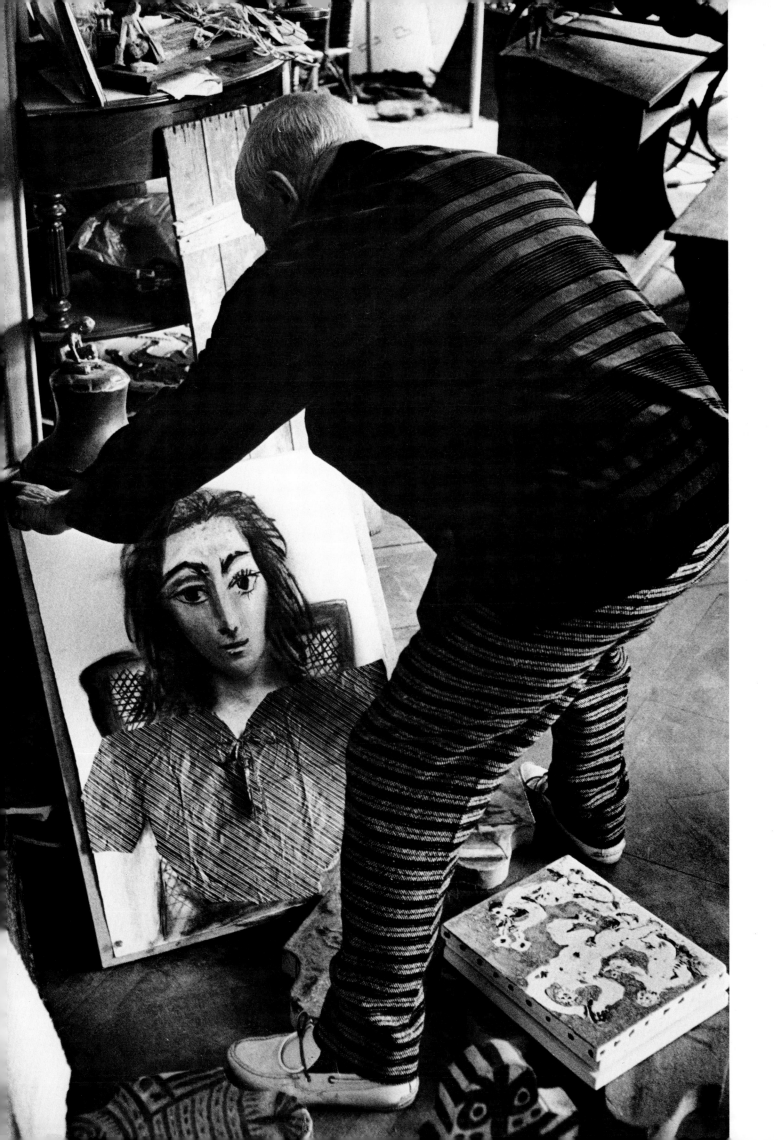

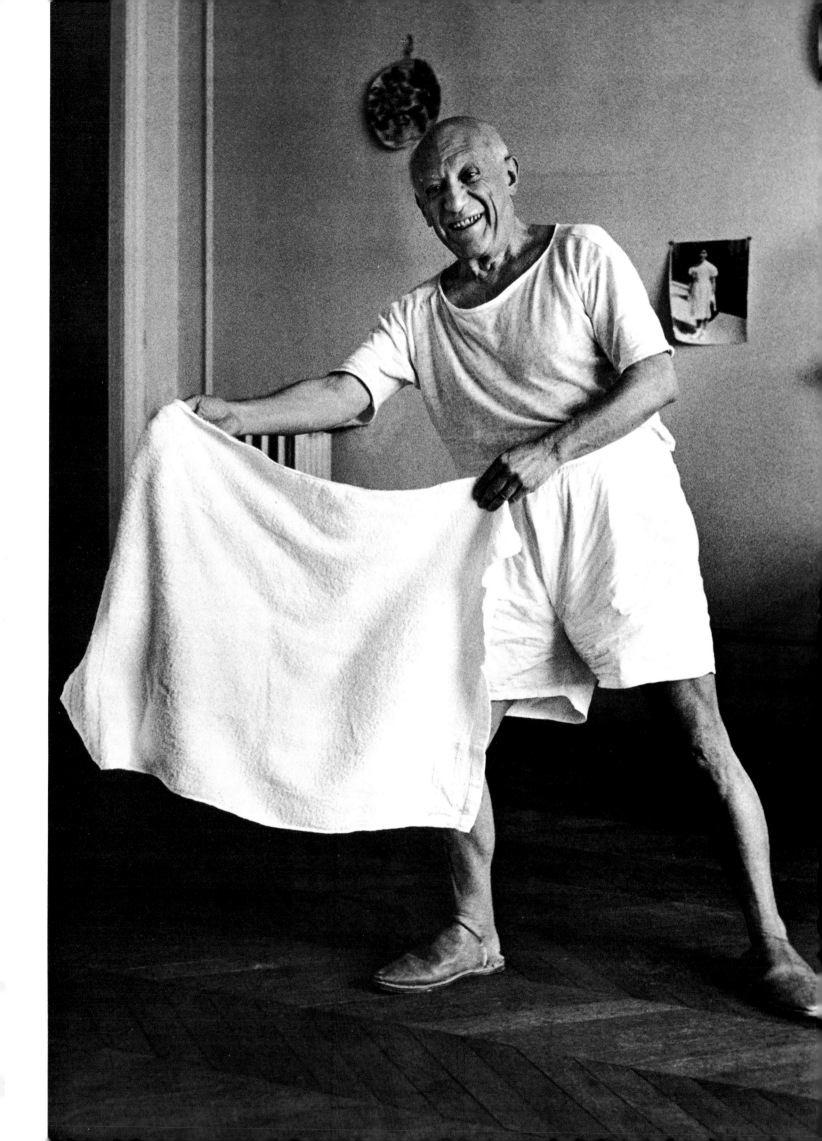

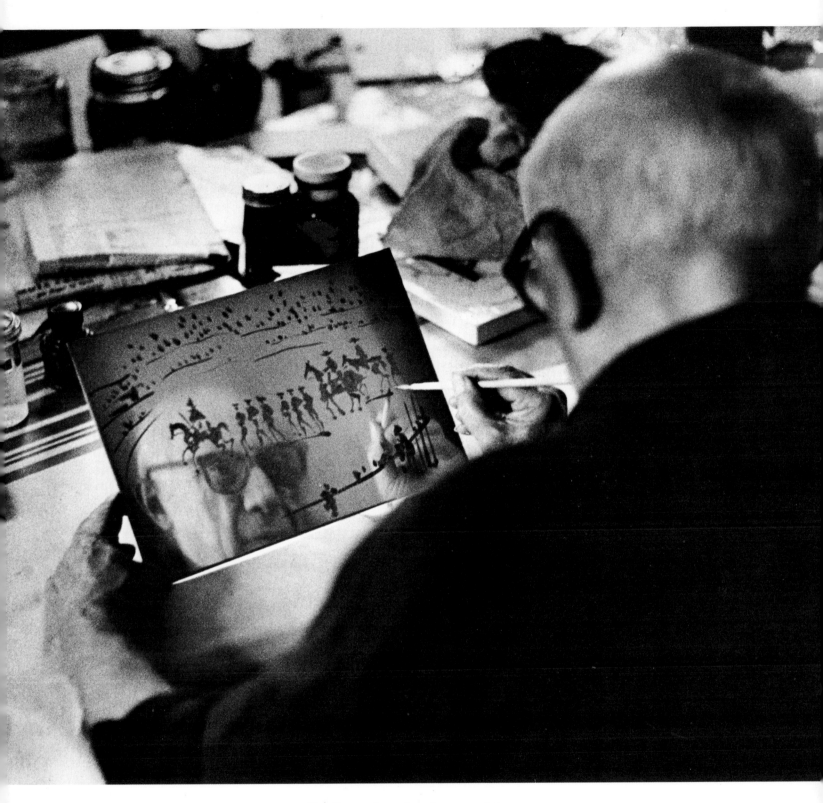

Dedicated to the freest spirit
—and the most disciplined—
I have ever known

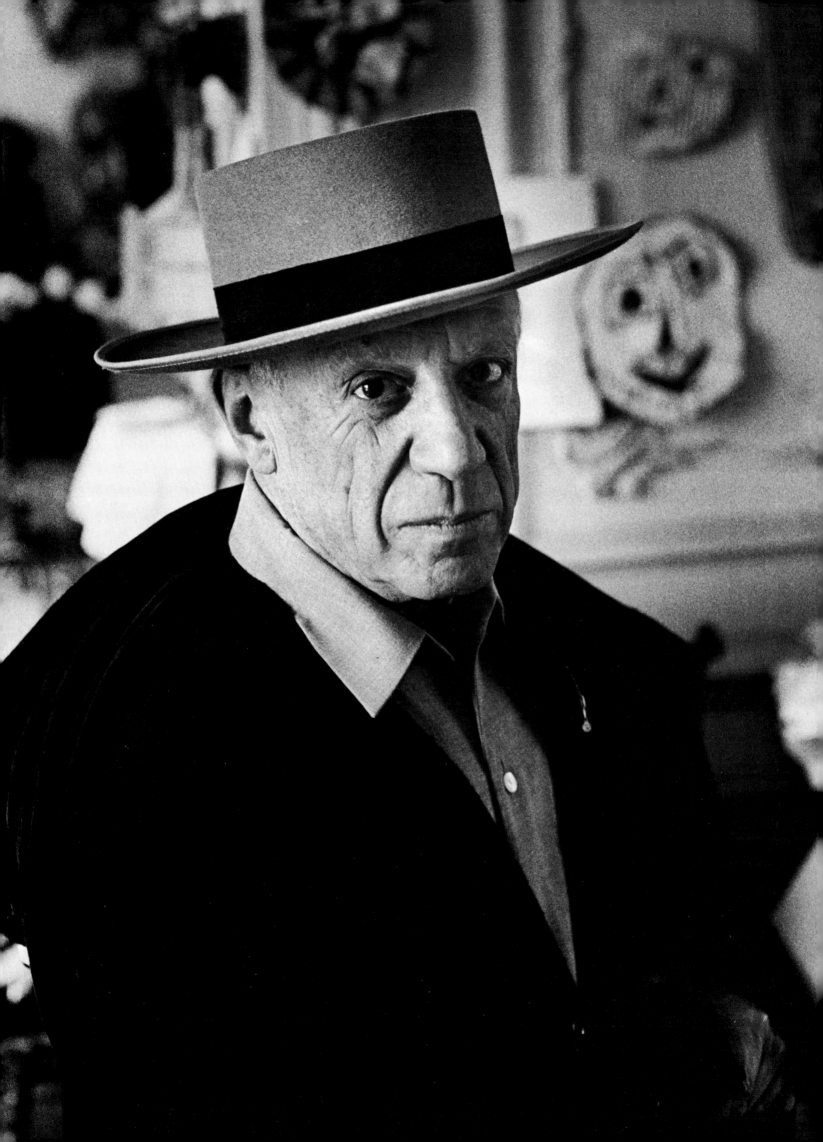

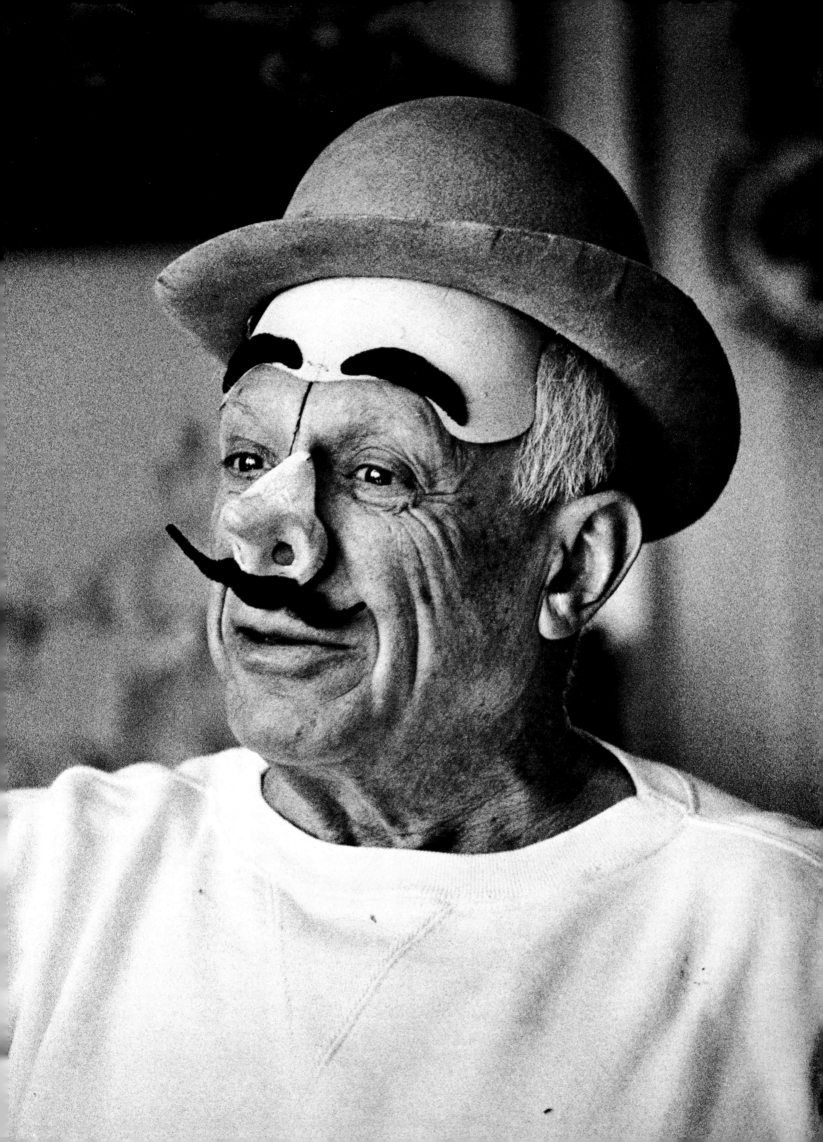

Nobody really knew Picasso. Not his children or wives or mistresses or art dealers or oldest cronies or newest friend; not any biographer or artisan colleague or photographer or lawyer or banker or doctor or bullfighter or publisher or poet or sculptor or engraver or other artist. No one, perhaps not even Pablo Ruiz Picasso, knew or understood the man who from his youth signed his work with only one word, *Picasso*, which he borrowed from his mother's maiden name. No one could anticipate his moods or predict with confidence the theme of creativity evolving daily behind the secrecy of the private world he wrapped around himself—a one-man kingdom, born with him, to vanish when he died. His footprints are already found deep in the bedrock of mankind, revealing a long lifetime of wandering alone through the canyons and mountains of his imagination. And they confirm his reality, which might otherwise be viewed one day as a myth; a sorcerer whose graffiti are often as incomprehensible, but treasured, today as are those fetish talismans carved during an epoch when mastodons still roamed the earth.

Love—selfless love—came to Picasso, probably for the first time, when Jacqueline Roque entered his life. Forty-seven calendar years separated them yet they were as one. Jacqueline was the companion who became his model then wife, a confidante who sensed each nuance of almost every mood, his envoy to the outside world, an errand girl, his secretary-protectress, and hostess to the renowned and the unknown who entered the throne room of 20th-century art. She was chauffeur, chef, surrogate mother for his vacationing children and everybody's occasional nurse while always reigning as the high-wire tightrope queen without a safety net during those precarious hours, days, weeks—even months—of unrelieved tension when the maestro reigned over his arena of rampant visions. Then, once again, forest gardens of freshly painted canvases, peopled by a race of creatures unique unto themselves, were ready for Kahnweiler and their fate.

Daniel-Henry Kahnweiler had been Picasso's art dealer in Paris since the birth of cubism early in the century. "In those days," he recalled years later, "Pablo would bring me a few pictures. I would hang them on a wall. Then I went sailing with Vlaminck. We had a little boat on the river. In those days there was so much time! I had perhaps five or six clients in the whole world, including the Russians Morosov and Shchukine, who might be interested. There was no promotion, of course. We never held exhibits. Nobody cared. Pablo hated them anyway. It was a good time."

One afternoon at La Californie, his studio-home in Cannes, Picasso asked Jacqueline to send a large portfolio of etchings to Kahnweiler, who still had a gallery in Paris. When he looked up again from an owl platter that he was painting, Picasso saw her carefully counting each print. He threw down his brush, ran to her and slammed the portfolio shut. He was scarlet, choking with outrage. "They're for *Kahnweiler!* He's not a...spy!" In his distress over what seemed to be an insult to the honor of one of his oldest friends, Picasso had reverted to Spanish from French, and had sputtered *"espía"* when he meant *"ladrón"*..."thief."

The telephone rang late one night just after we had finished dinner, in the kitchen as usual. It was Kahnweiler calling from Paris with the news that every work in Picasso's latest show was sold. They had been offered as the complete sketchbook studies for his series of paintings based on Manet's monumental canvas, *Le Déjeuner sur l'Herbe*, in the Louvre. Kahnweiler was elated. Picasso sat without moving after he put down the tele-

phone. Then he reached under his chair and brought out a stack of new sketchbooks. He opened one, then another, each filled with drawings of familiar figures, all from *Le Déjeuner*. "How could I tell Kahnweiler about these, drawn after I finished the others that he's sold in Paris? It's very much easier to start than to stop!"

Picasso's UNESCO mural in Paris—interpreting the Greek legend of Icarus who fell back to earth with melted wings after flying too near the sun—was unveiled with the usual ceremonies which the artist ignored, as was customary regarding exhibits of his work. Jacqueline had arranged a preassembly of the mural—painted on interlocking wooden panels—in the schoolyard of Vallauris, a nearby Riviera village which Picasso had inadvertently resurrected through his postwar infatuation with ceramics. Although making pottery was a cottage industry that had arrived with the Romans, the kilns were being abandoned by young craftsmen who sought easier lives elsewhere. When I mentioned Icarus's failings as an astronaut, Picasso shrugged. Then he reached for three massive sketchbooks. Page after page revealed a classic scene—an artist at his easel in a studio with towering windows, beneath which posed a nude model. One book was filled with subtle variations on the girl's figure, single-line drawings where the pencil never lifted from the paper. Picasso looked up and exclaimed: "You see! That's what I had planned for the mural. But look what happened when I began to paint!" He told me several times that he sometimes felt as though he had no control over the subjects appearing under the pencil or brush in his hand.

Picasso's life spanned almost a century. During those decades he alone produced more works than any other artist who ever lived, even those with numerous protégés and whole stables of assistants. He slept very little; he had worked until nearly daylight the morning he died. He left no will, probably because it would have taken too much time from other, more important projects. Art experts appraised the total estate at an easy-to-remember figure: three hundred million American dollars. He had warned his son Paulo: "Have your fun now. Later, the roof will fall in!" And it did, but then Paulo died, too. Some years earlier, the day one of his youthful portraits was auctioned off for nearly a quarter of a million dollars, I asked Picasso if he remembered the picture. He turned those unblinking black-chestnut eyes on me and said: "I remember carrying it down from Montmartre with an armload of others, hoping to sell something that day. It began to rain. I asked a nearby shop owner whether I could leave my work in his place until the storm stopped. But he threw me out, and them, too. Yes, I remember. I later sold it for five gold francs, twenty-five dollars. My friends and I had dinner that night." *La Belle Hollandaise* is now one of the treasured works in the Stuttgart Museum.

Pablo was in the bathtub, Jacqueline had been scrubbing his back, the day we met. I had stopped in Cannes, on the French Riviera, en route to North Africa after an earlier photo assignment in Afghanistan, where I had found a translucent carnelian ring stone engraved with a Picassoesque rooster, dating from around the time of Christ. I thought Picasso might like it. An old war-photographer colleague, Robert Capa, had once mentioned to me Picasso's enjoyment of stories about our nomadic lives and that he might welcome another gypsy to his studio. Bob said that he would introduce us some day, but he was killed first, on a story originally intended for me, in Indochina. He had been nearer, in Japan, while I was trailing Soviet agents along the Iron Curtain. A telephone call to Picasso's villa, La Californie, explained that although Capa could no longer in-

troduce us I would like to leave a gift with the gatekeeper—then adiós, I was on my way to the Berbers in the High Atlas mountains of Morocco. A beautiful girl, in black—cashmere sweater, slacks, and scarf—awaited me beyond the open gate. Without a word, she took my hand and led me through a front door flanked by bronze Amazonian goddesses and convoluted steel pterodactyls, upstairs past a grazing nanny goat and into a barren, old-fashioned bathroom where Pablo Picasso waved hello and continued soaping his back. I gave him the carnelian ring. As he traced the engraving with his fingernail, the first words I ever heard spoken in that house were his question: "I wonder what tool he used?" Later, after Picasso and Jacqueline stood on their front step watching me drive away, I wondered about his parting words: "Come back—here is your home."

Picasso was seventy-five when I photographed him—in his bathtub—for the first time. He died April 8, 1973, then approaching ninety-two. Our friendship—which endured a couple of bruising *corridas* between us—continued almost casually through those years. He and Jacqueline truly made their homes, La Californie, the Château de Vauvenargues, and Notre Dame de Vie, my homes, too; everyone else seemed almost like an intruder. I wasn't deeply concerned with the artist Picasso, even though my vision would soon be changed by his eyes forever. The man himself was a force apart. One who could quietly study my fiercely intelligent and stubborn little dachshund, Lump, and then weigh every word as he said: "Lump is someone with the finest qualities, and the very worst—like most of us." Picasso was a man who knew his strengths, and, surely, his failings. His was always the gracious warmth and almost courtly hospitality of a Spanish grandee, one who would devote his attention entirely to his guests. At no time, during all of those years at his side, did I see him reveal impatience with any visitor, even obvious bores who dragged out their departures and wasted endless hours of his fleeing, irreplaceable time.

He was also one of the most negligent of fathers, whose paternal interest generally surfaced during school holidays and summer vacations, when his children's visits to the studio were the least disruptive to his work—the primary love of his life. And yet, after I nearly destroyed his final, enormous, charcoal self-portrait, he only asked at what time had I started work that morning (at dawn, photographing his secret hoard of "Picasso's Picassos") and had I had breakfast? He revelled in telling stories involving other artists and their paintings, both famous and forgotten, in which he was only another actor in the cast of characters. He followed with grave interest—and personal anguish—the tribulations of that other world beyond his gate, and, while he had barely attended school anywhere in his life, he was among the most literate men of his time. Then, there was one thing more: although he had lived and worked as the bull's-eye target of controversy for both an antagonistic and adoring public during most of his extraordinary career, never in all of the seventeen years of our friendship did I hear Pablo Picasso speak about *Picasso*.

These are my favorite photographs, which share some of my memories of that man.

Castellaras, D.D.D.
France

Villa
La Californie

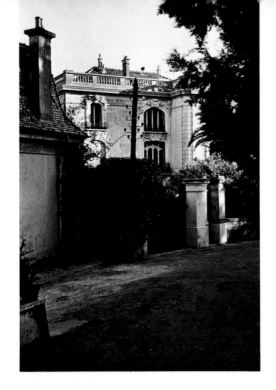

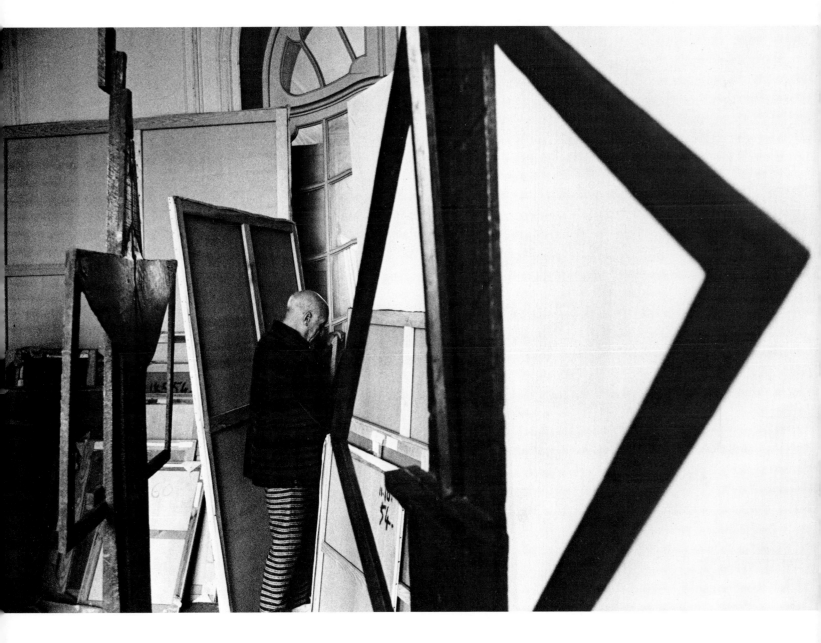

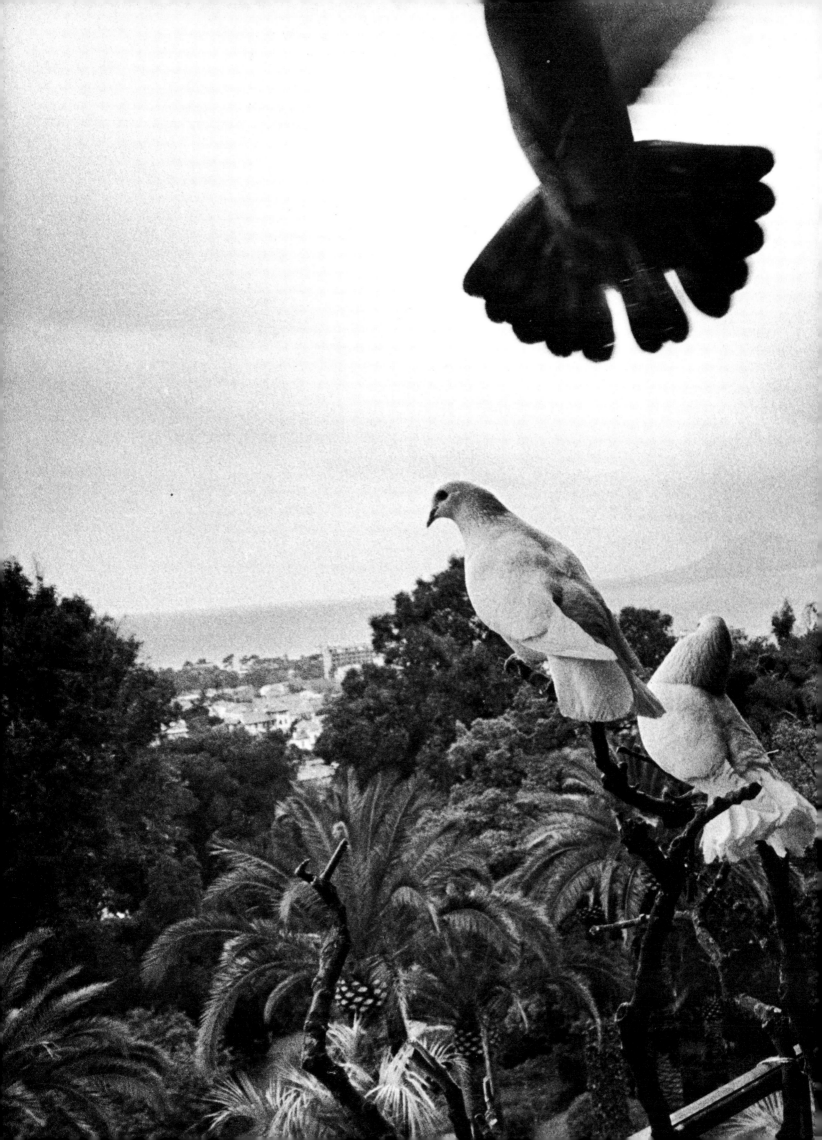

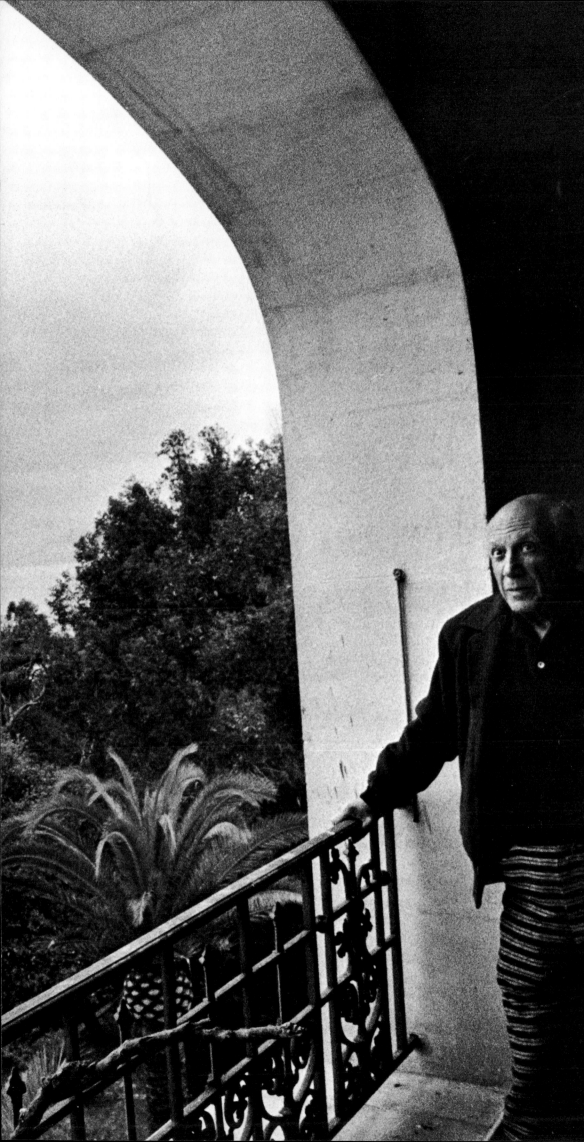

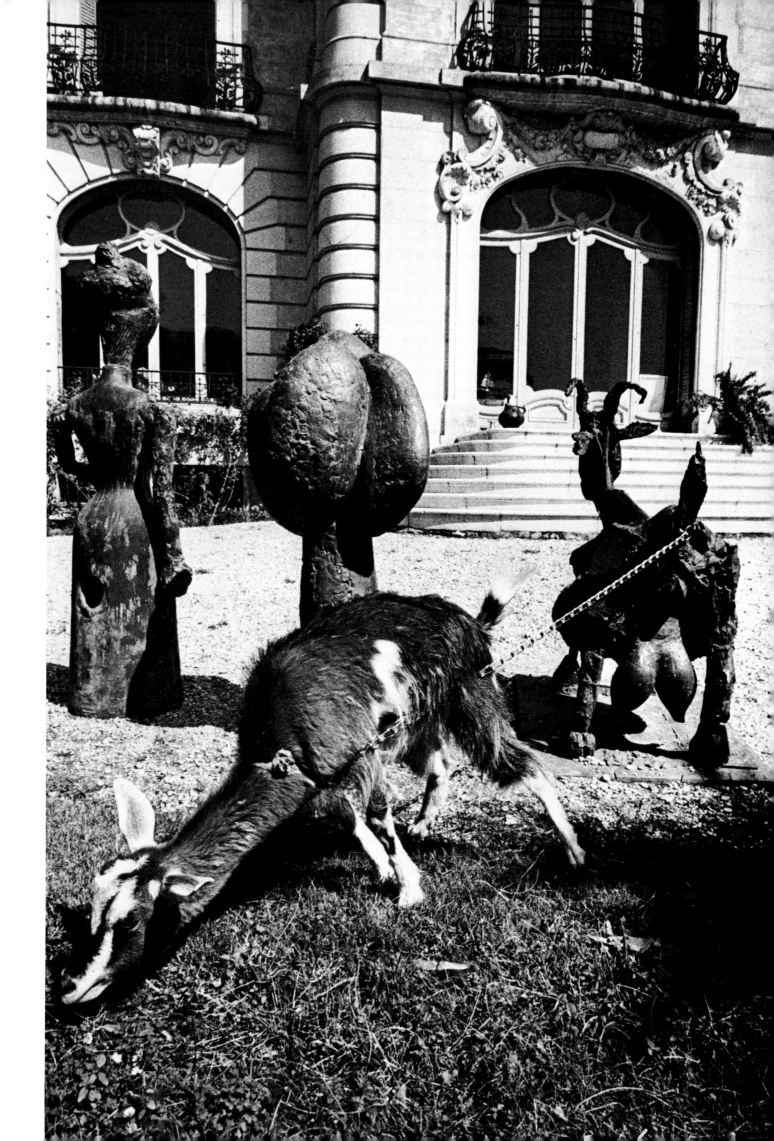

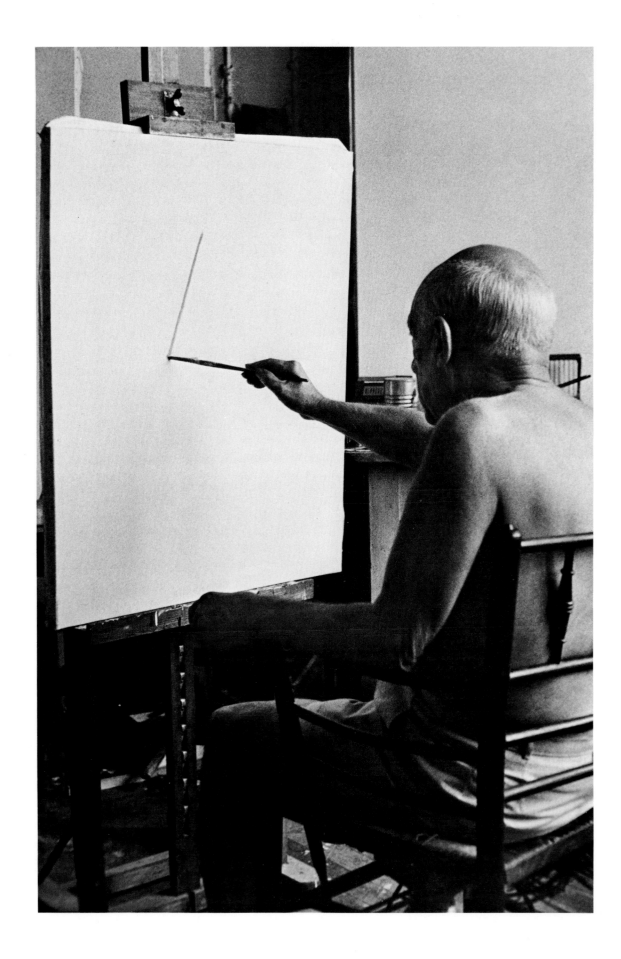

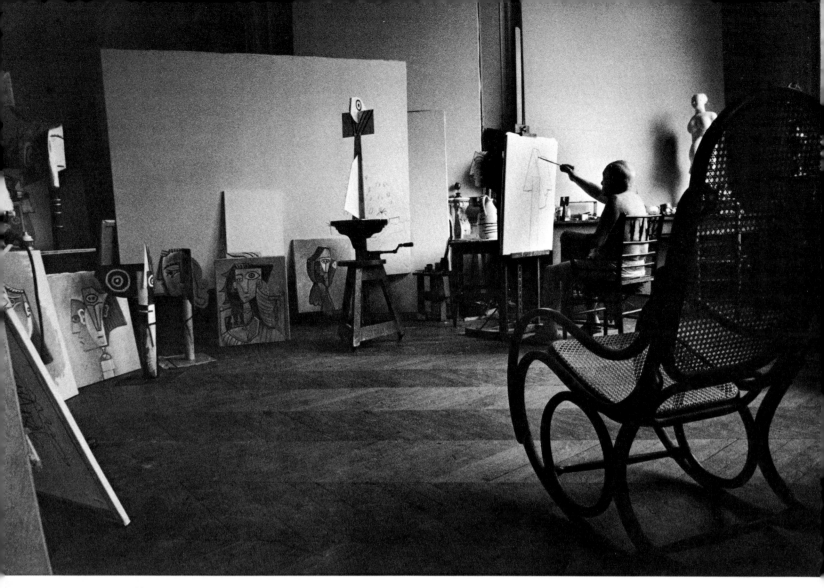

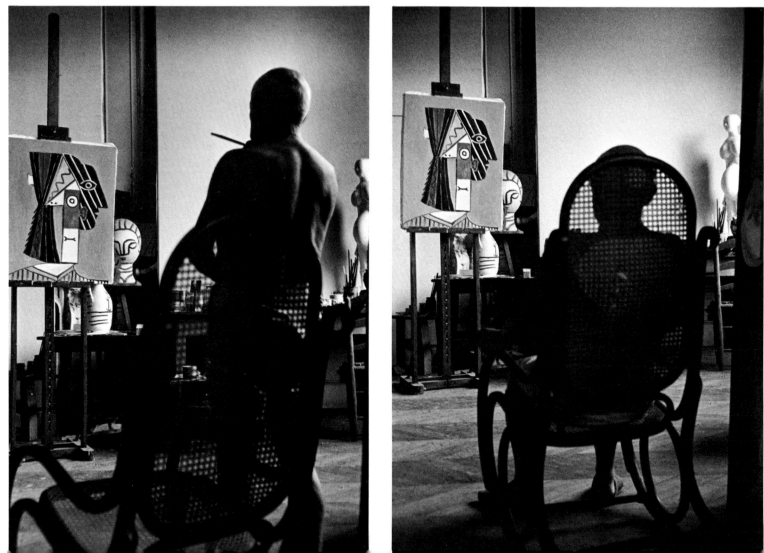

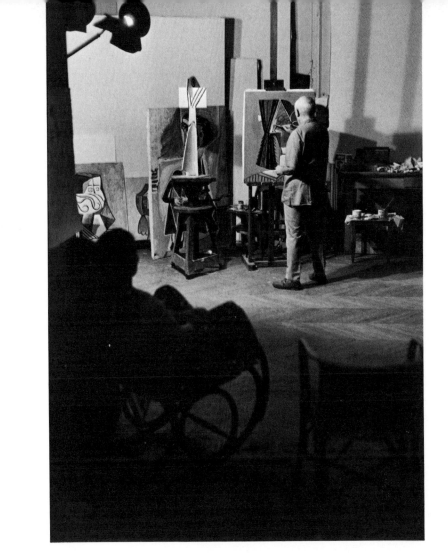

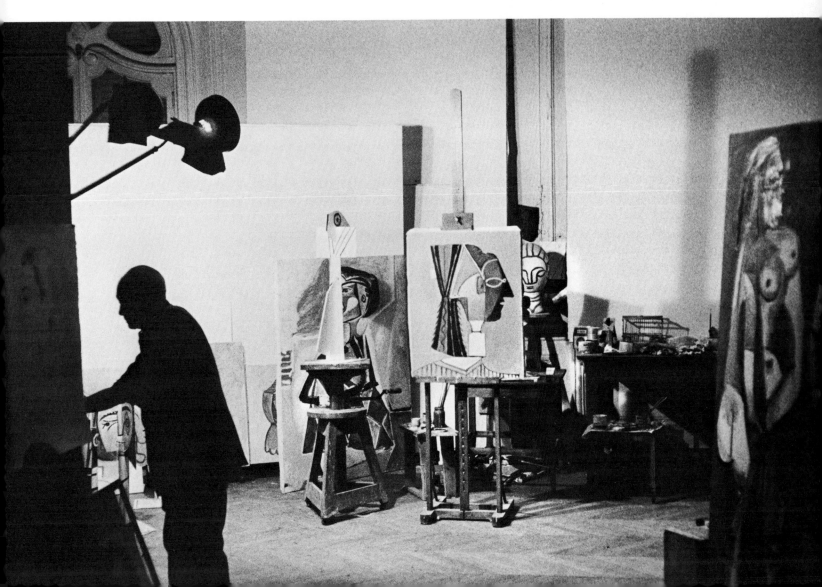

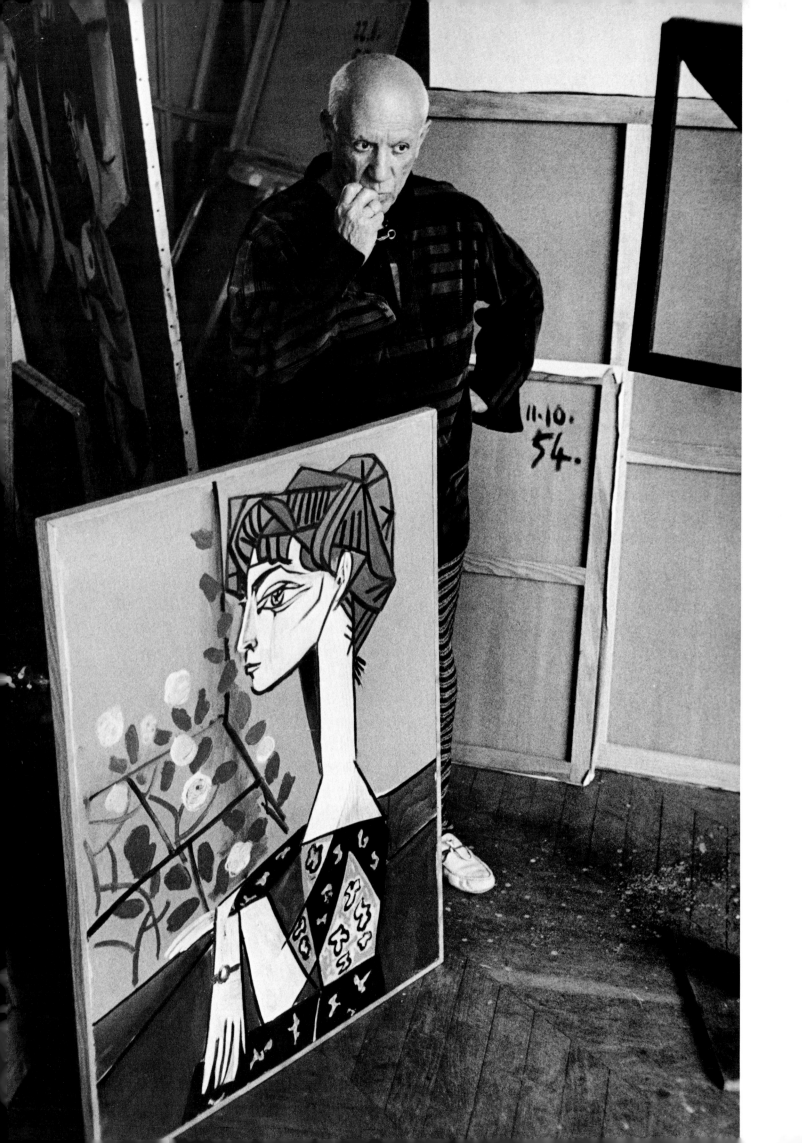

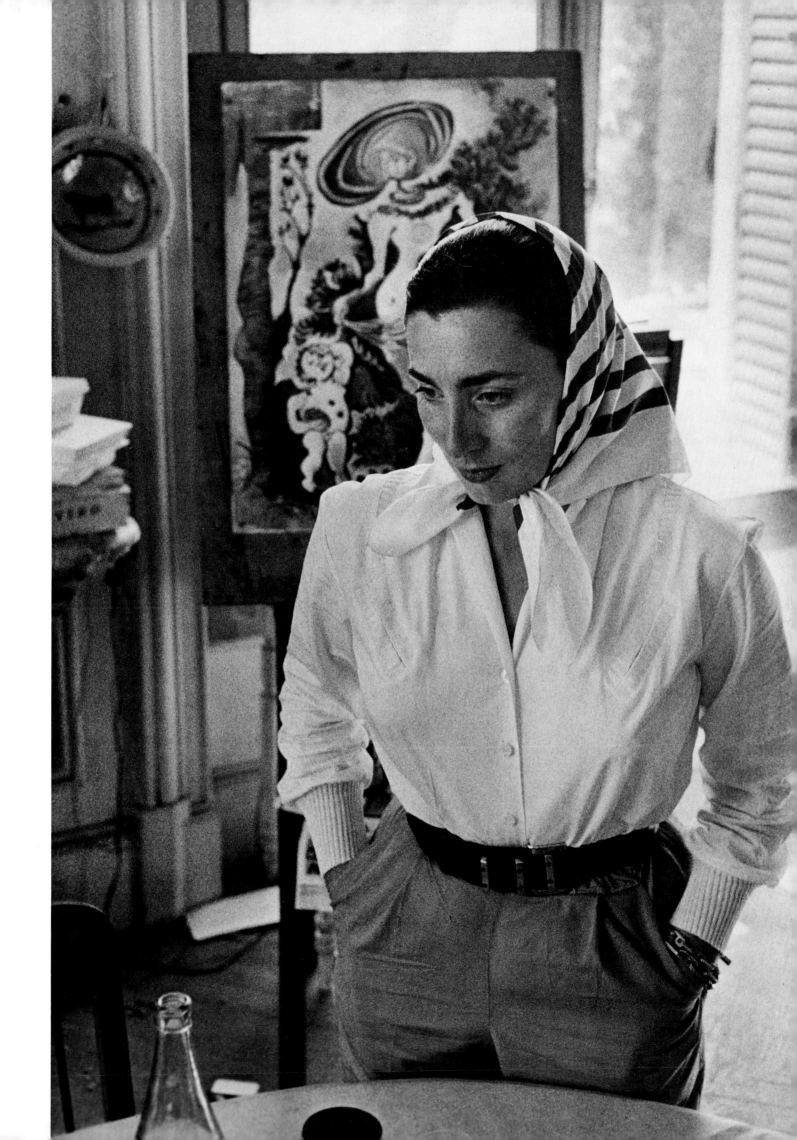

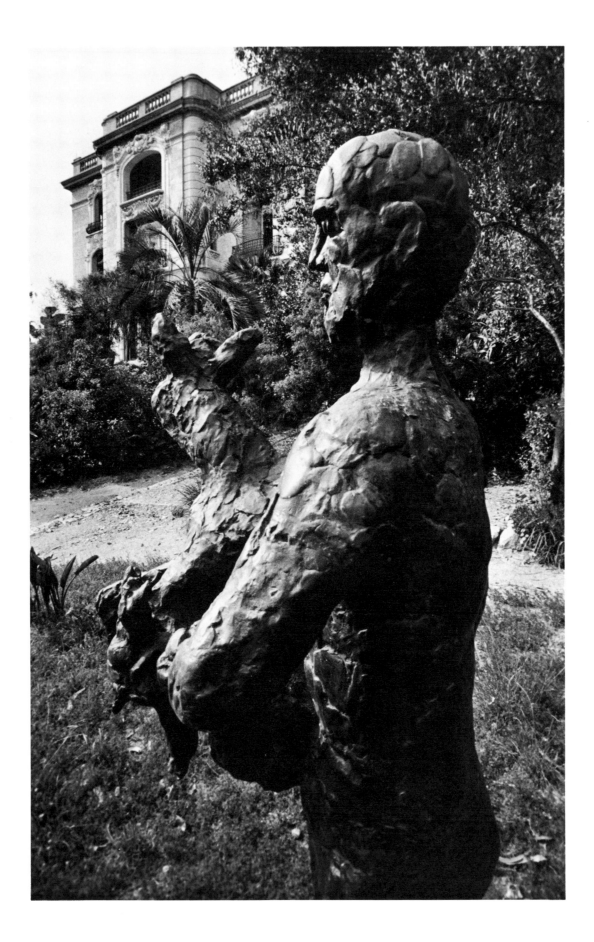

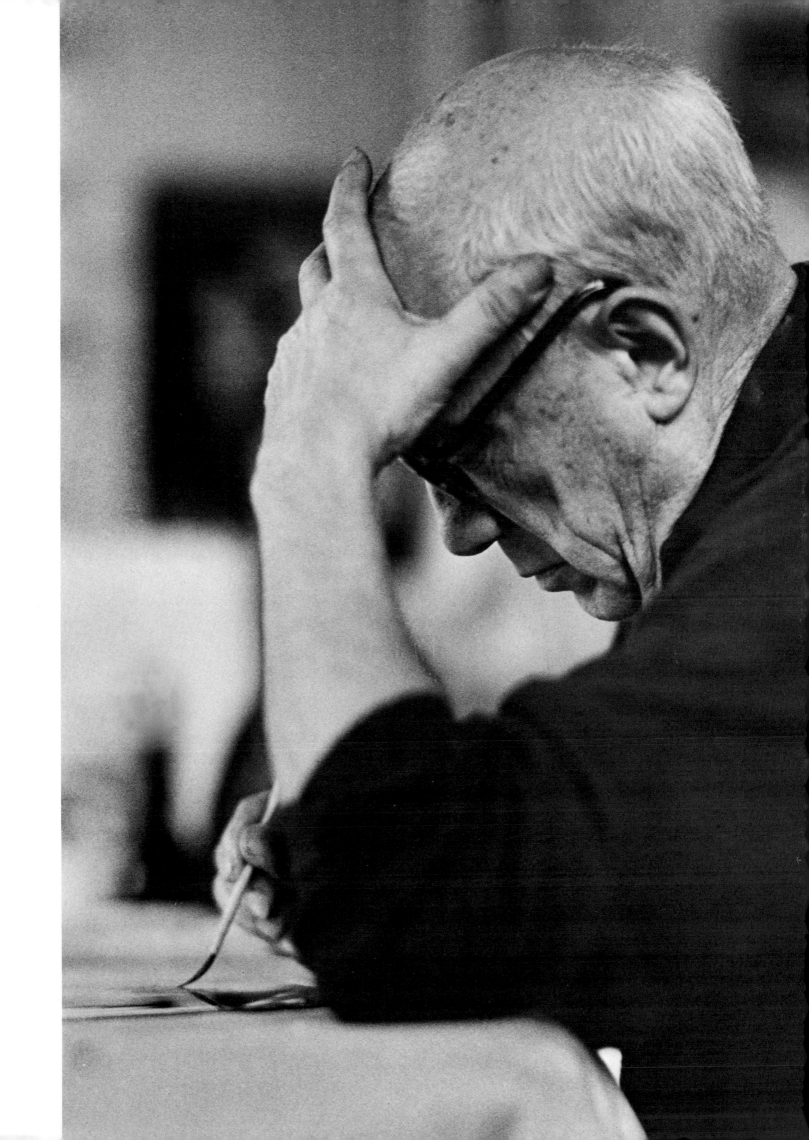

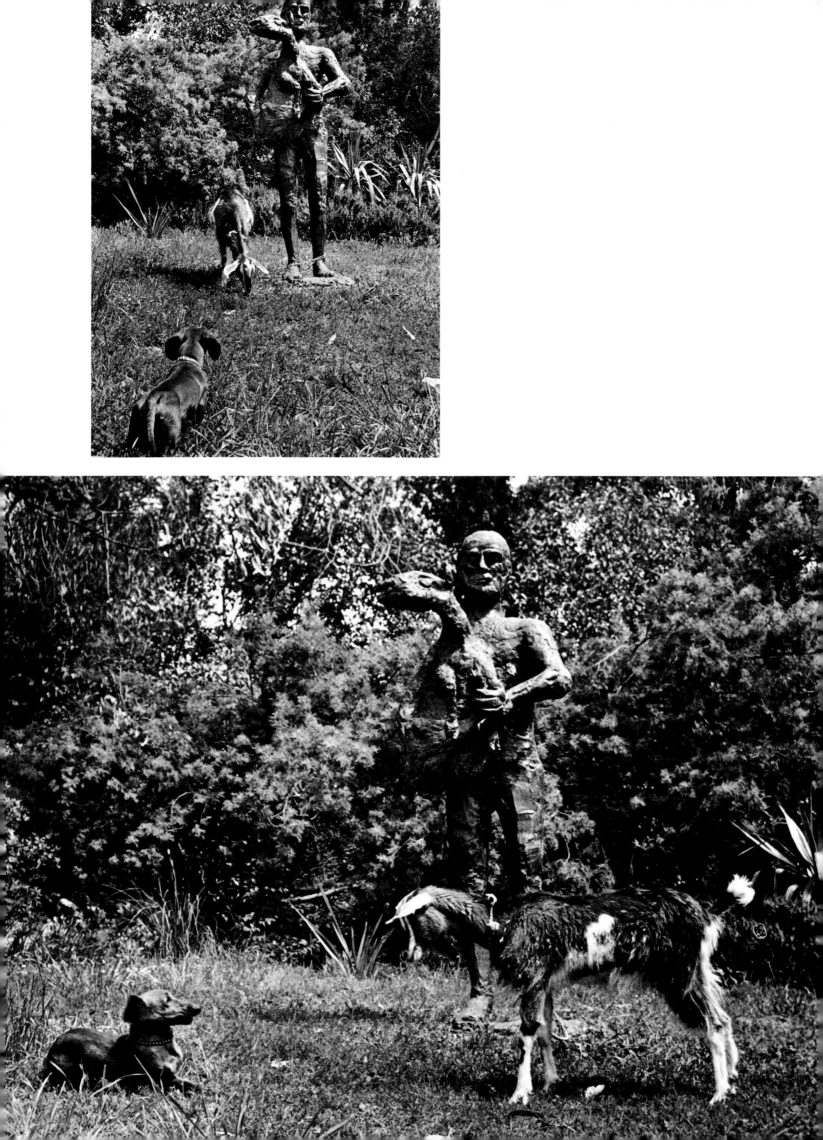

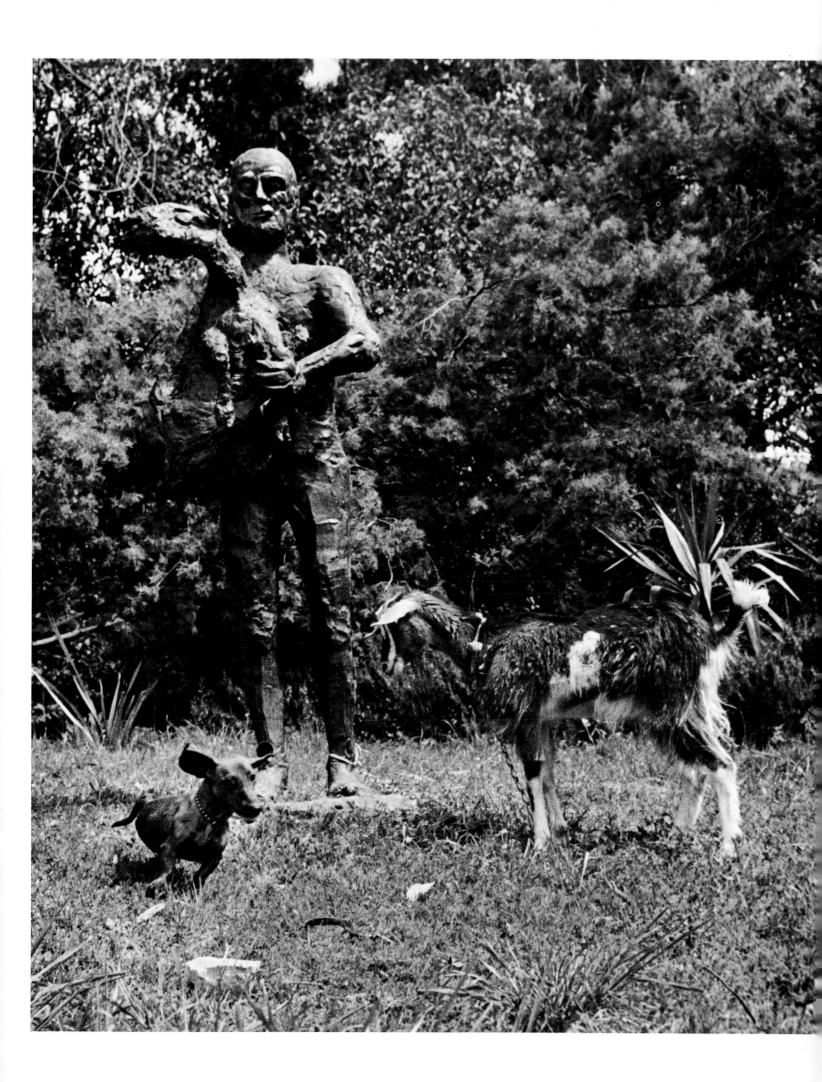

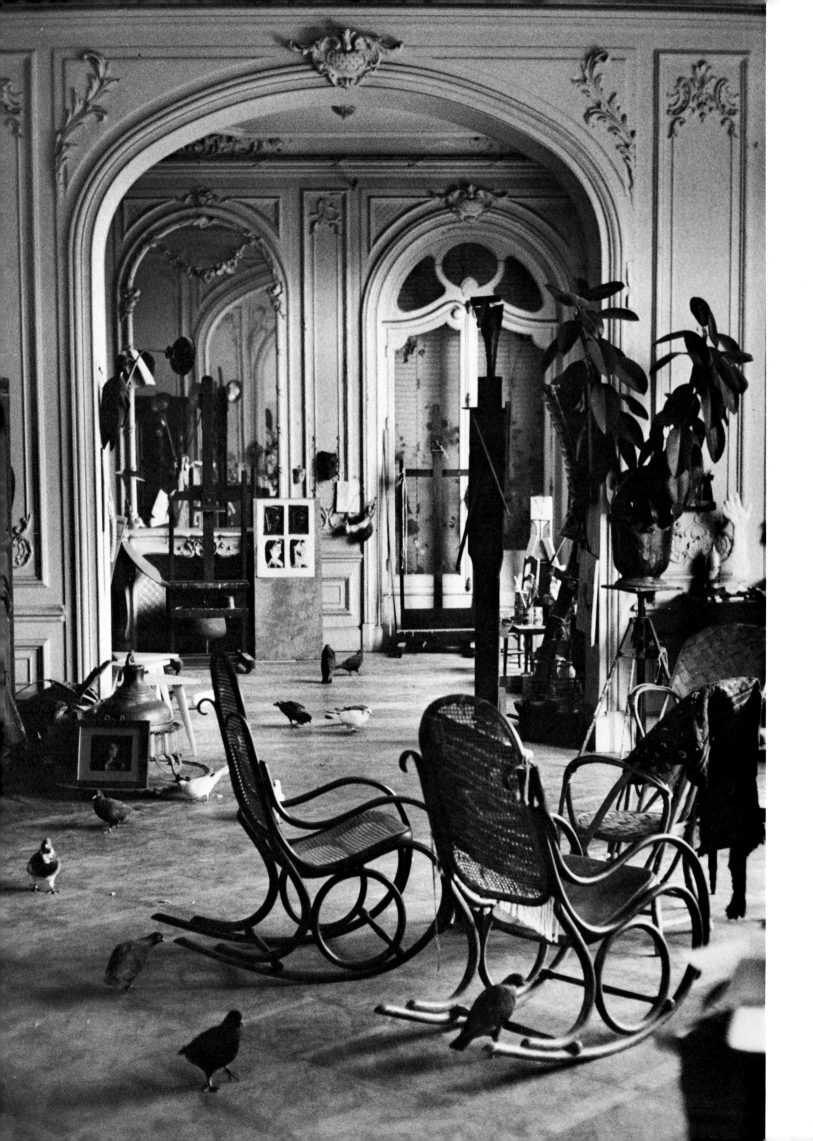

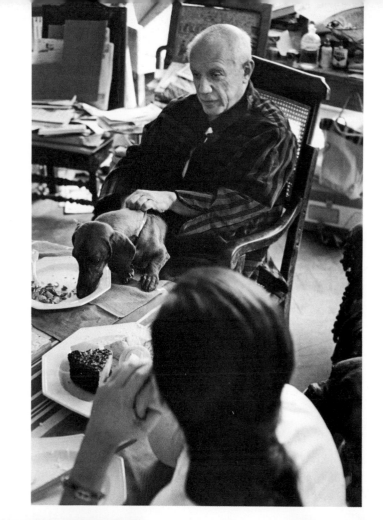

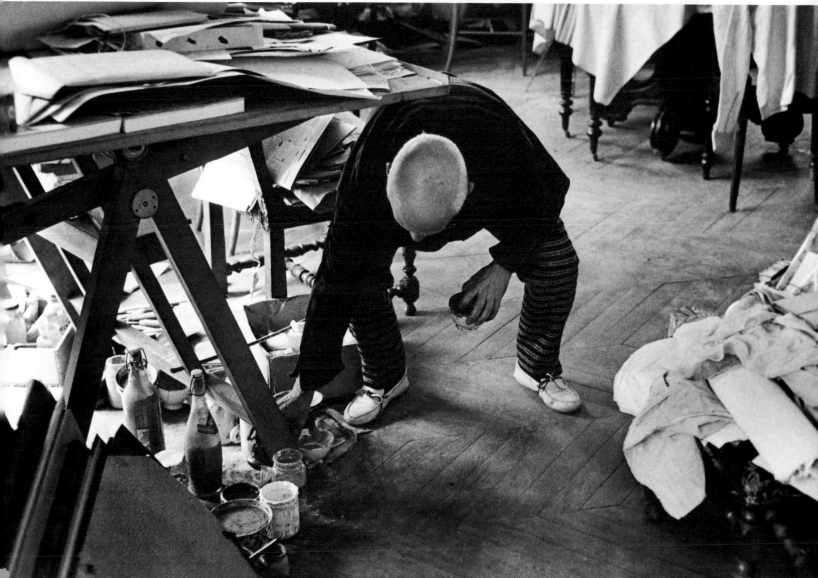

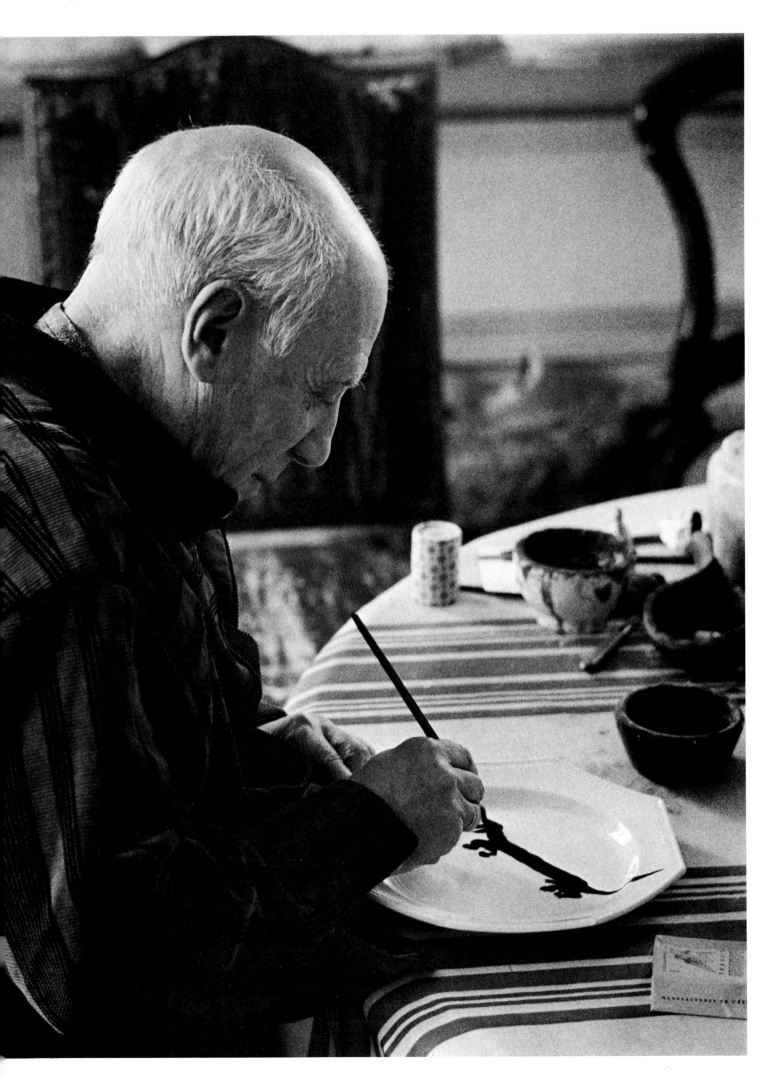

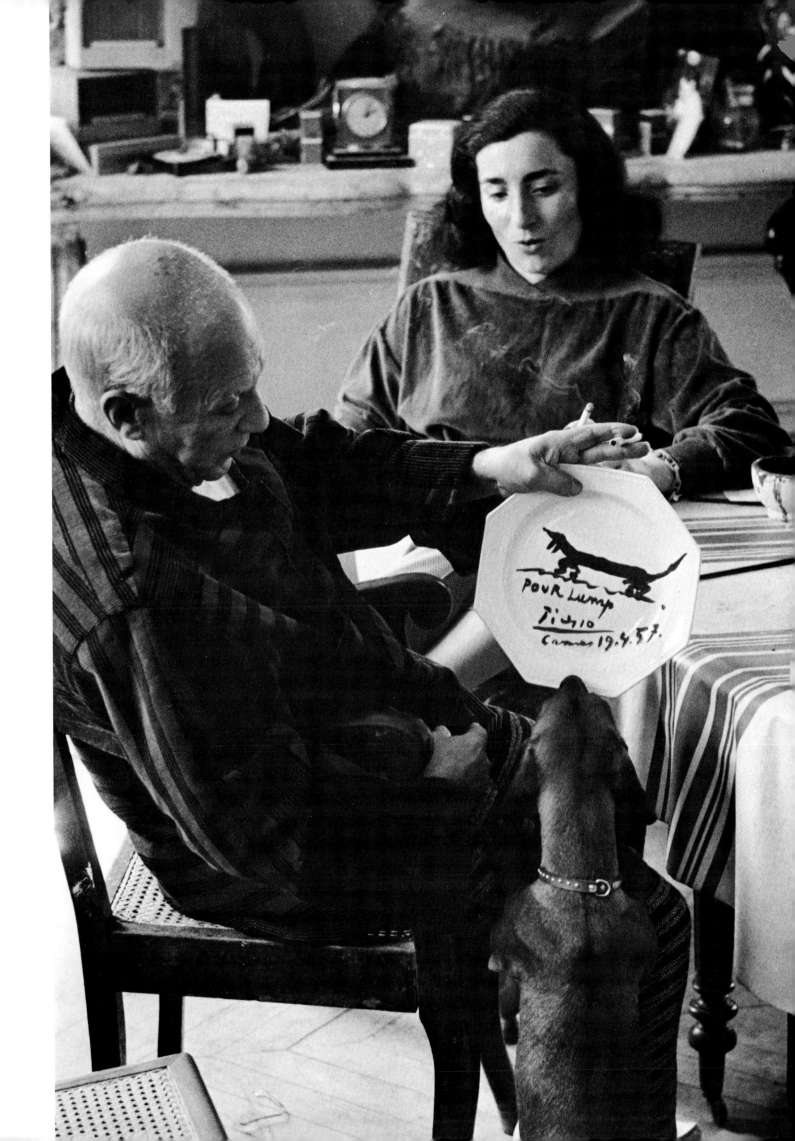

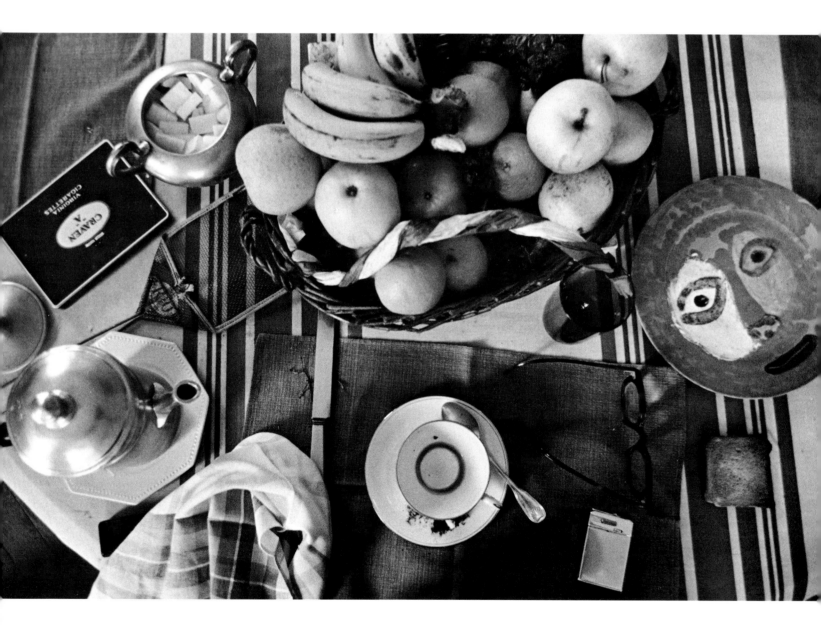

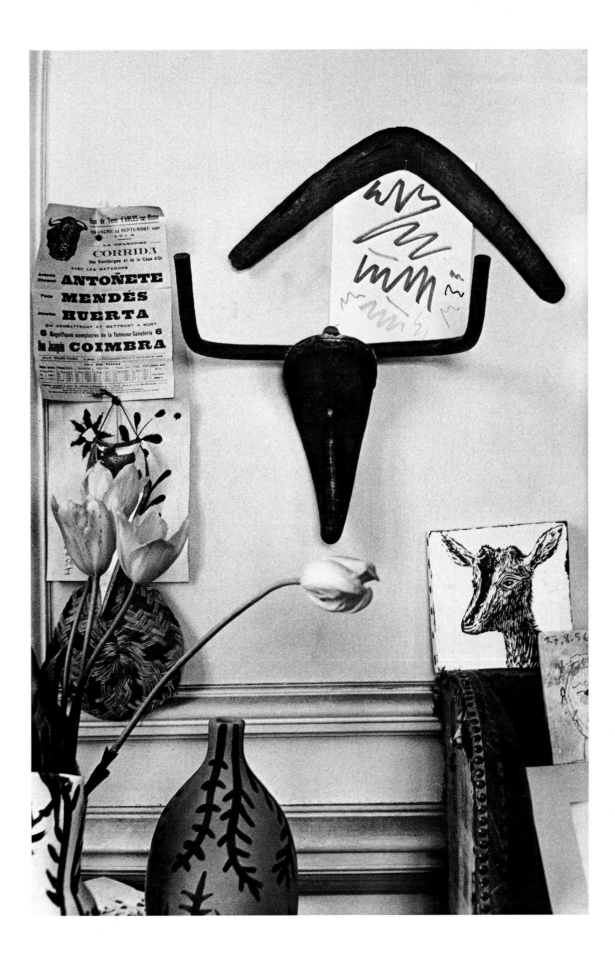

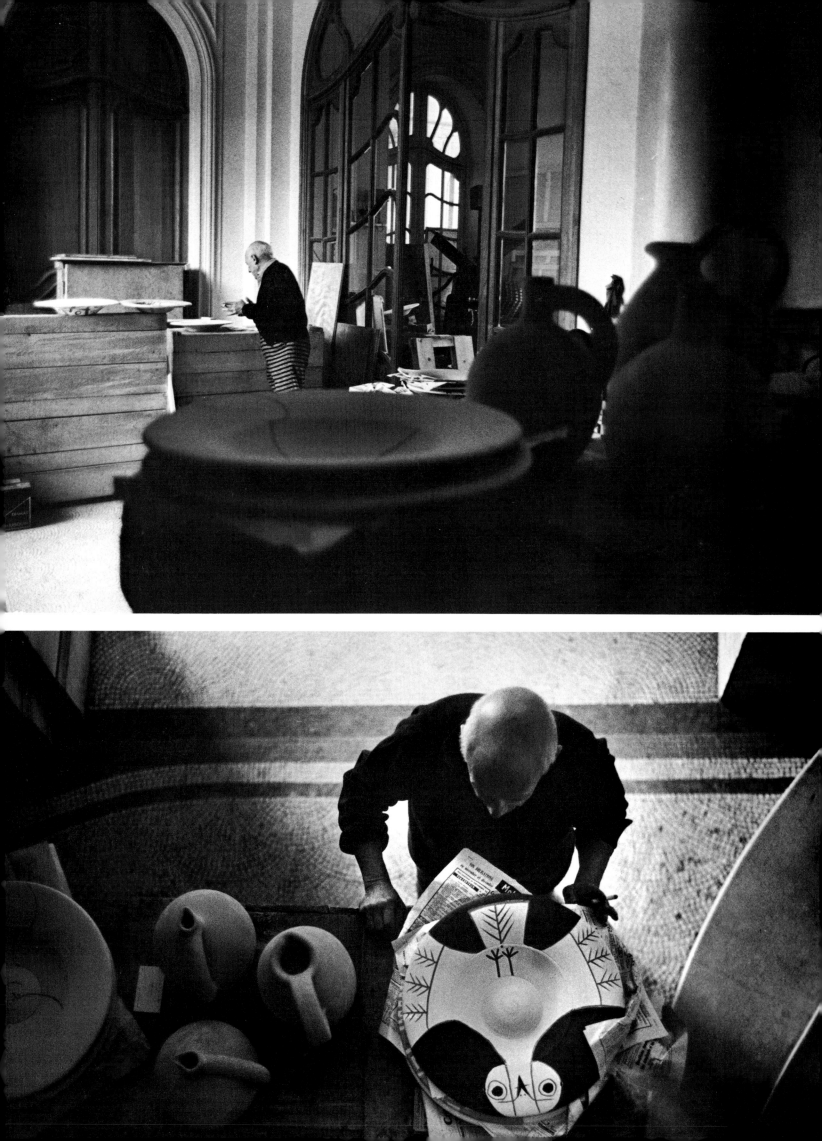

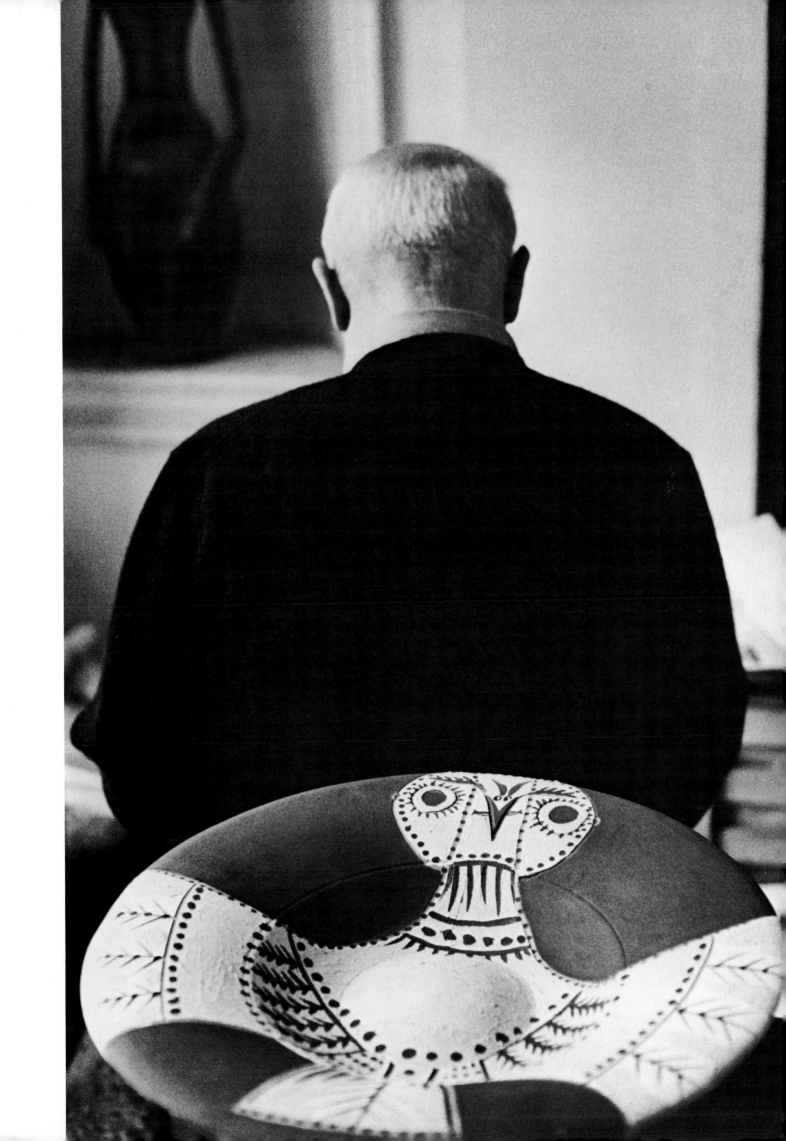

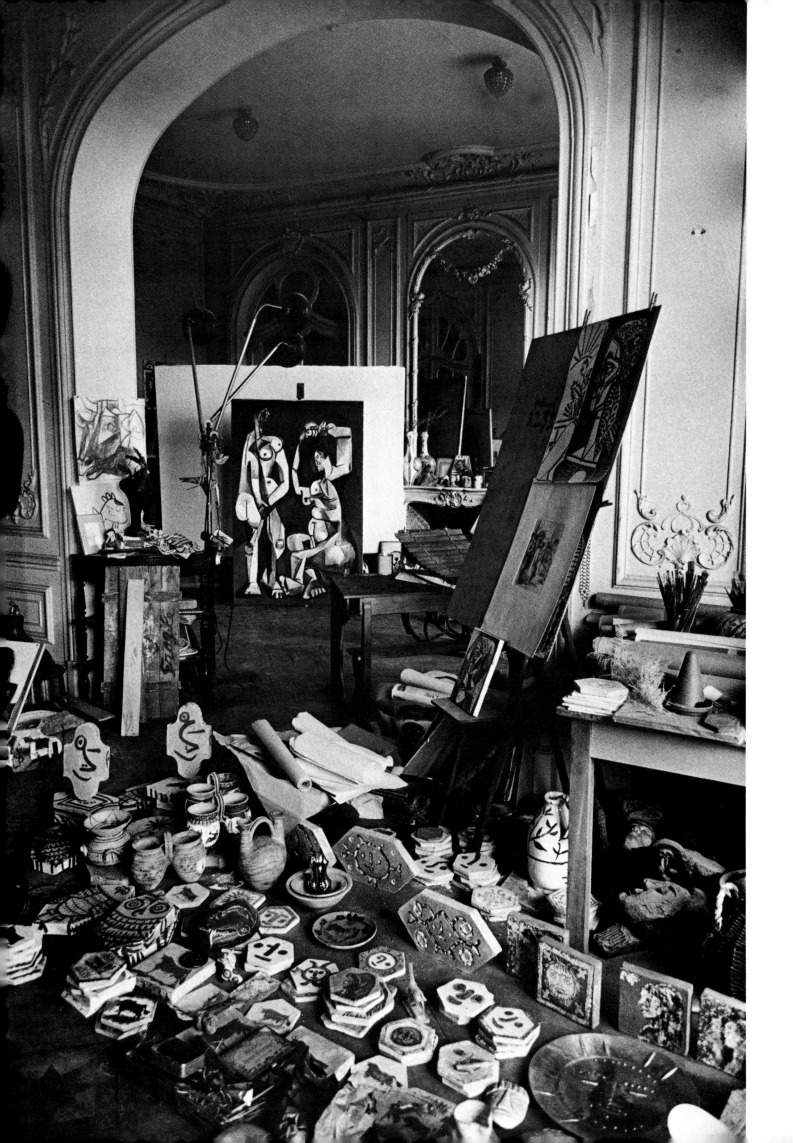

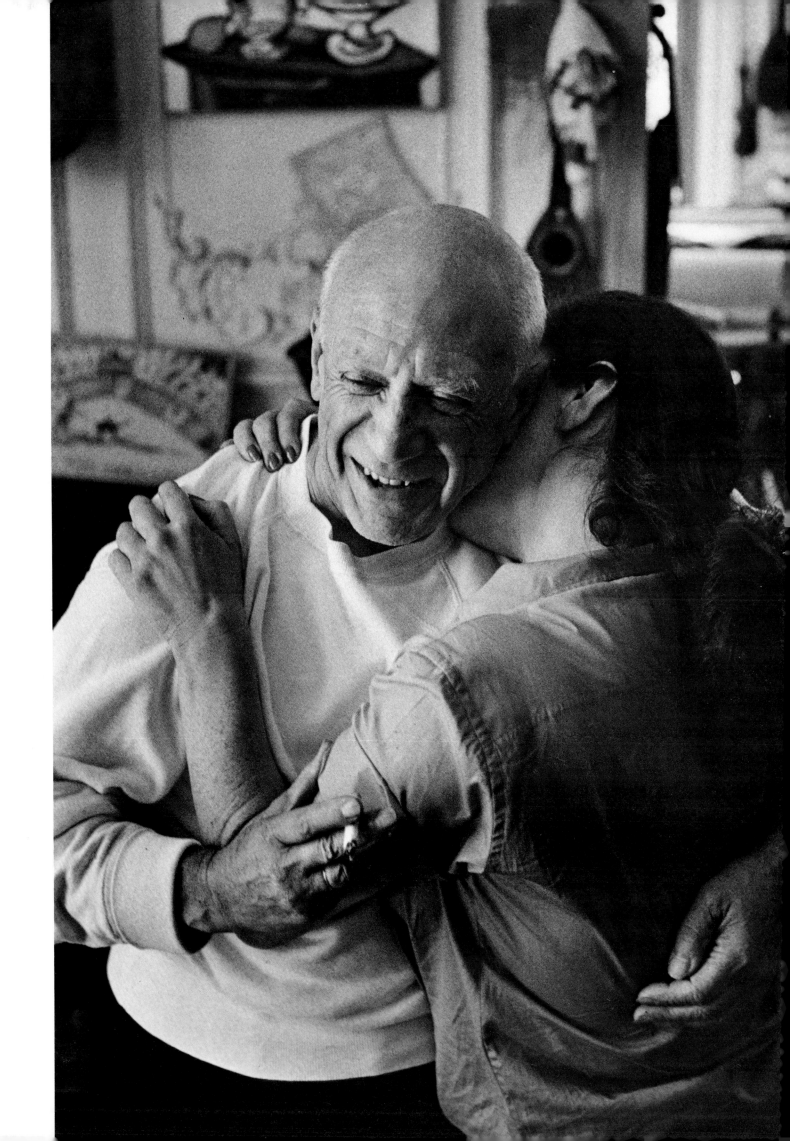

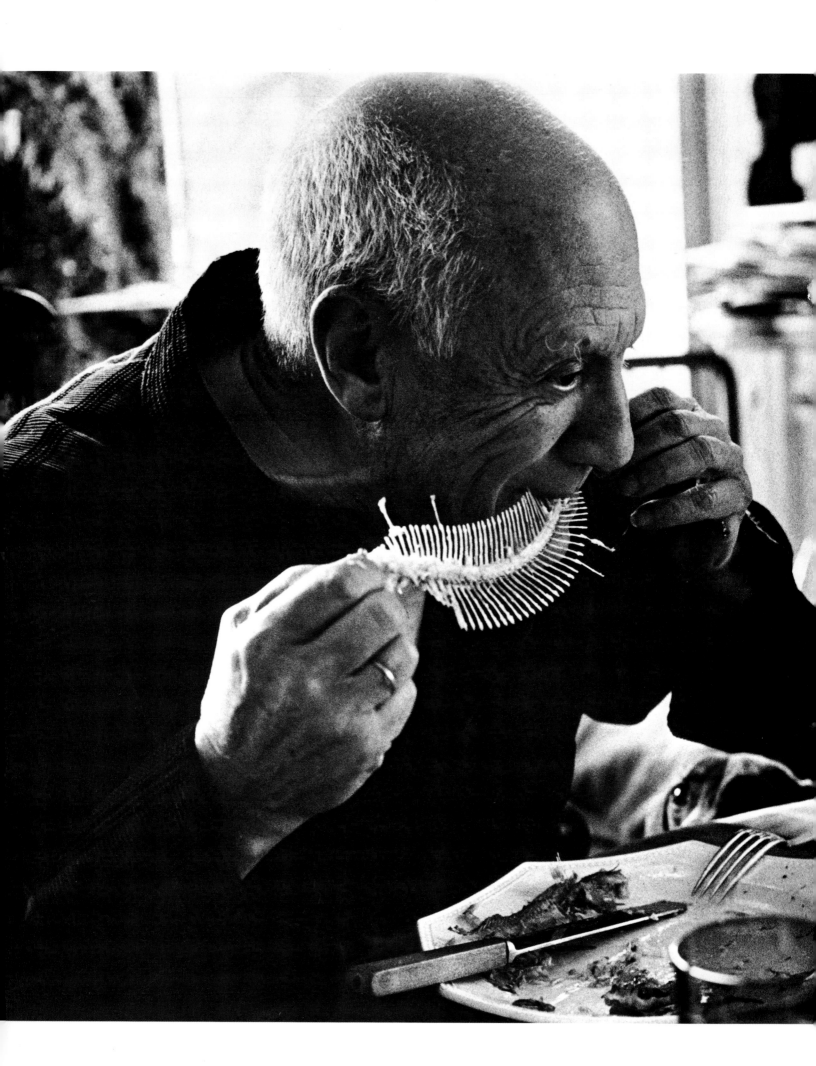

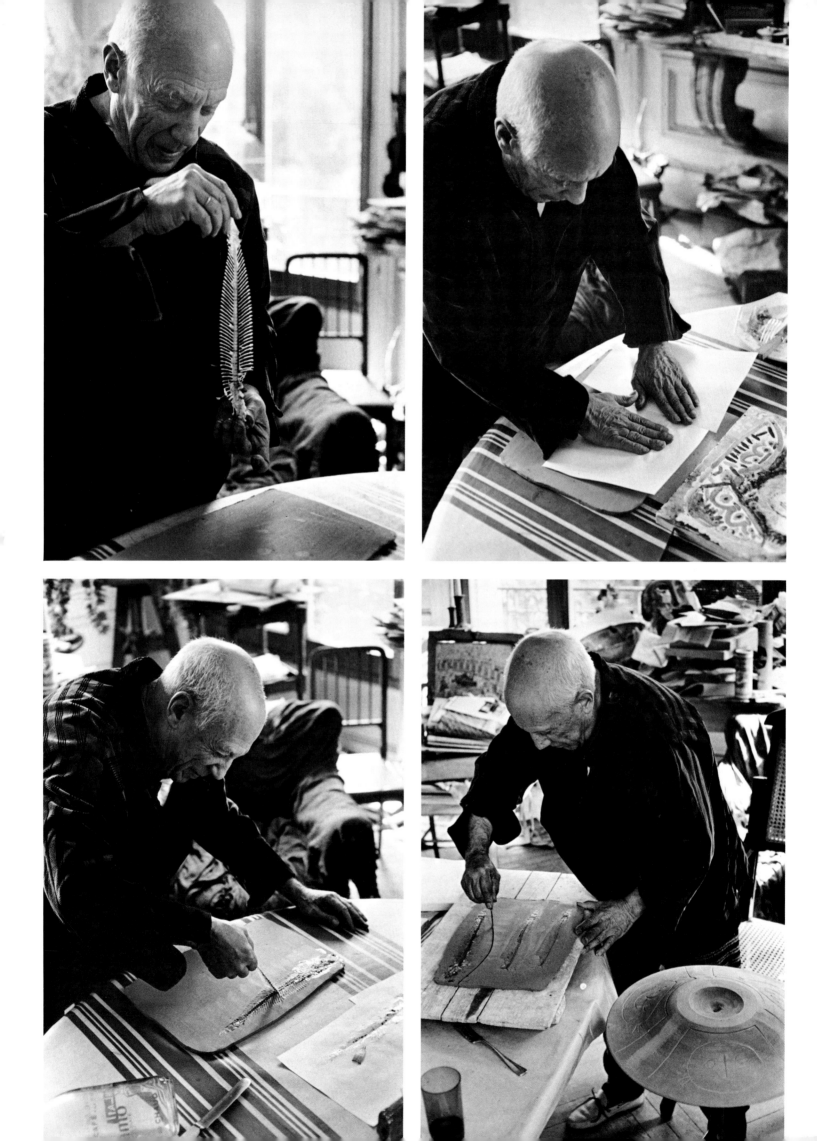

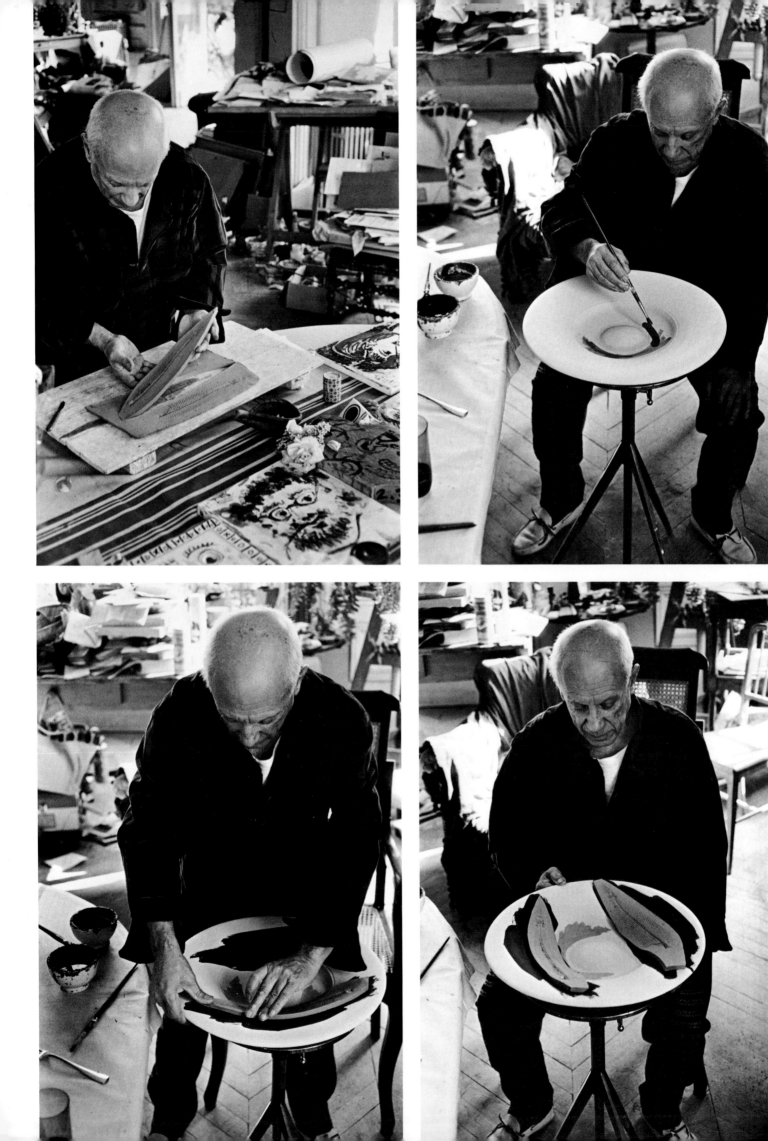

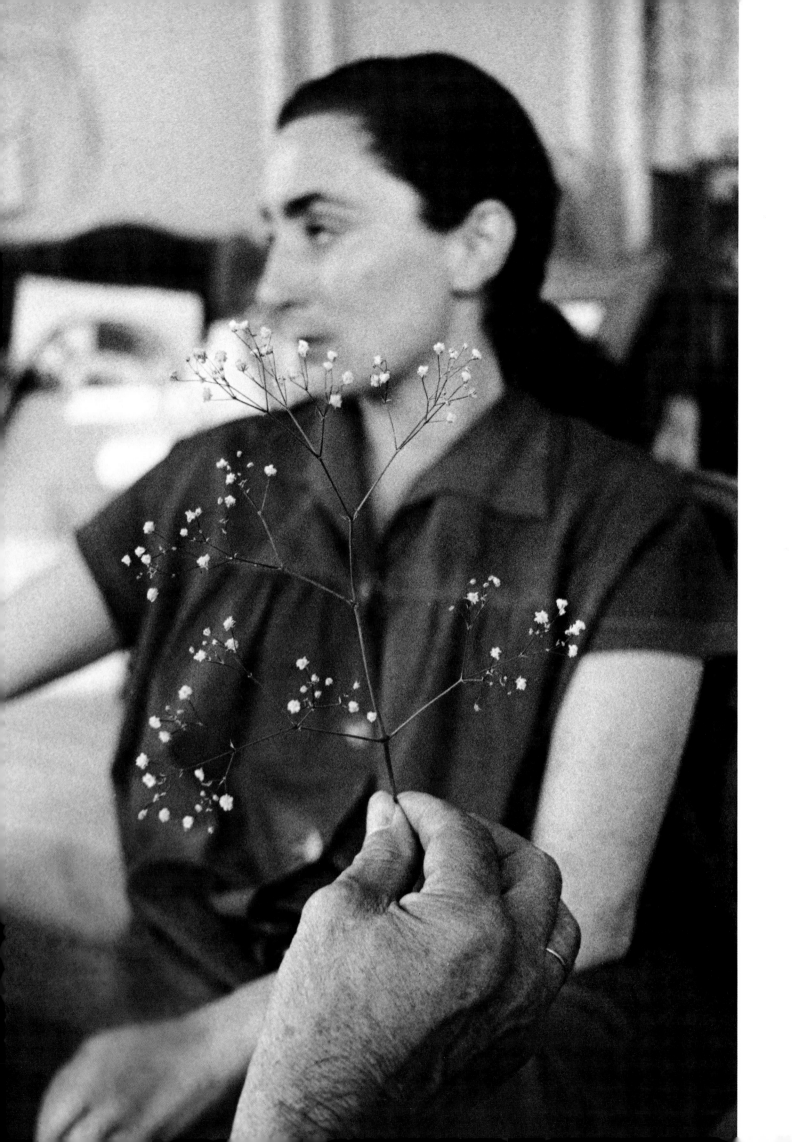

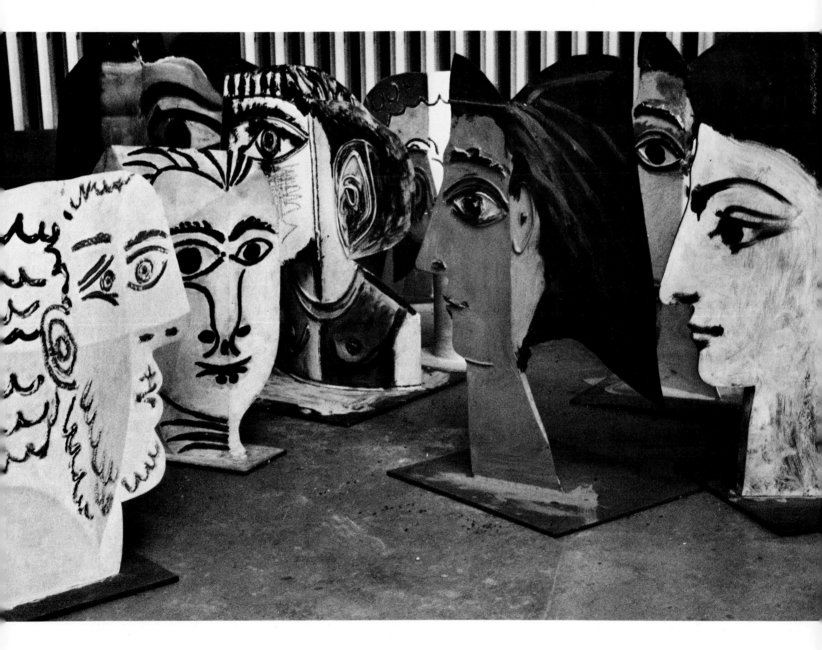

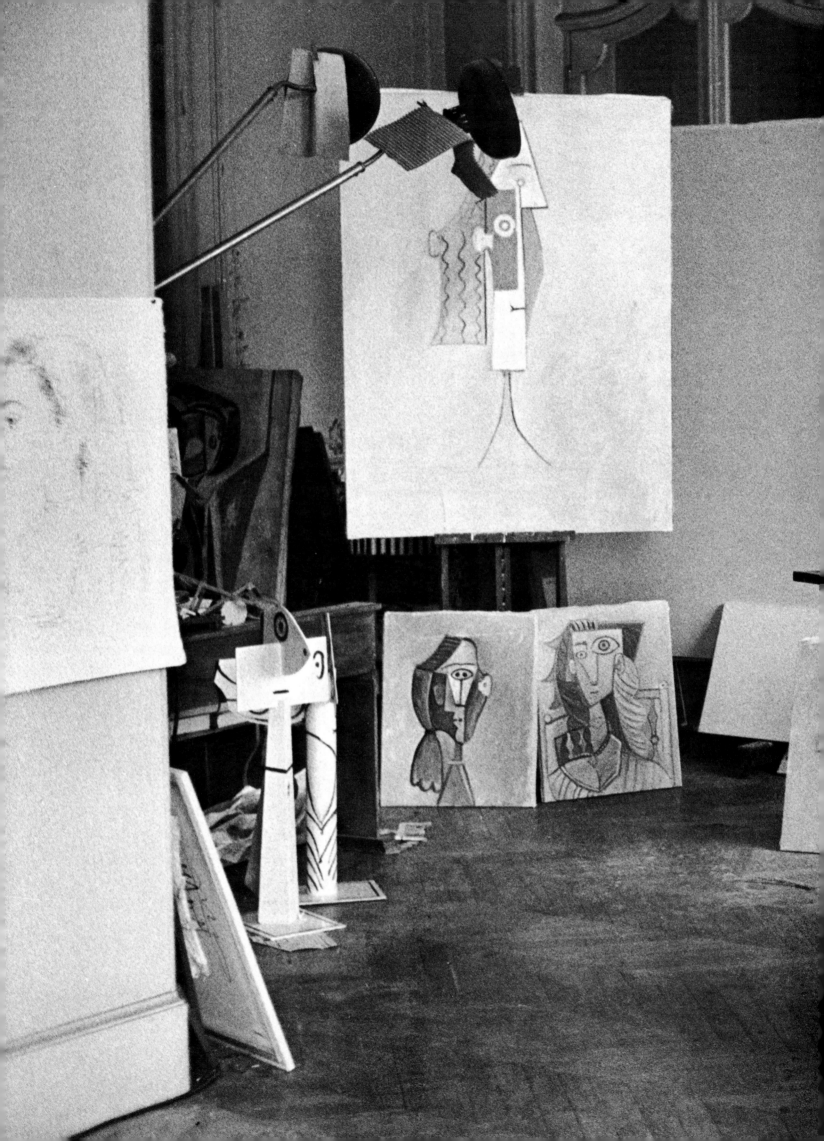

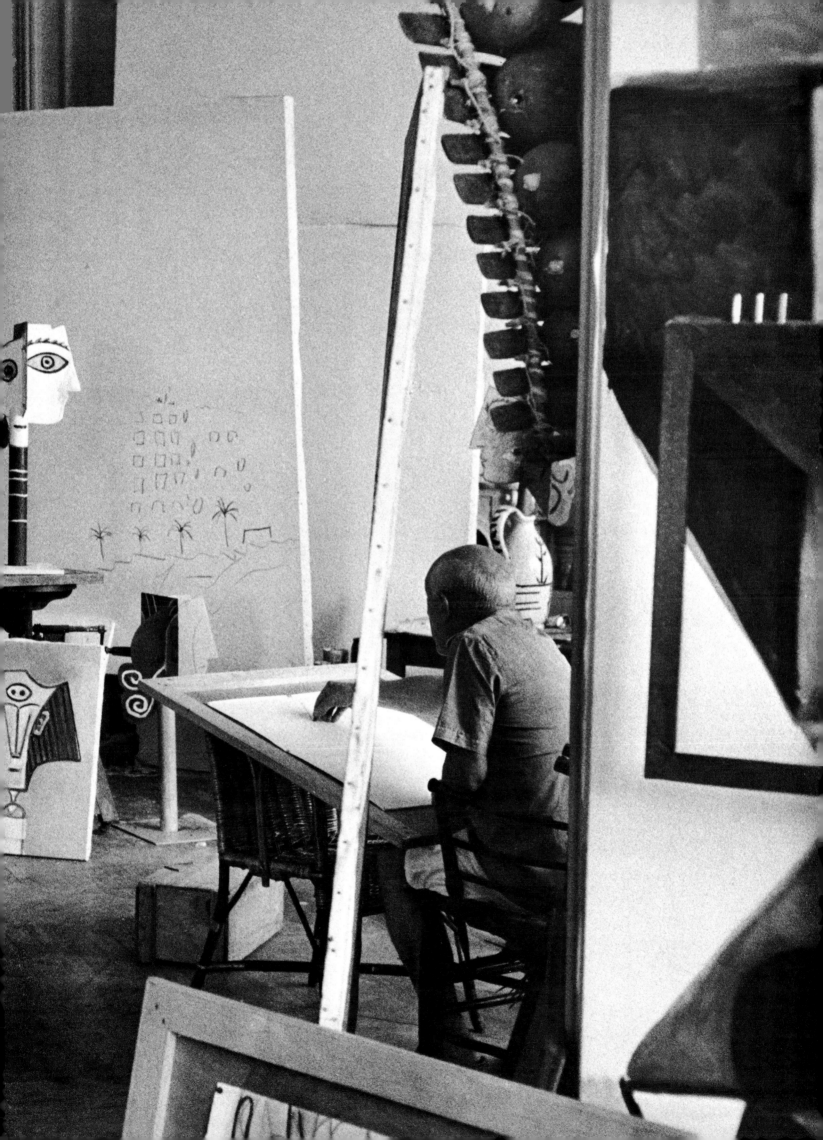

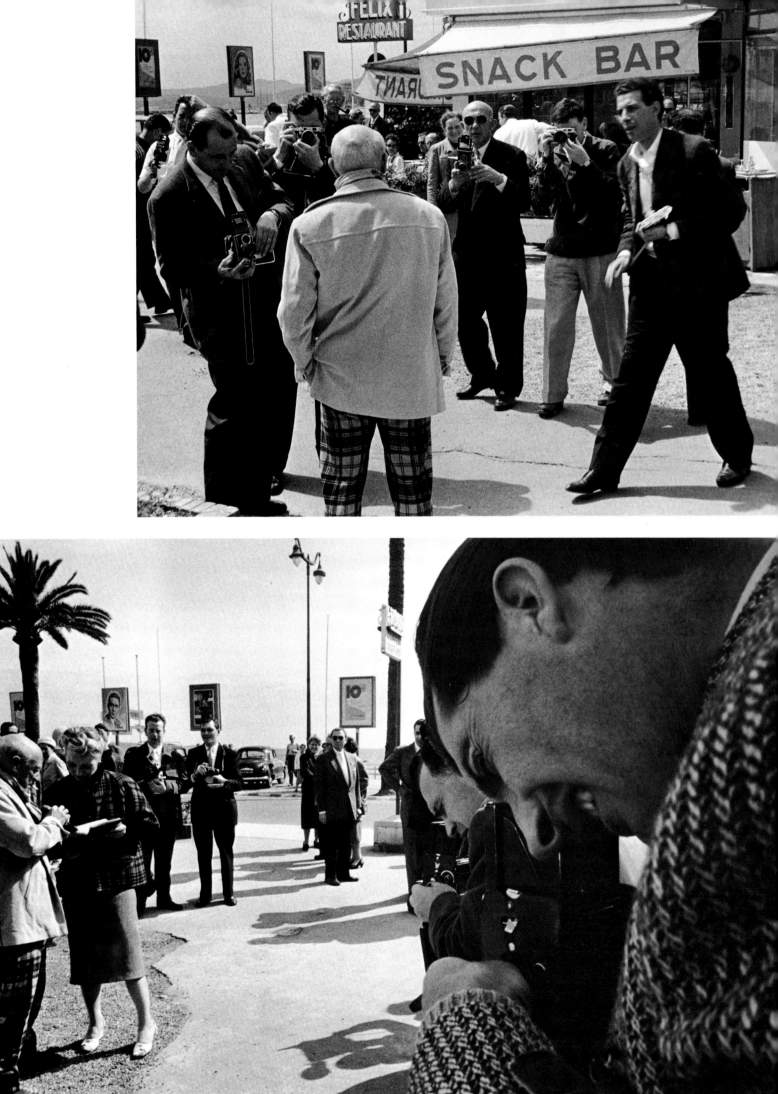

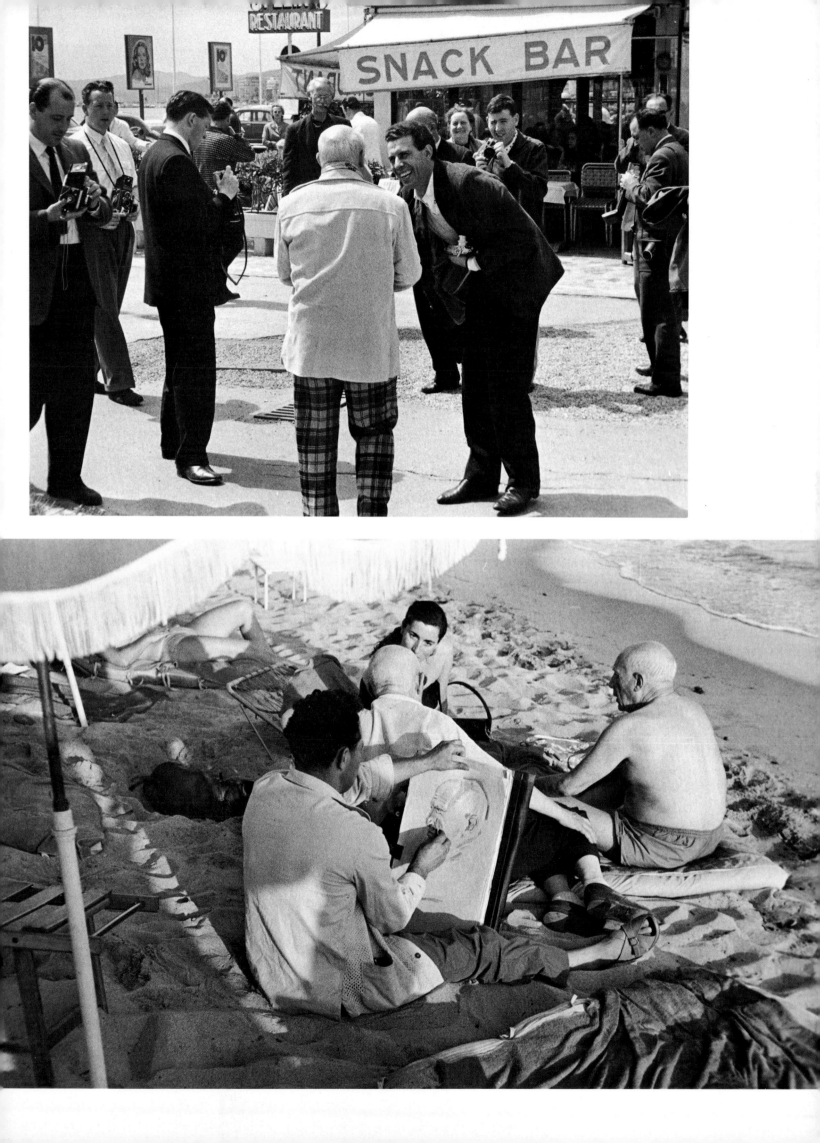

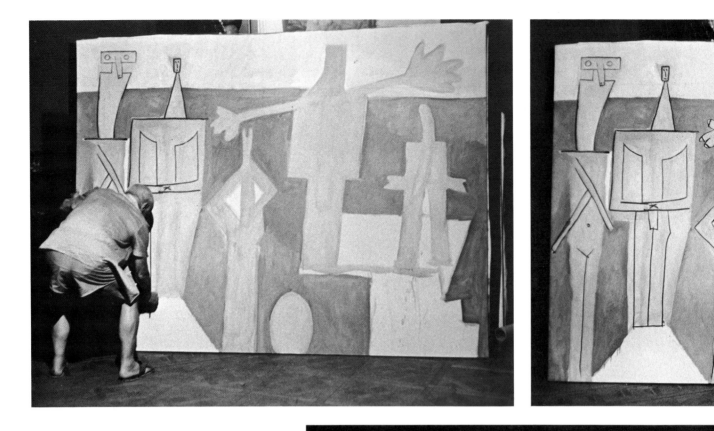

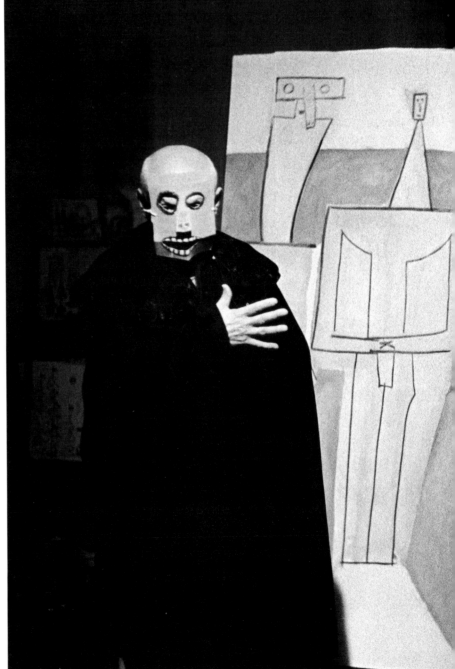

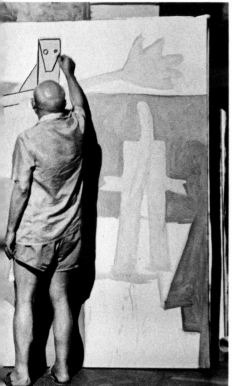
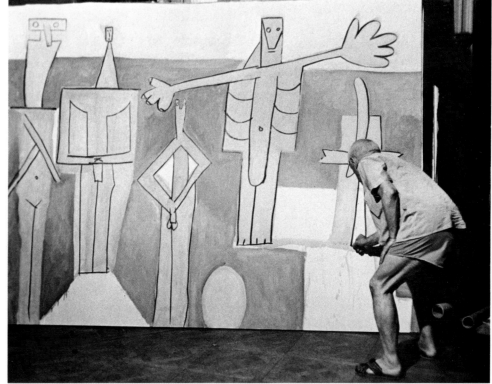
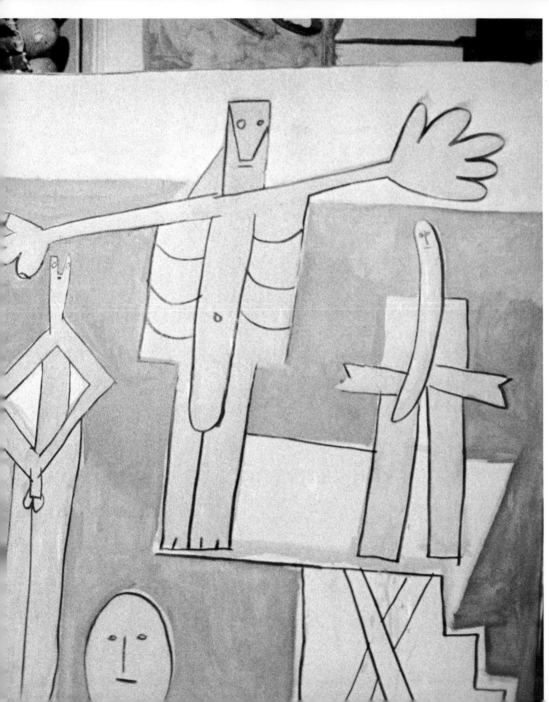

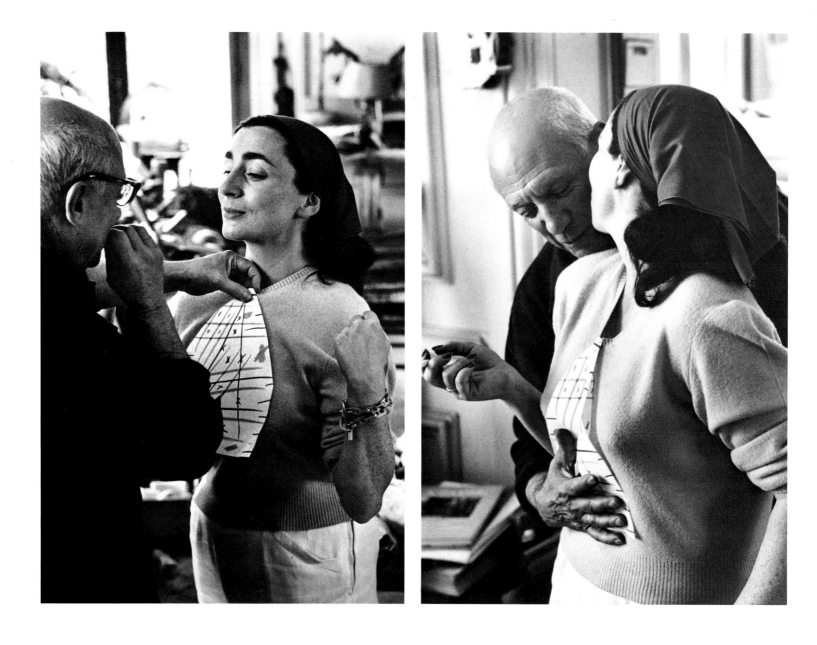

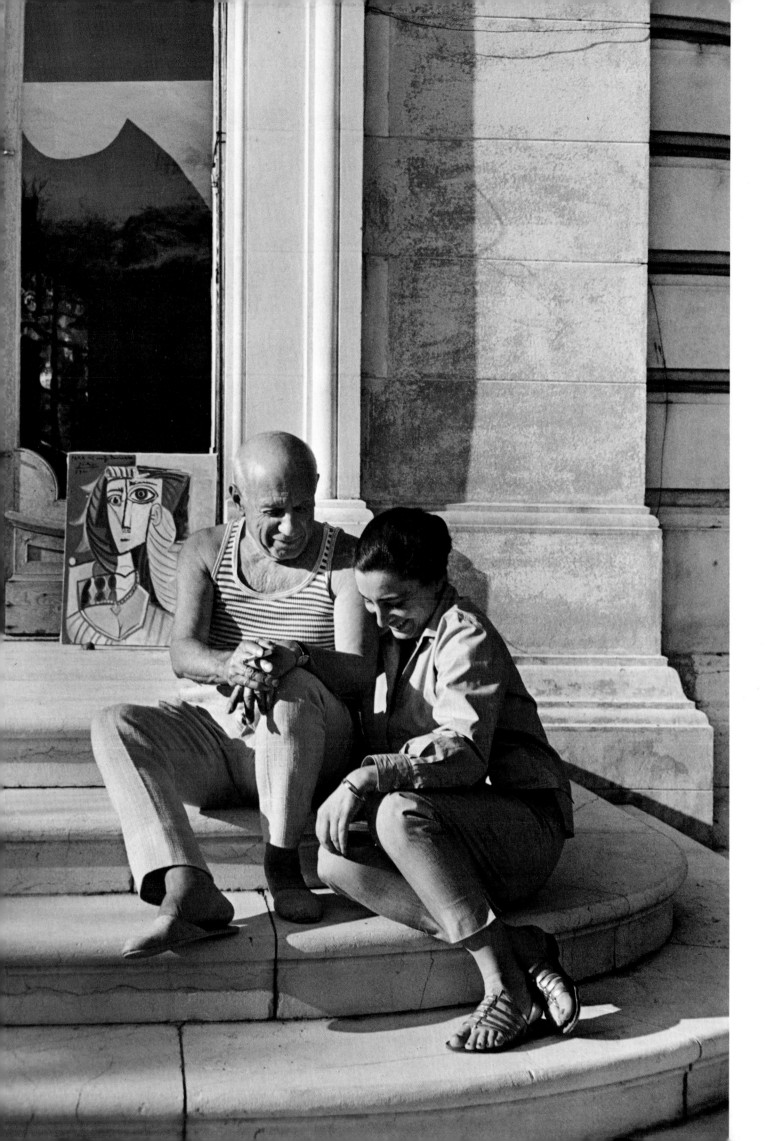

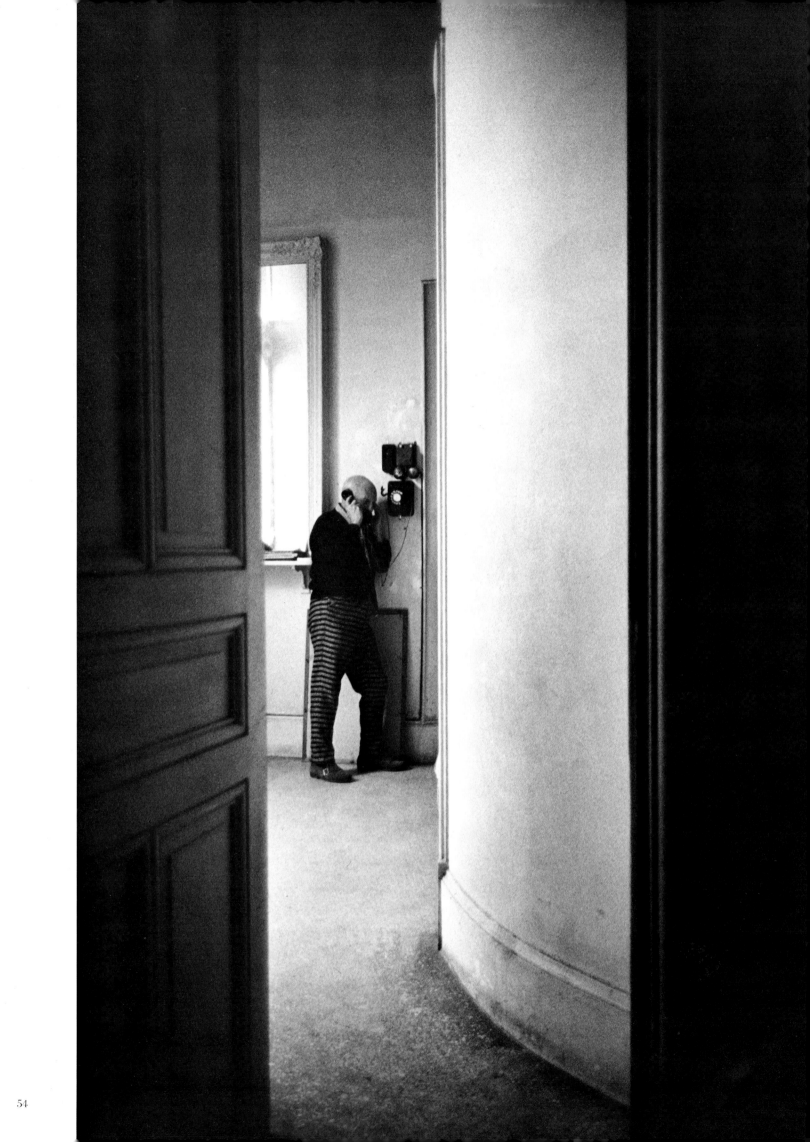

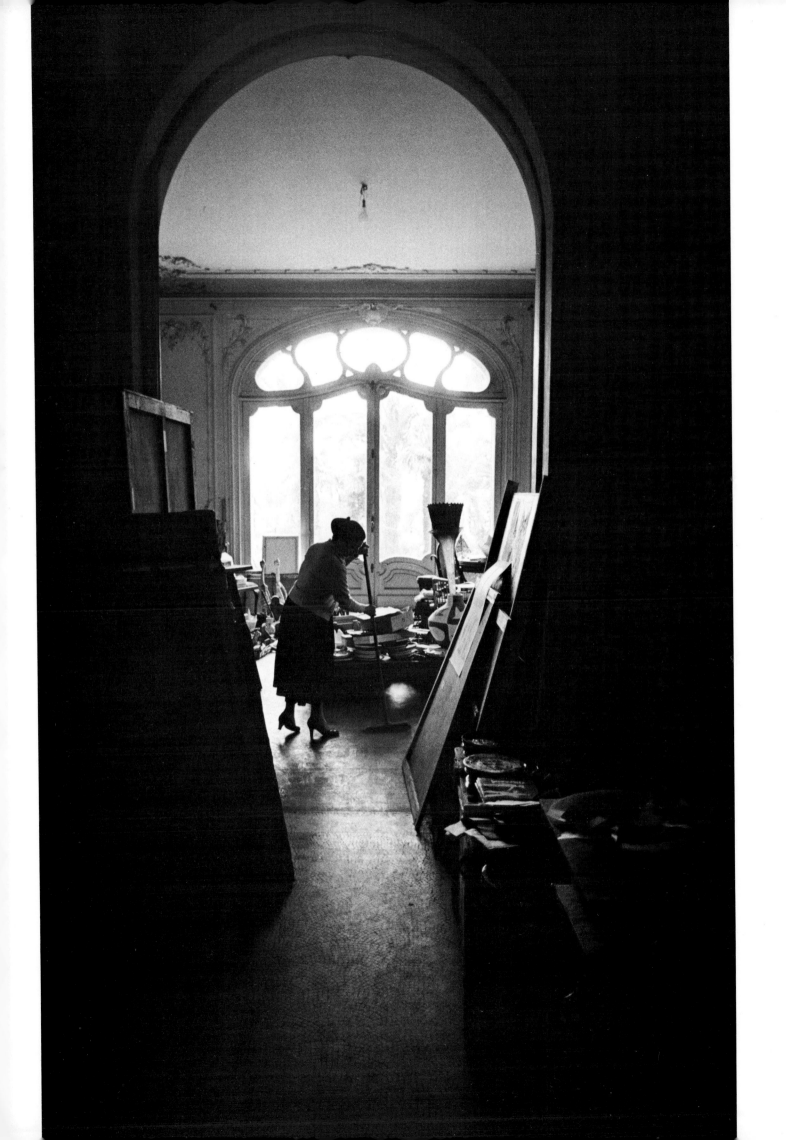

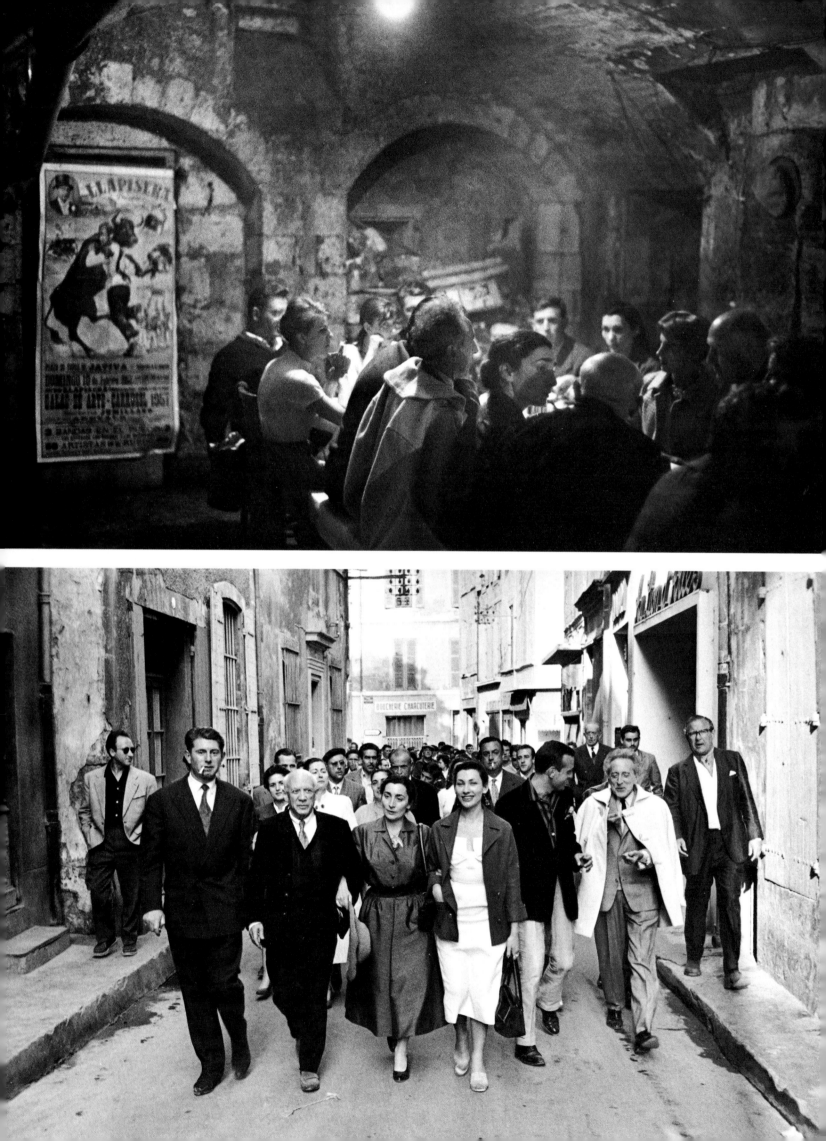

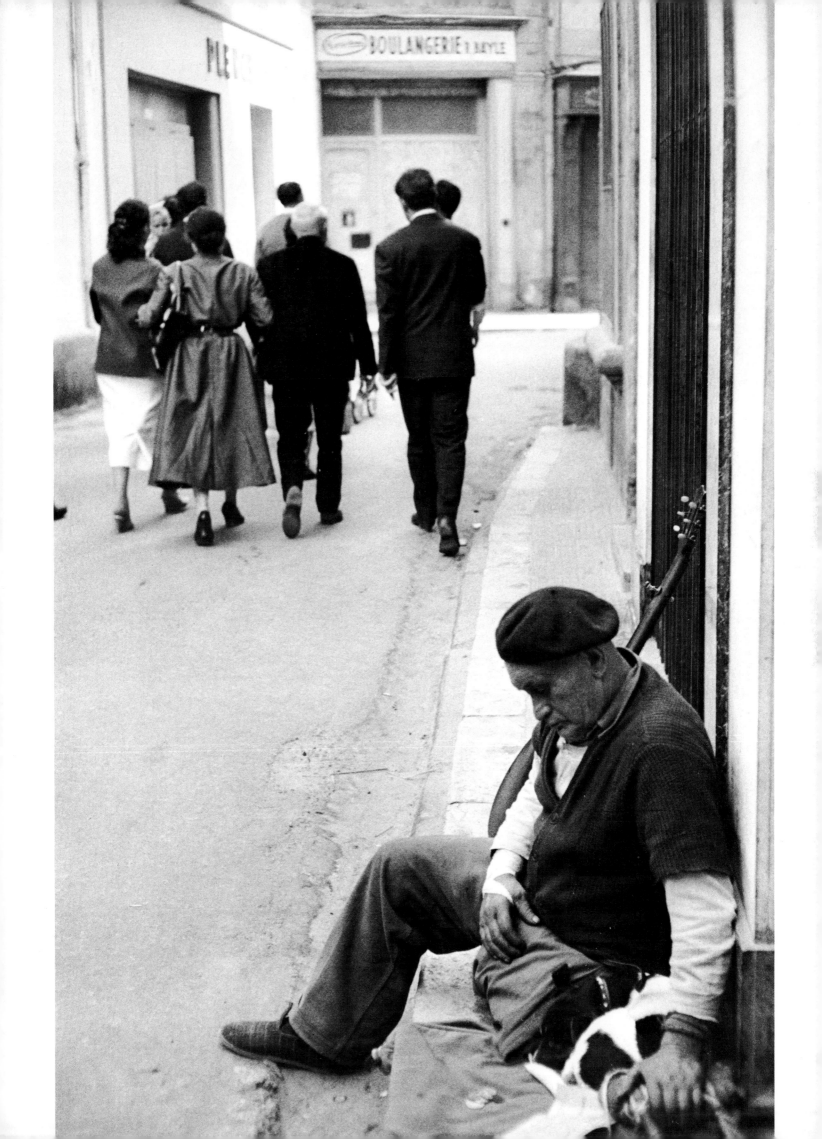

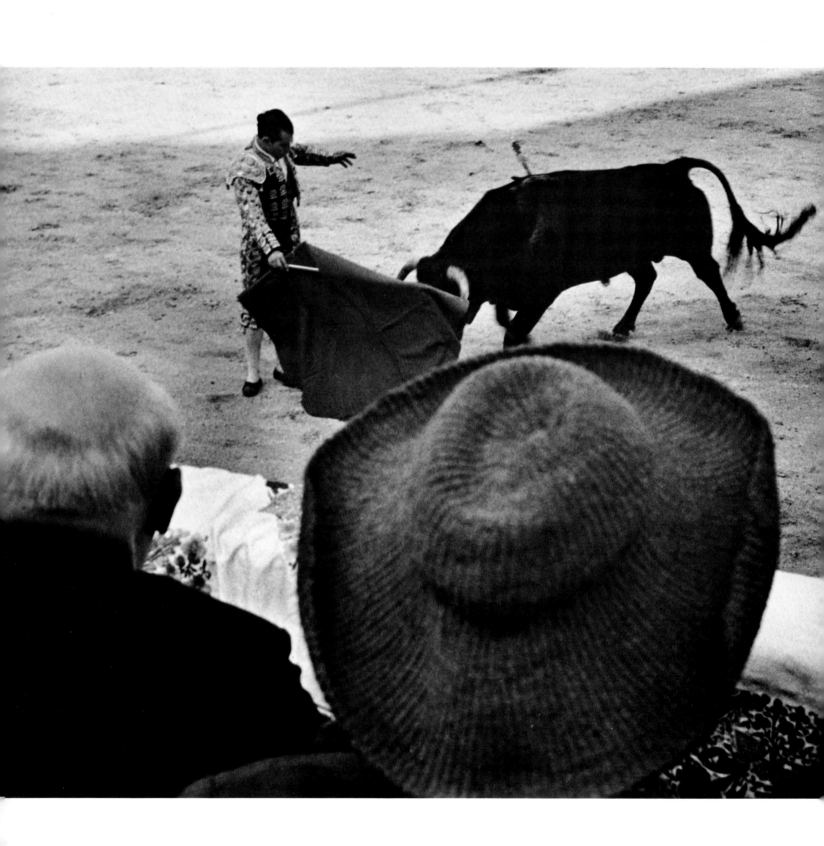

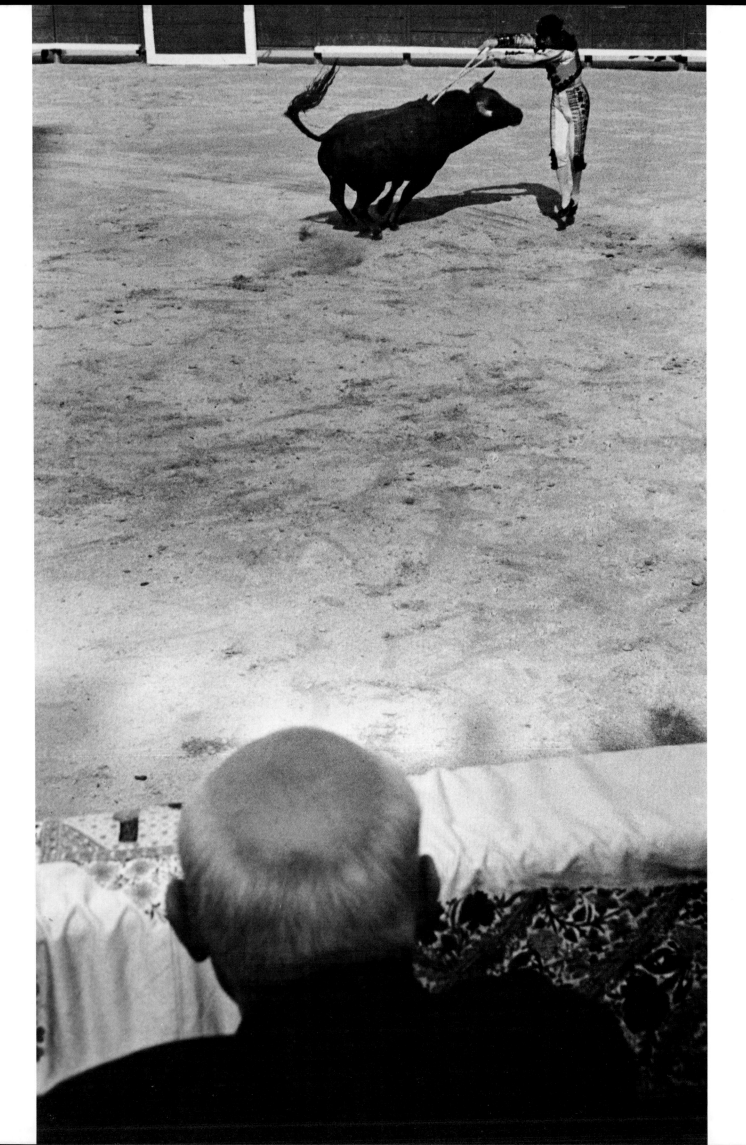

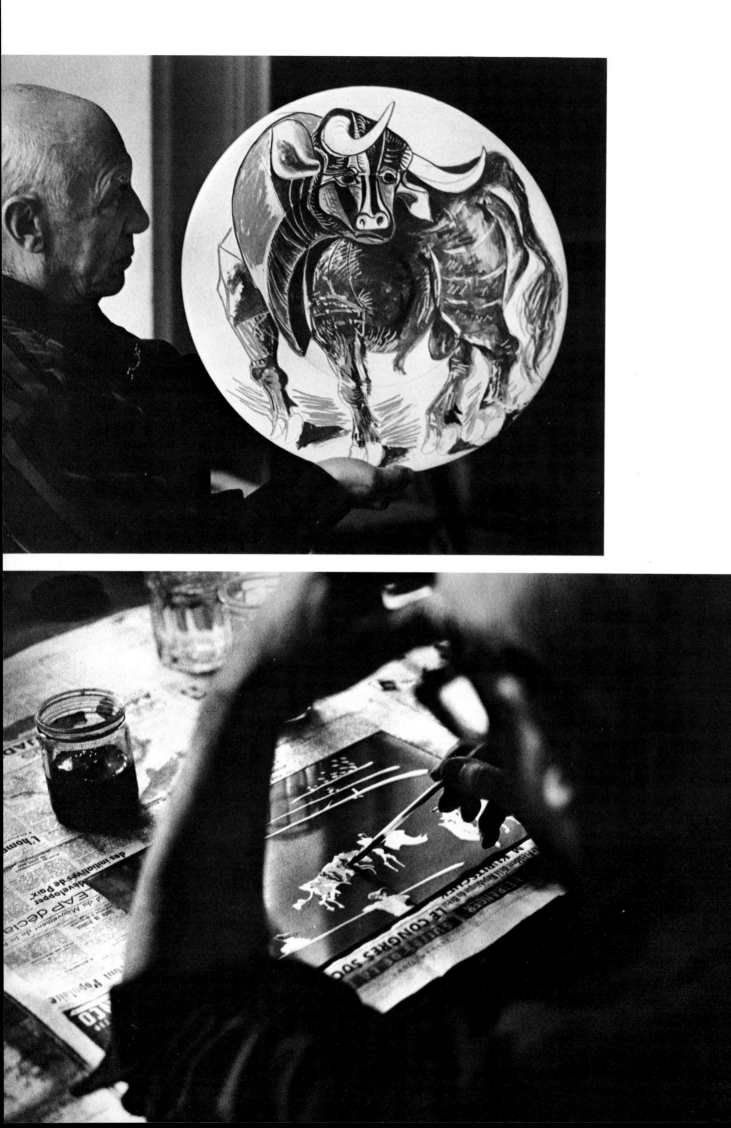

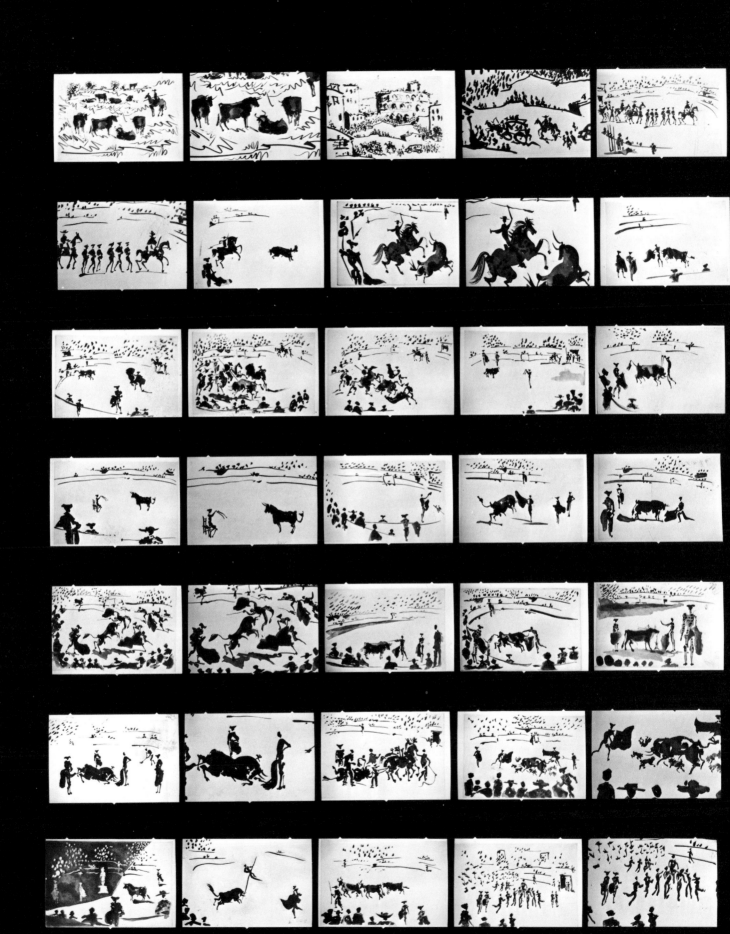

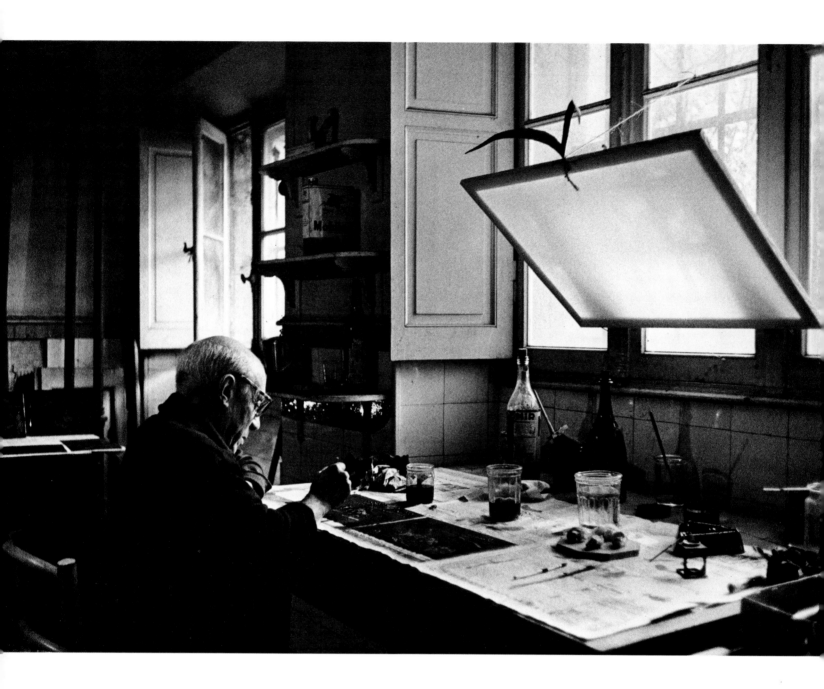

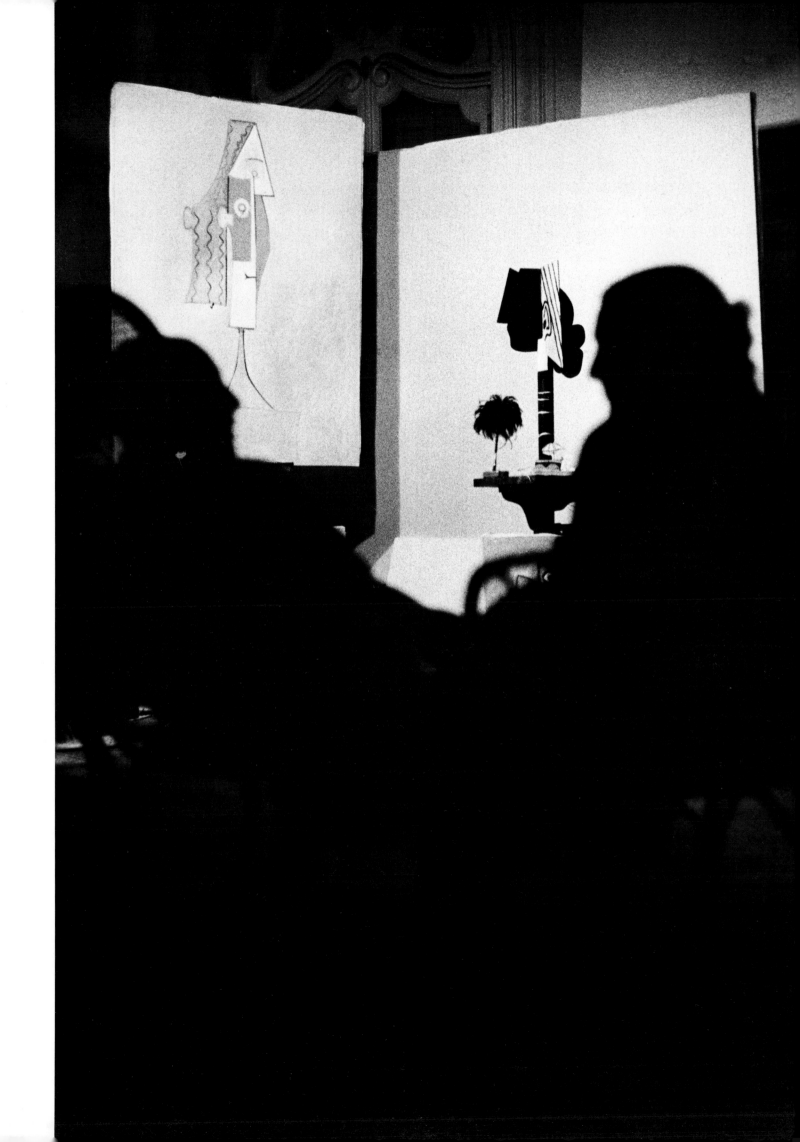

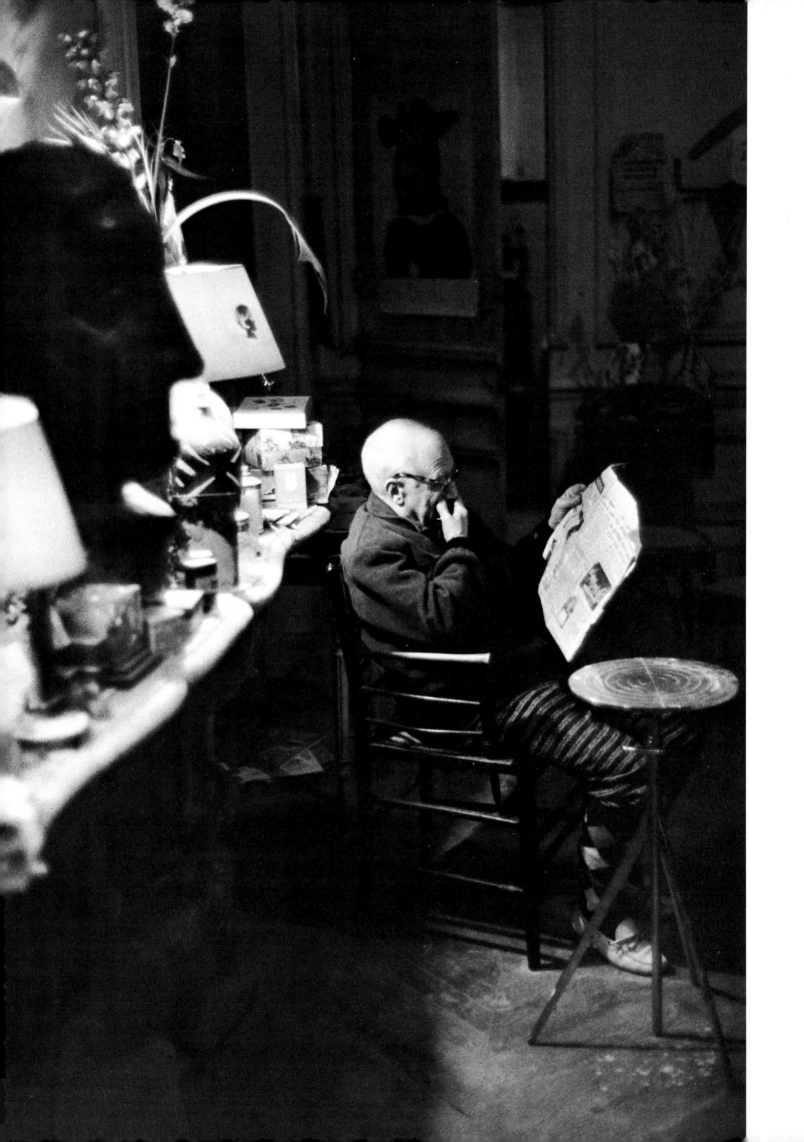

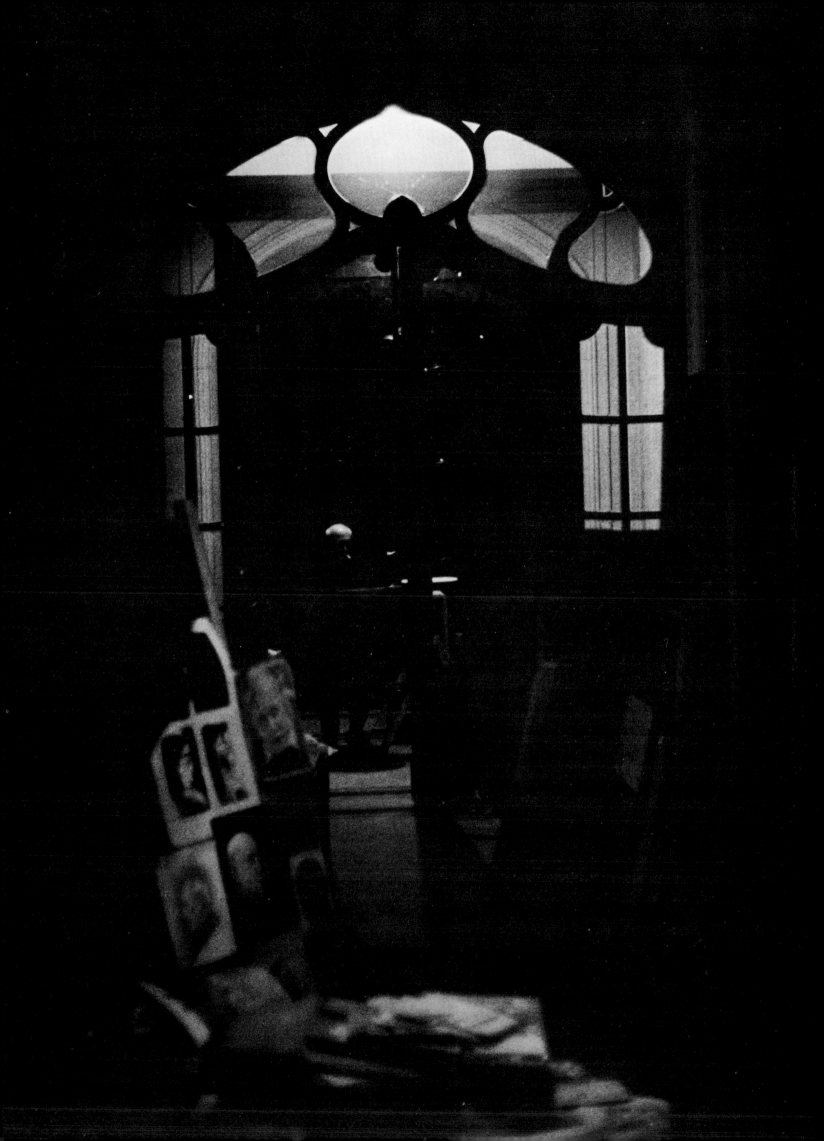

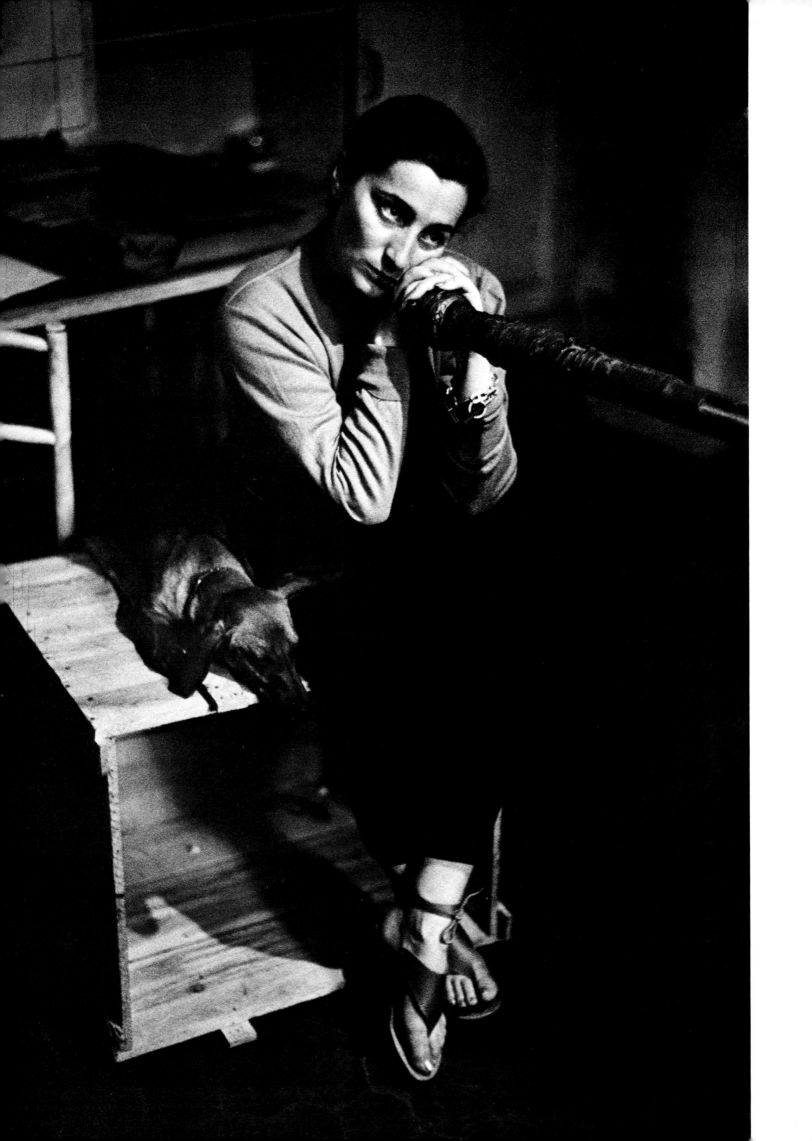

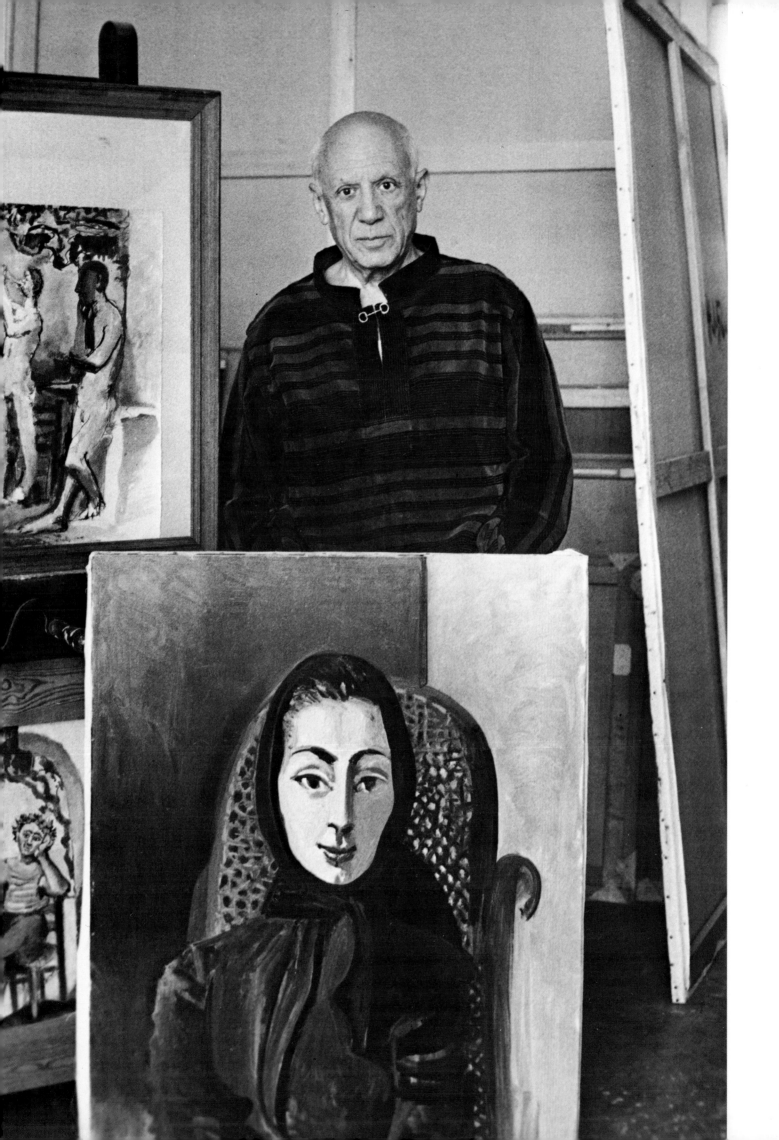

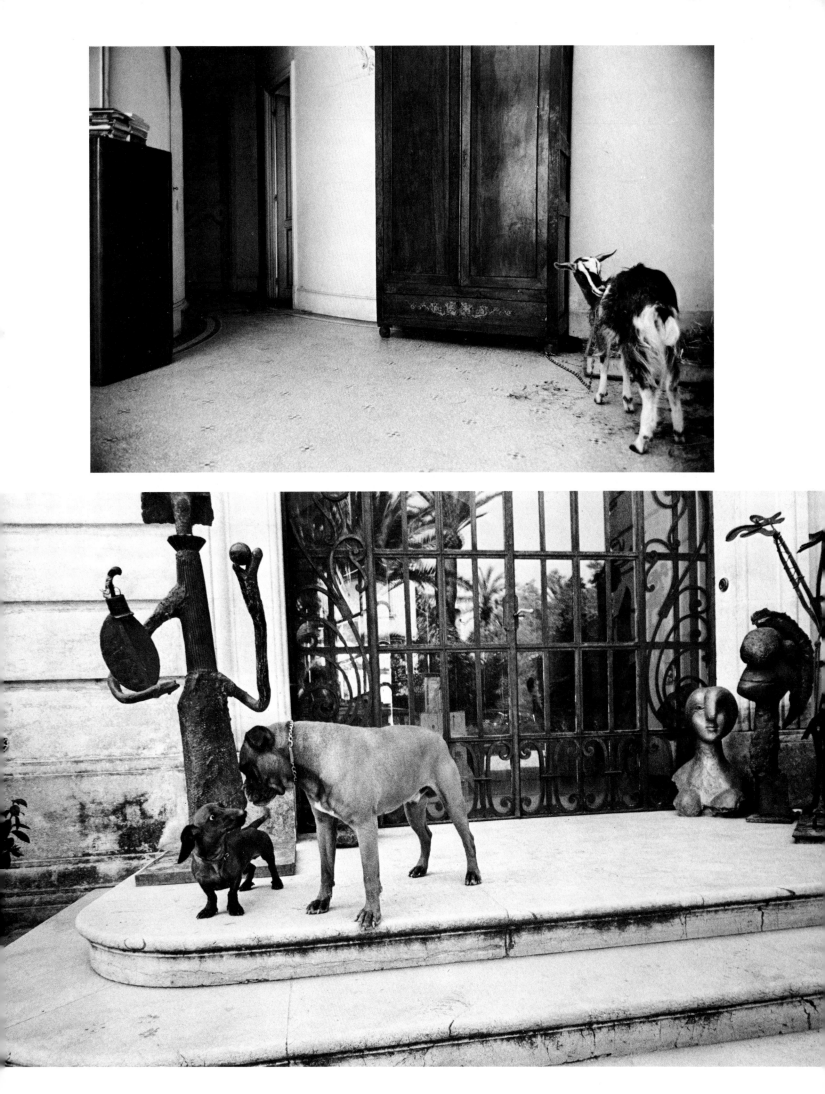

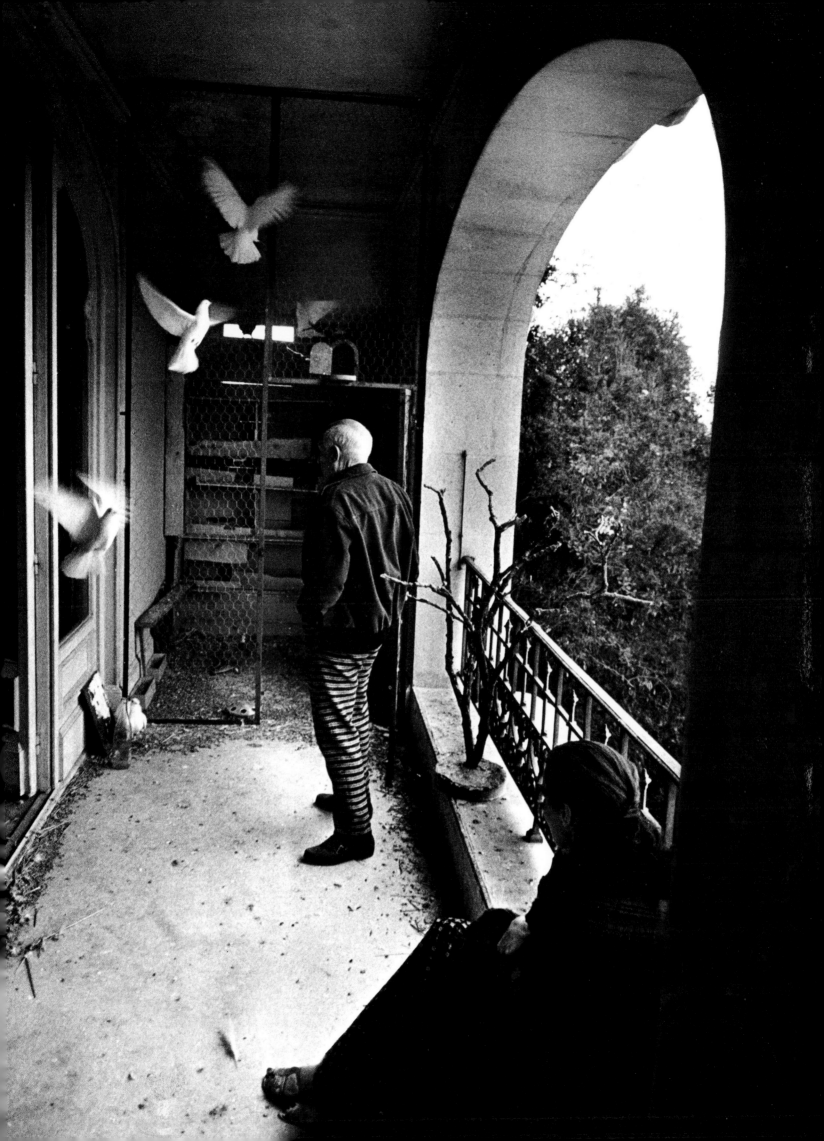

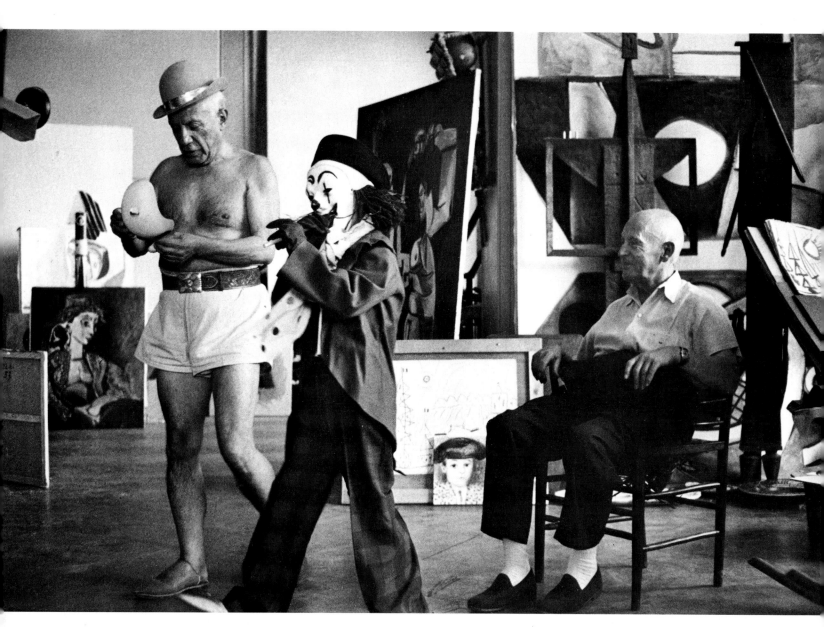

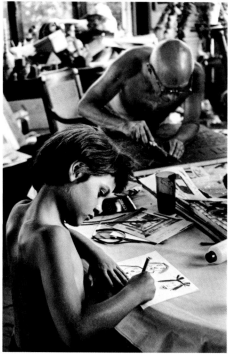

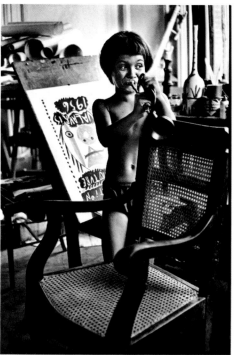

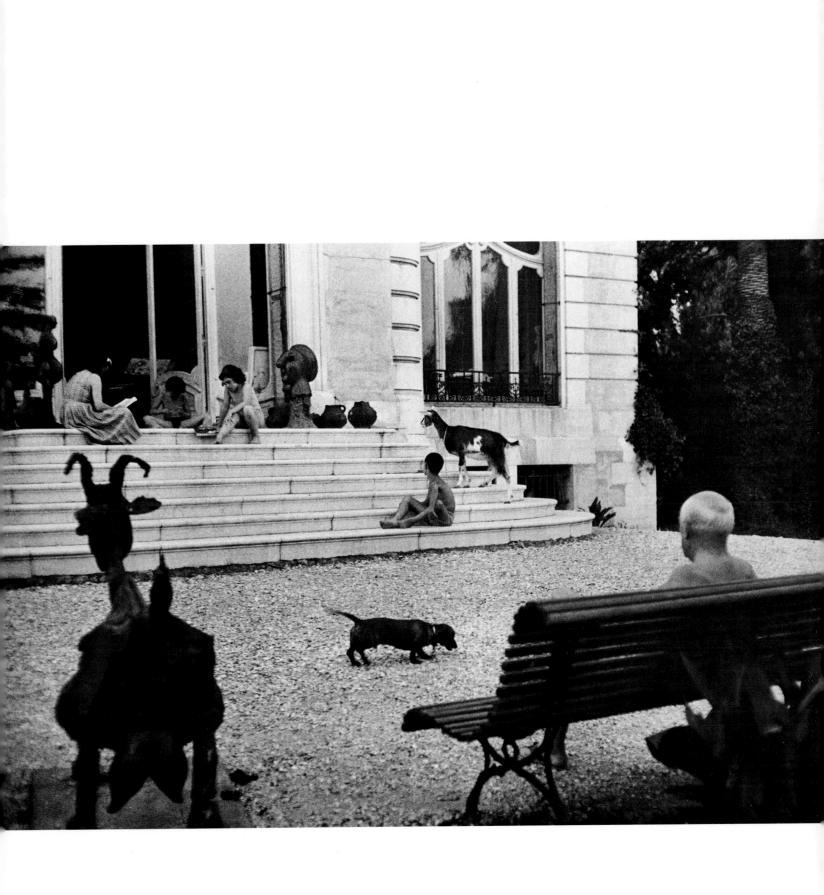

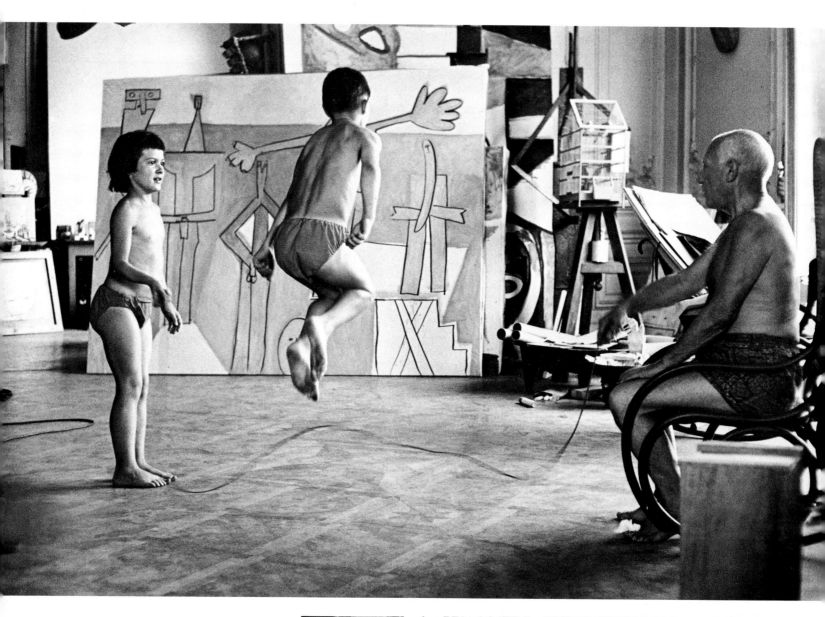

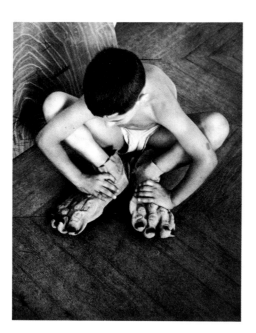

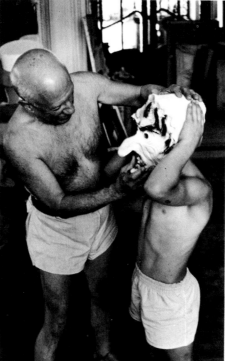

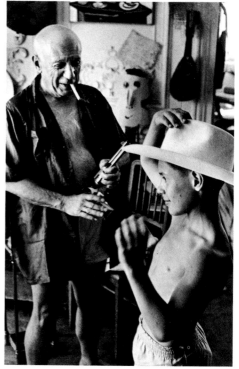

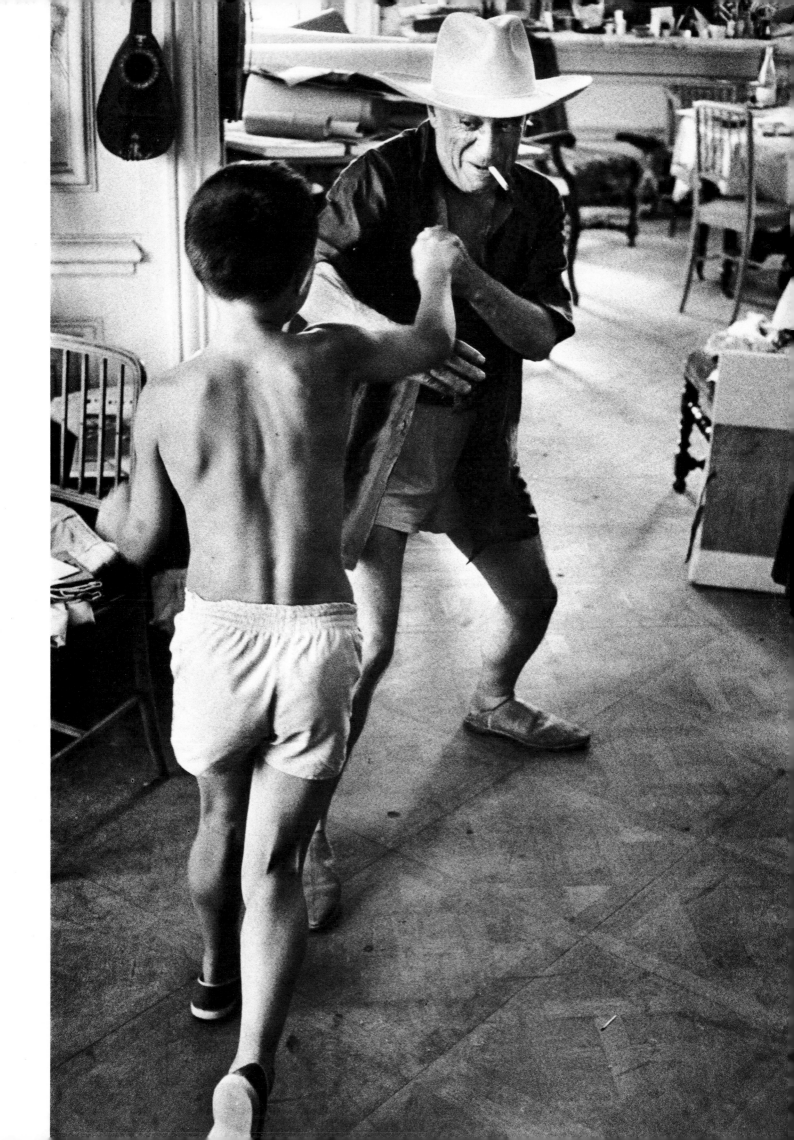

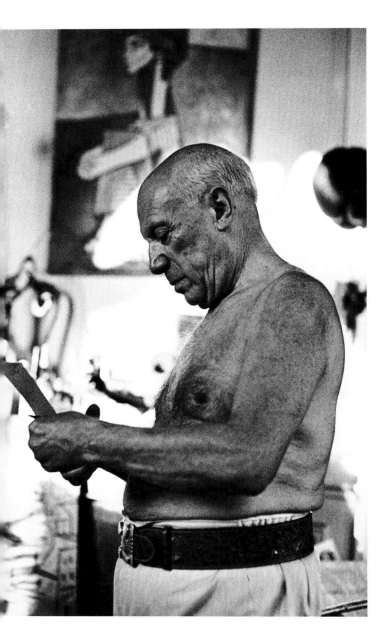

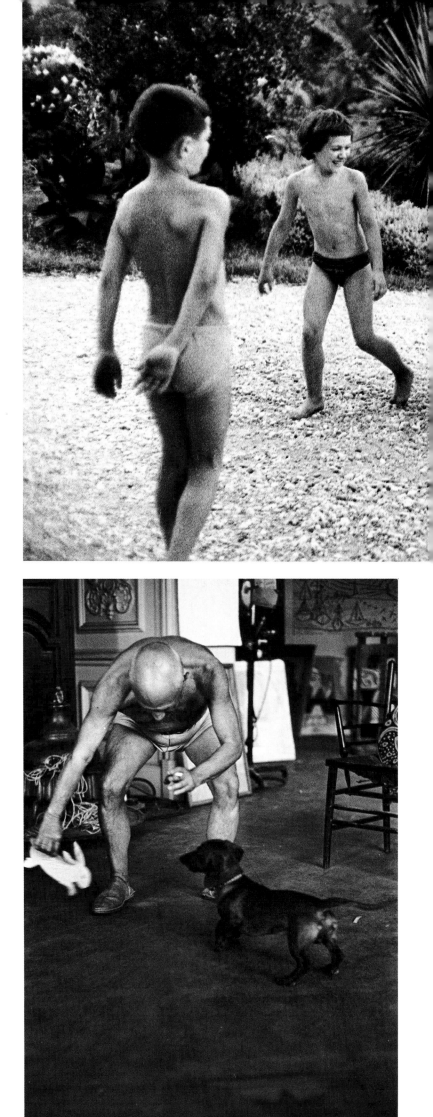

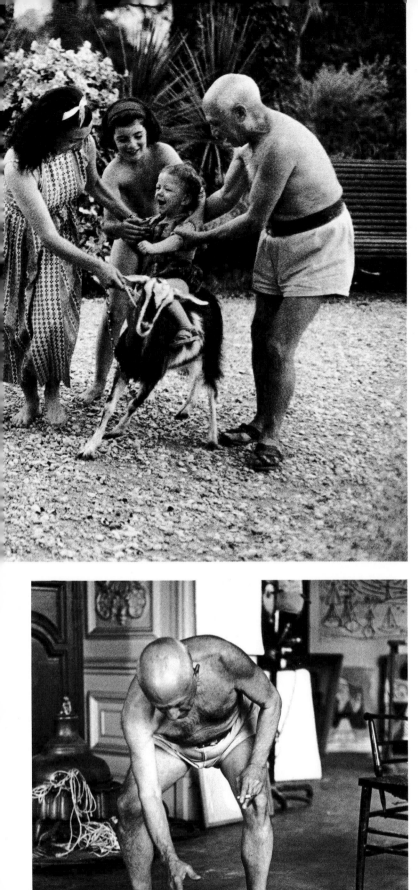

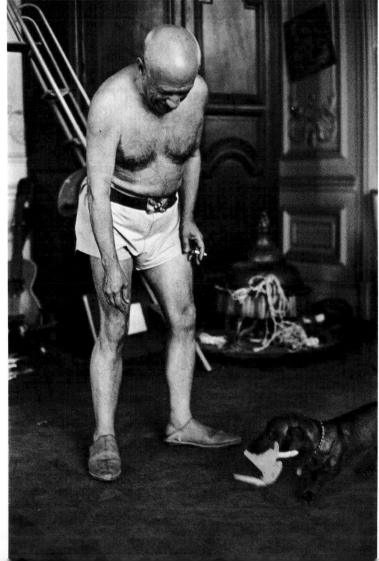

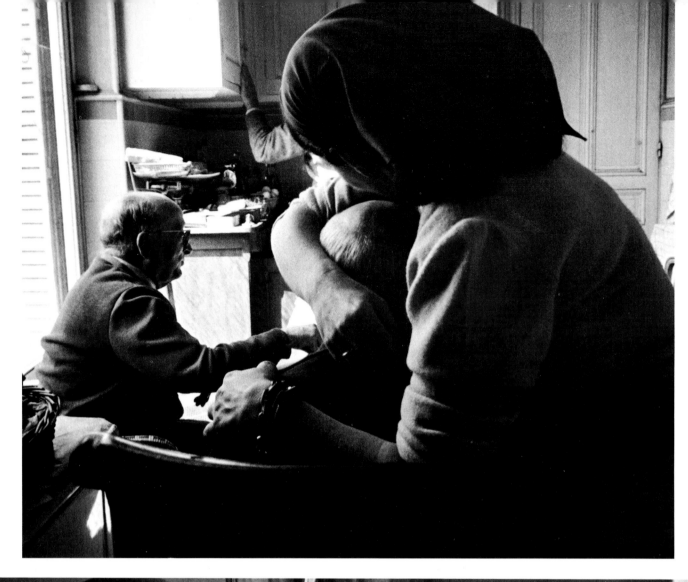

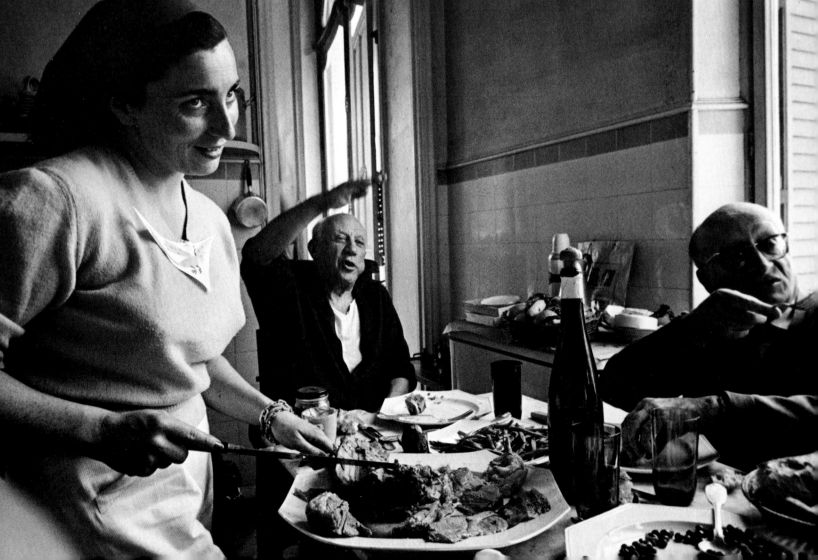

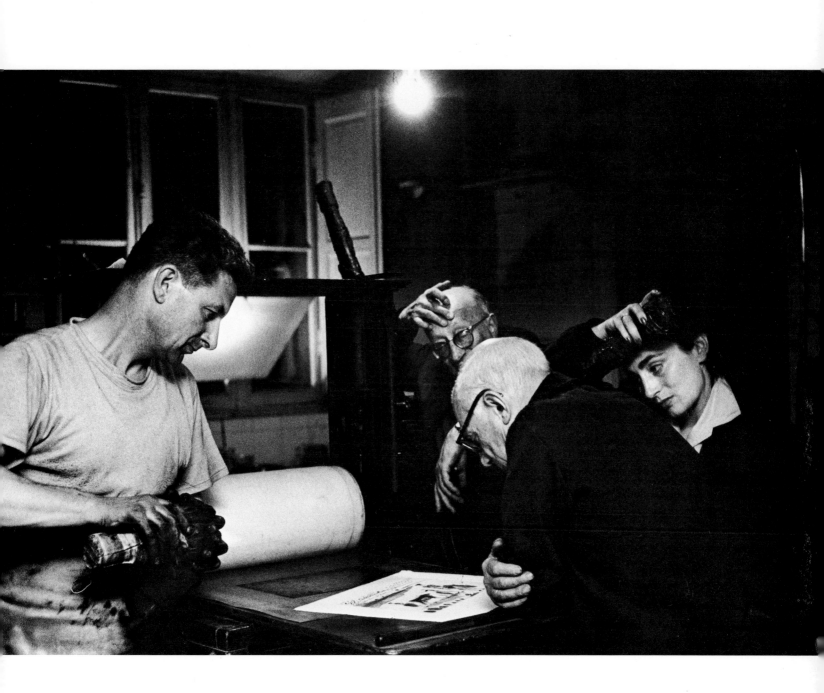

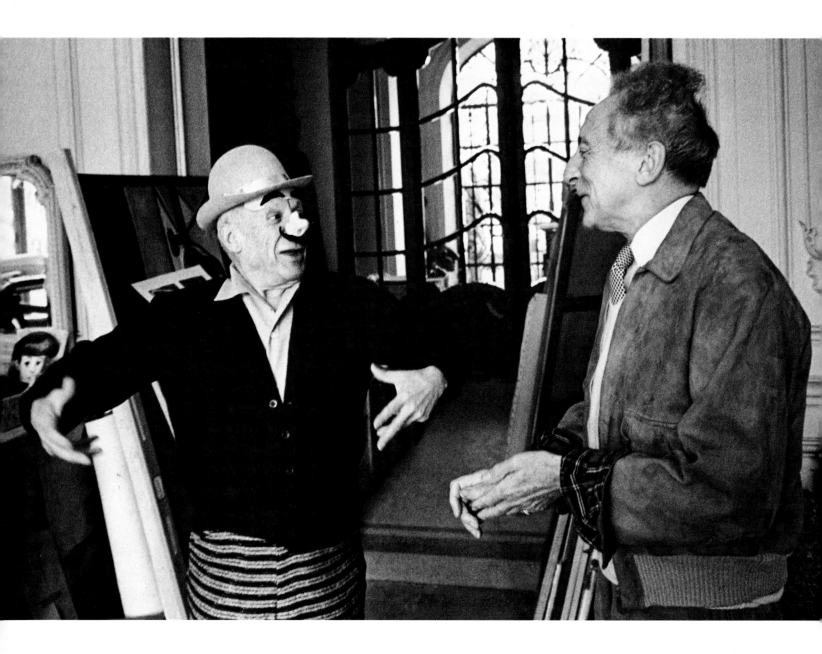

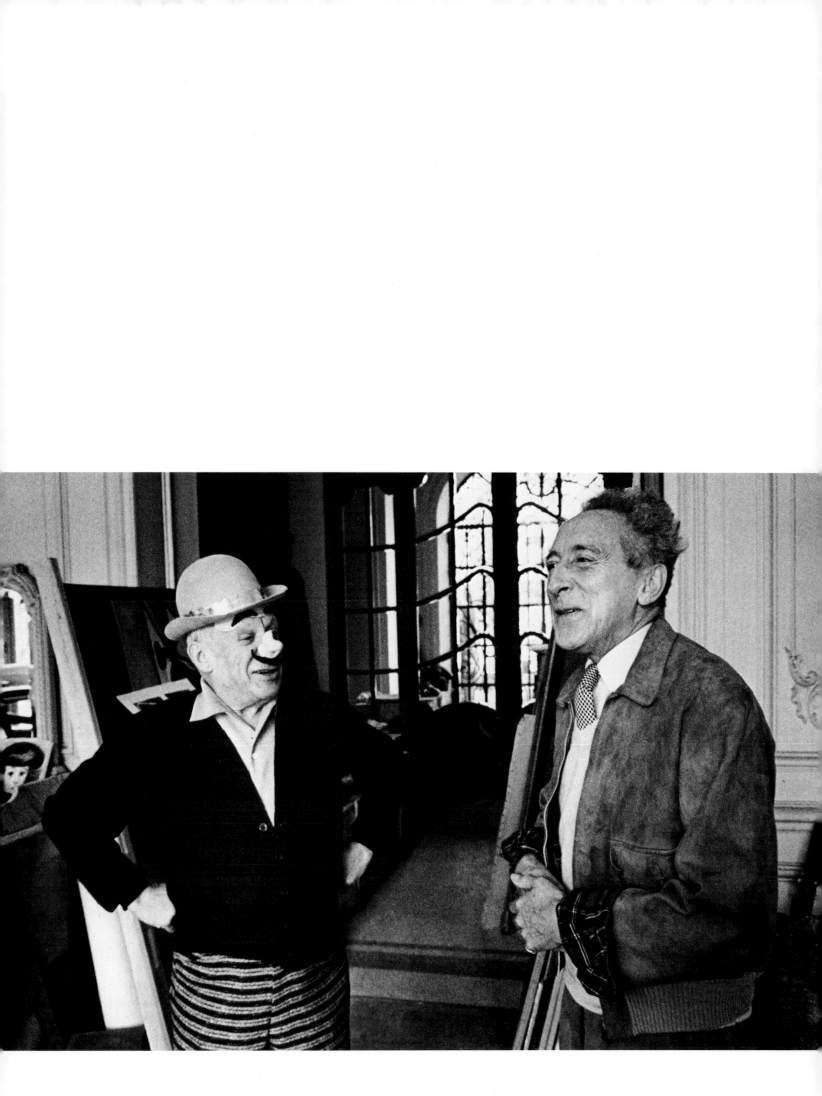

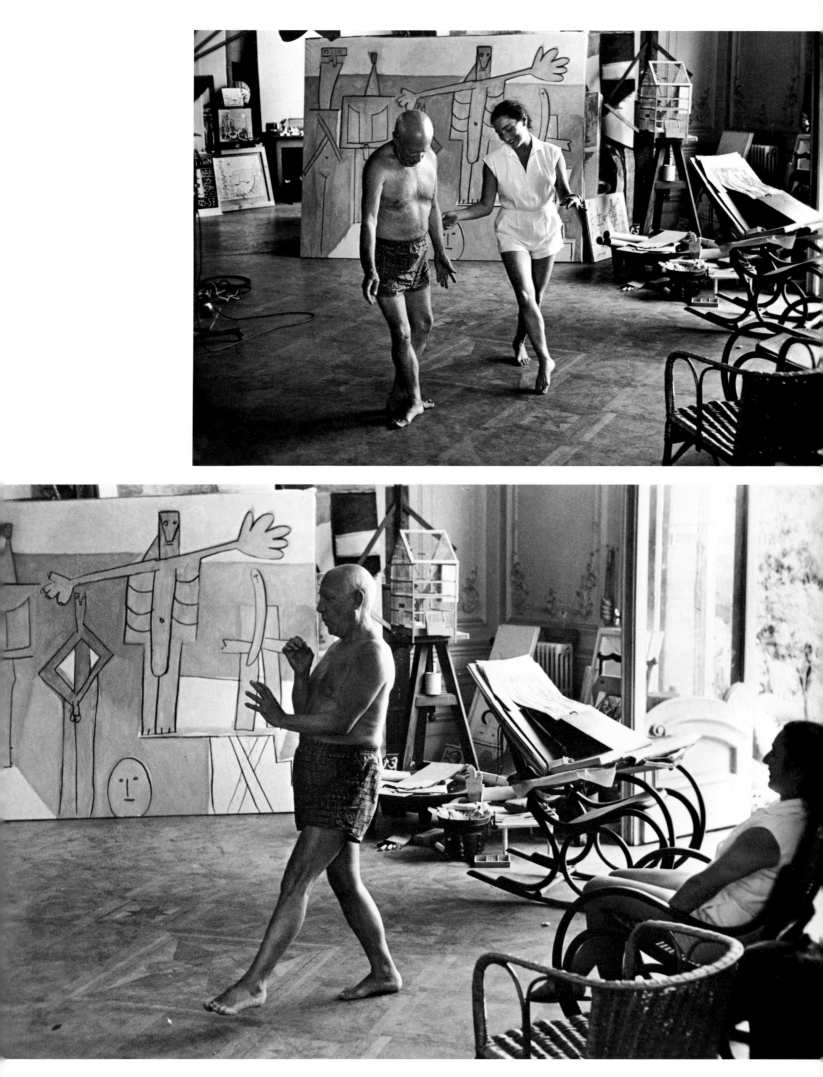

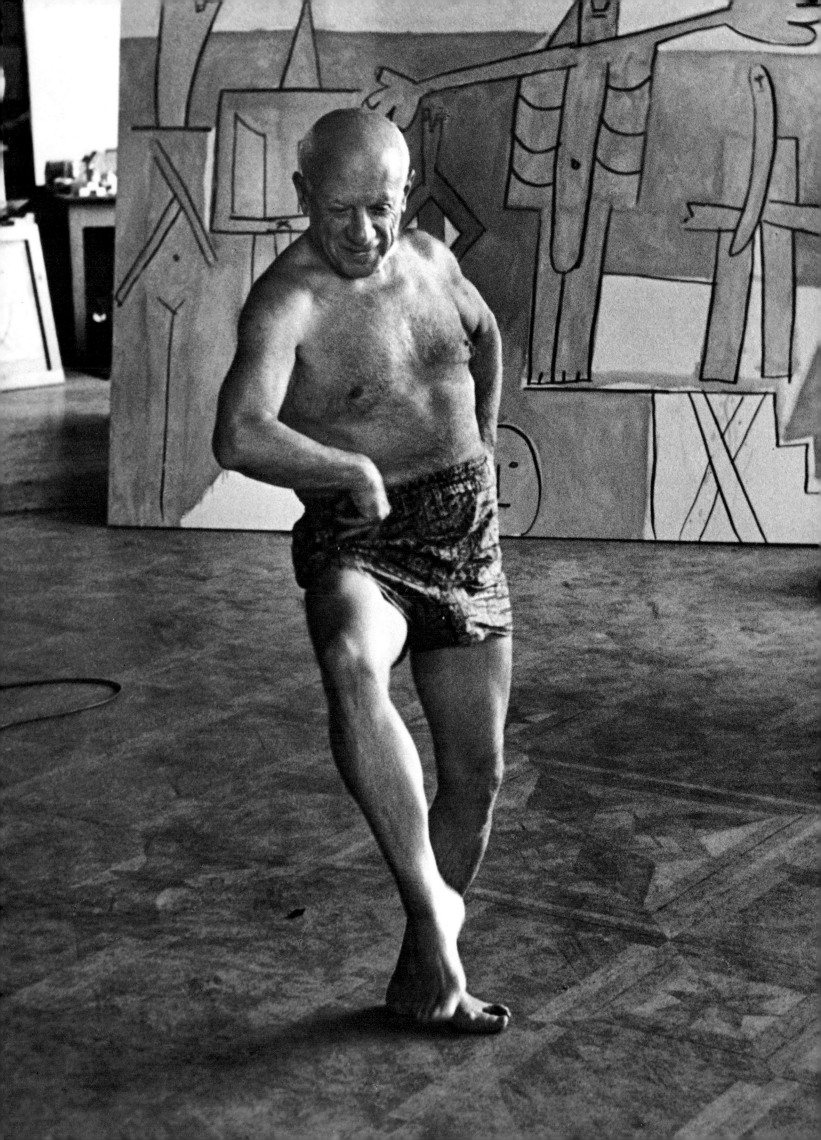

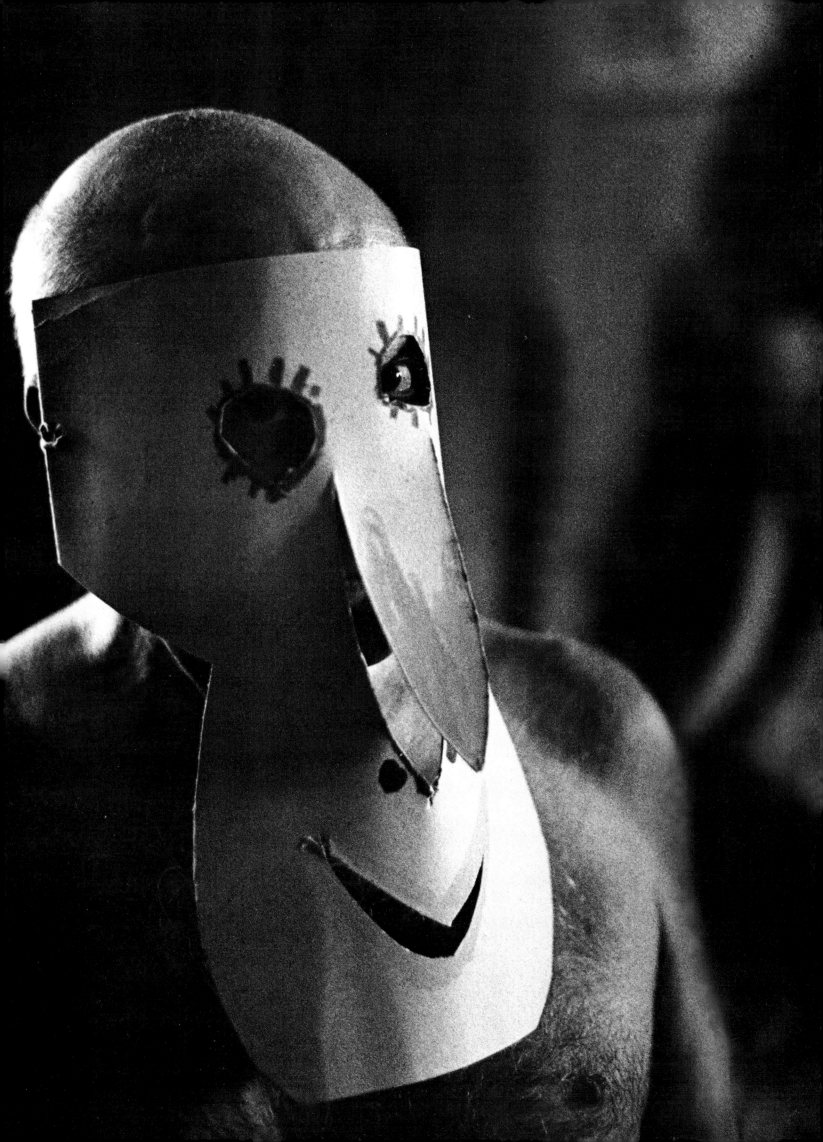

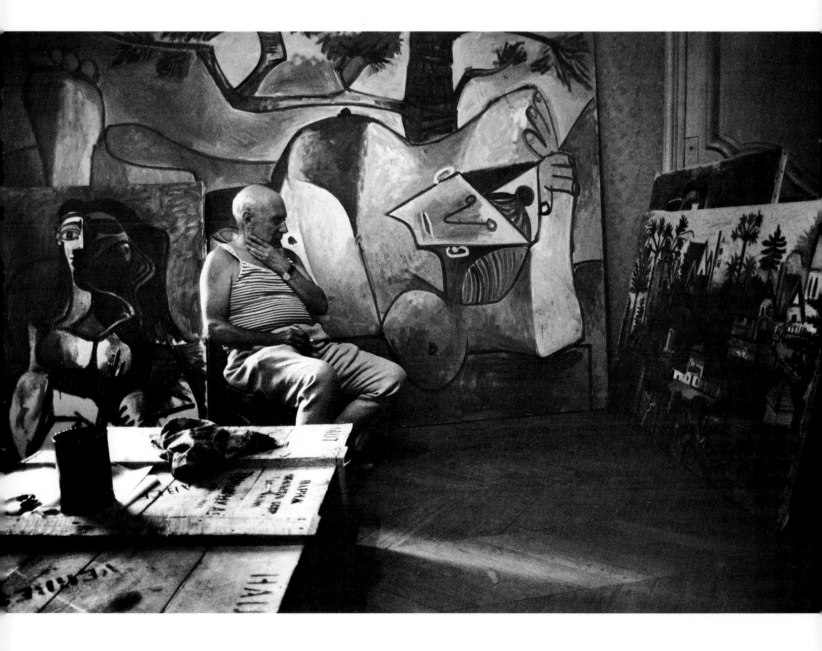

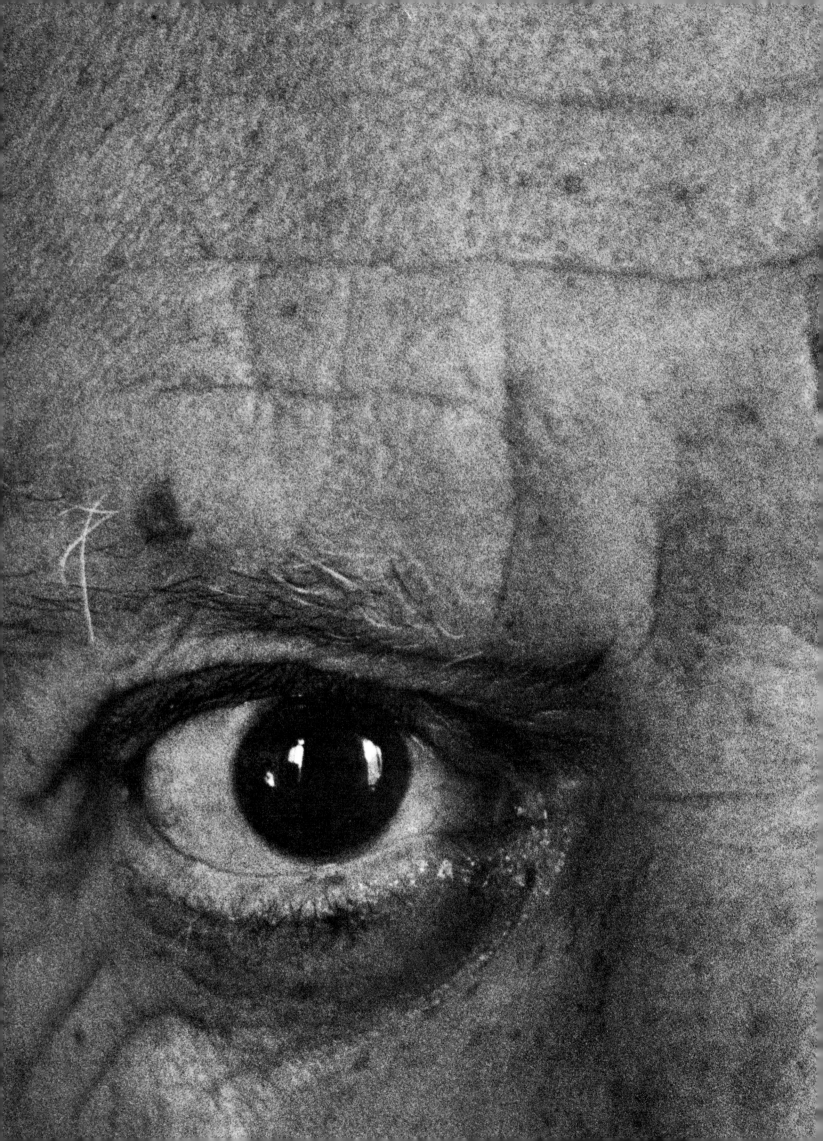

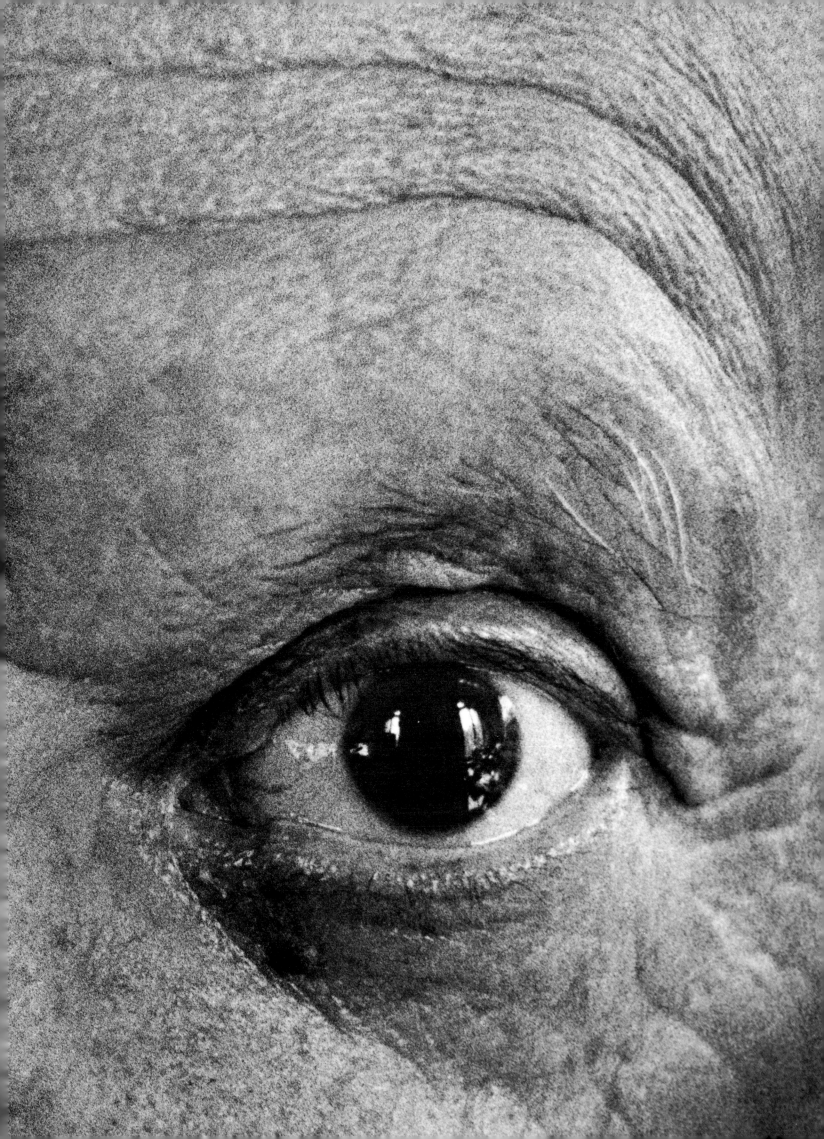

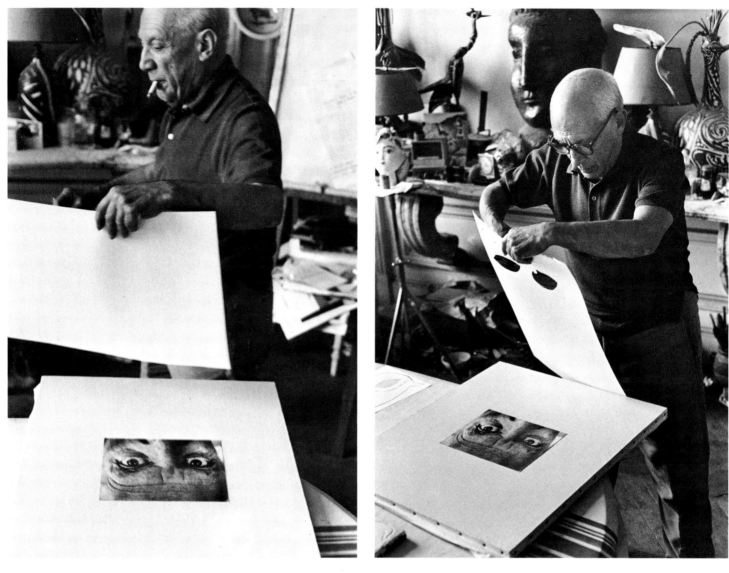

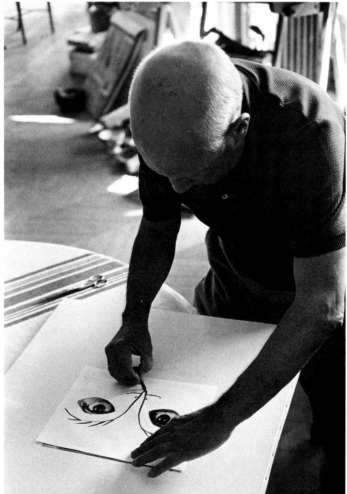

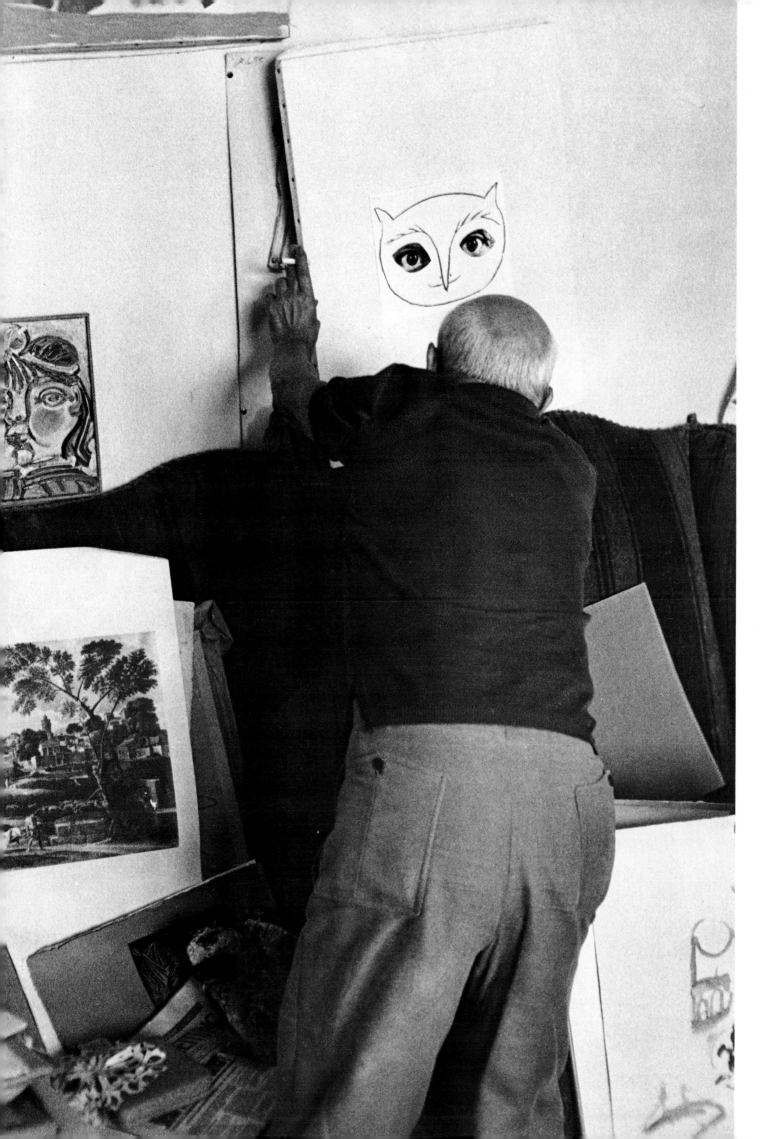

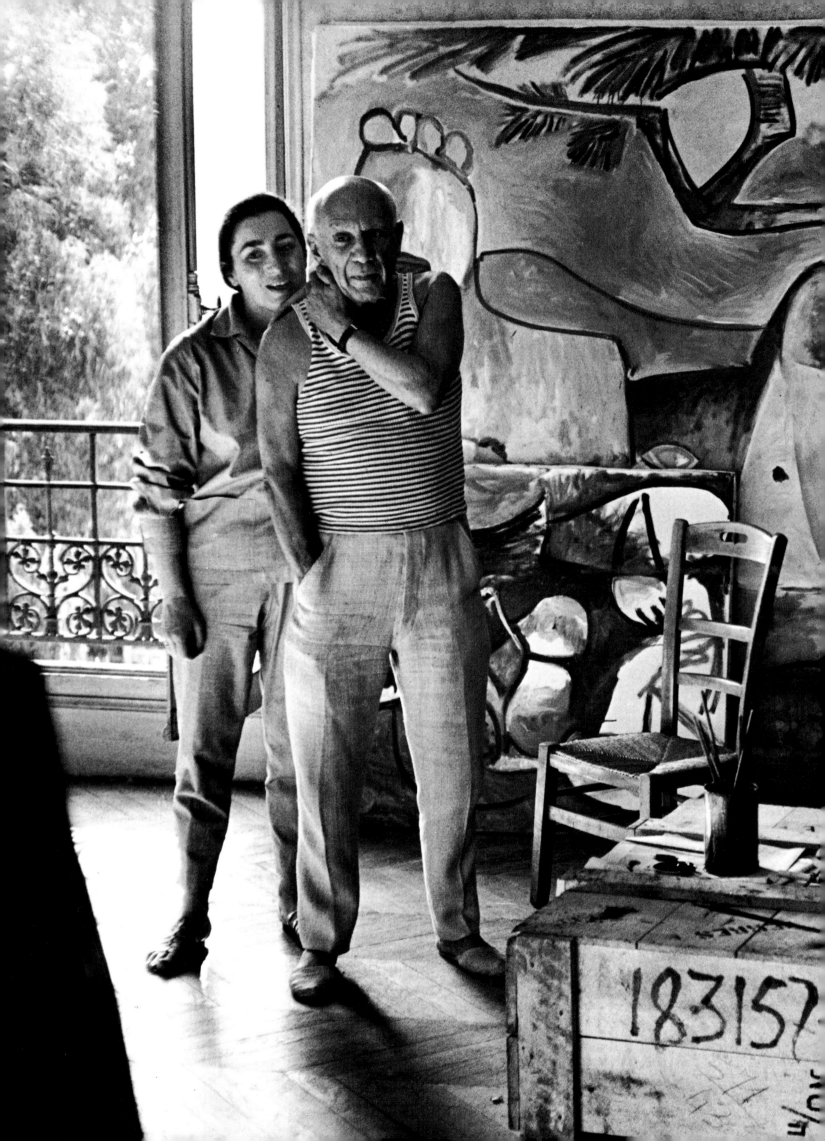

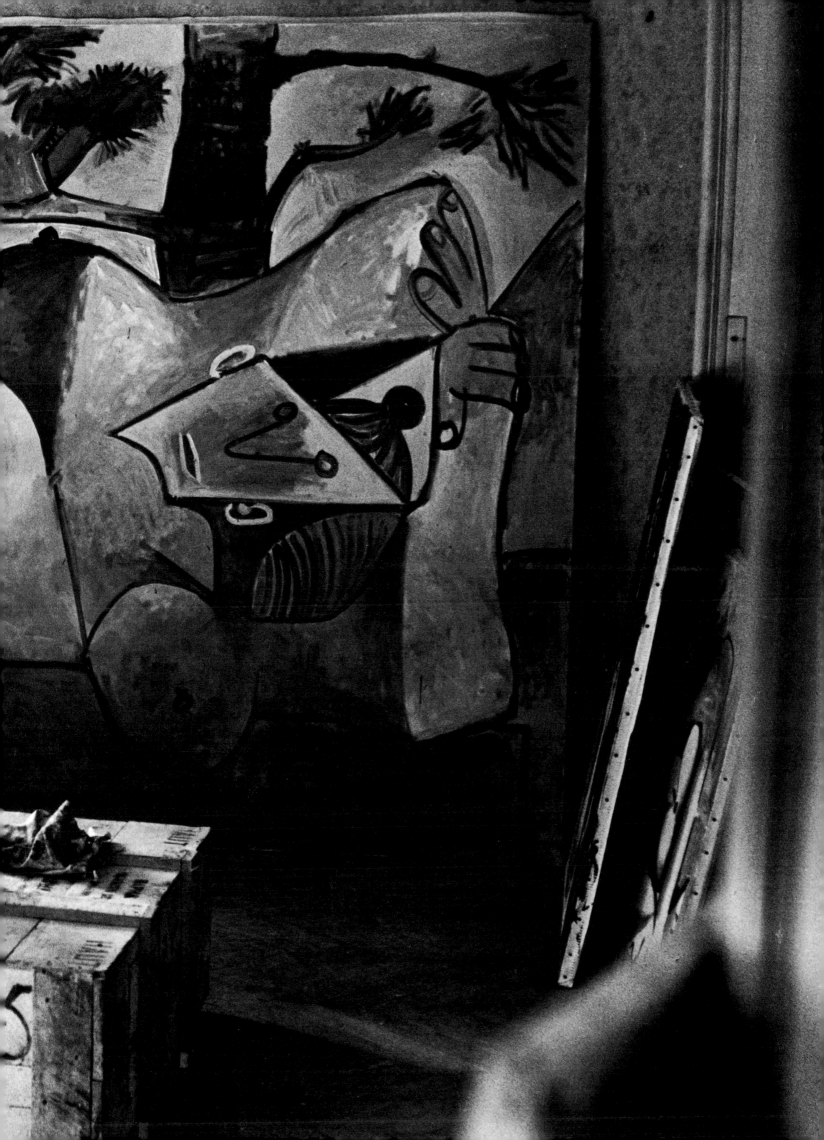

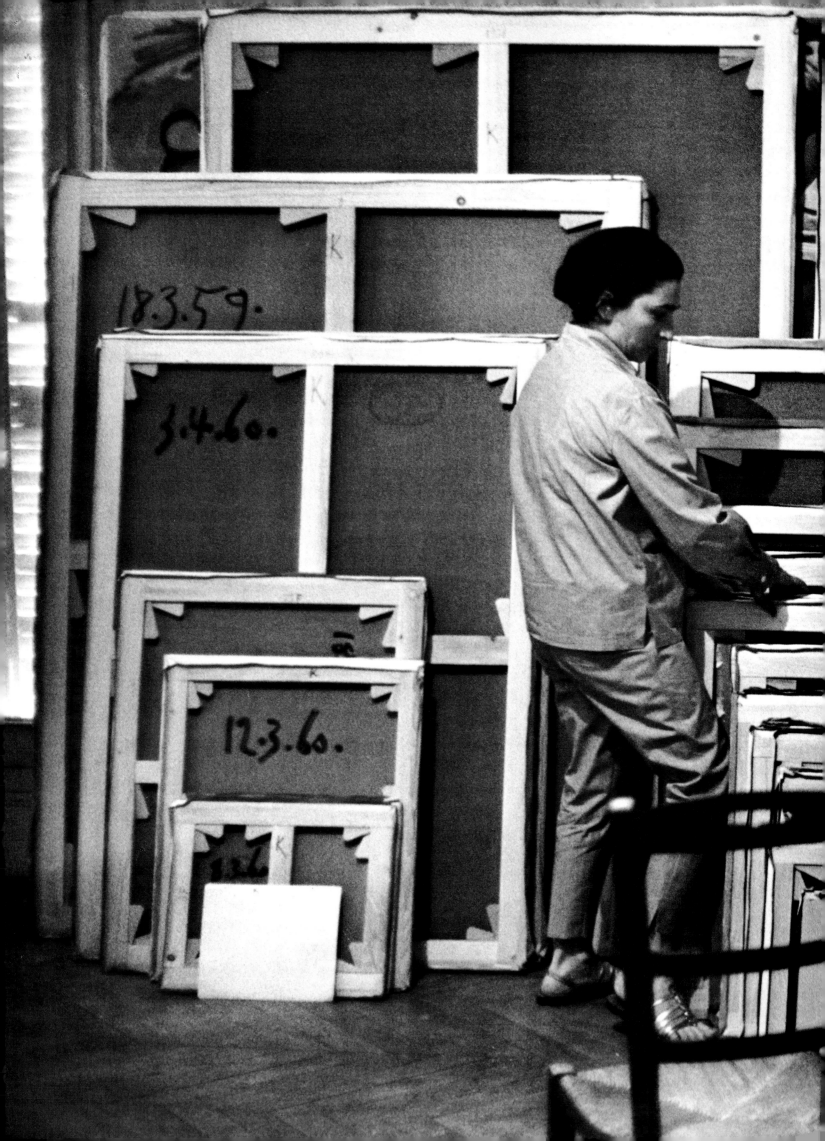

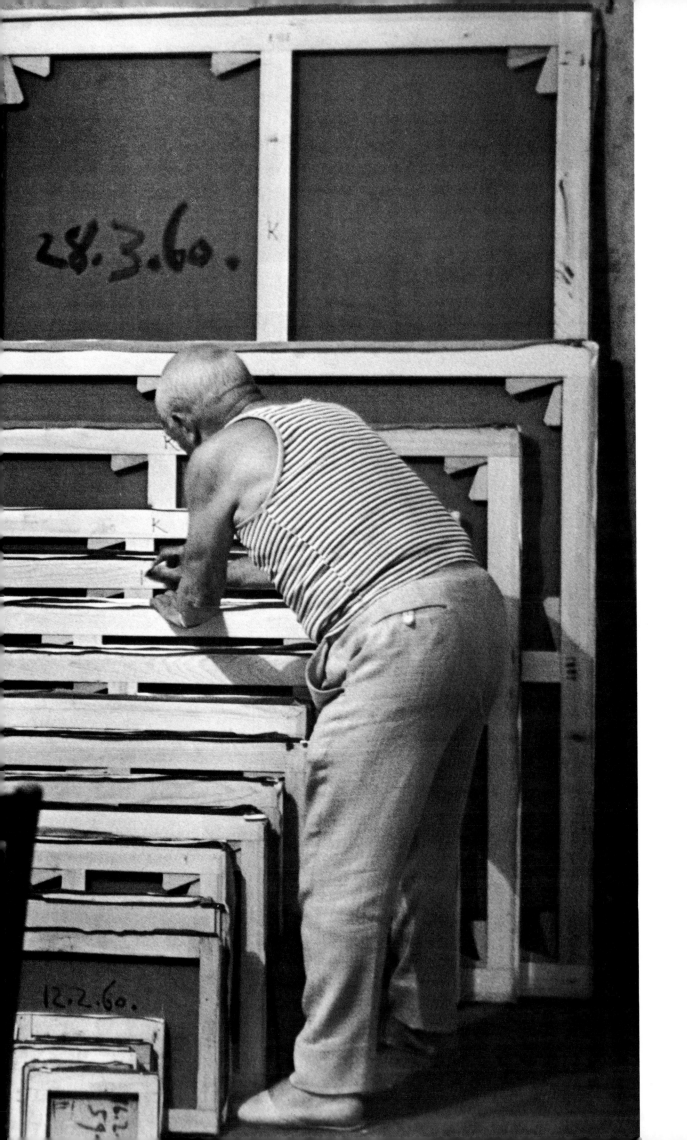

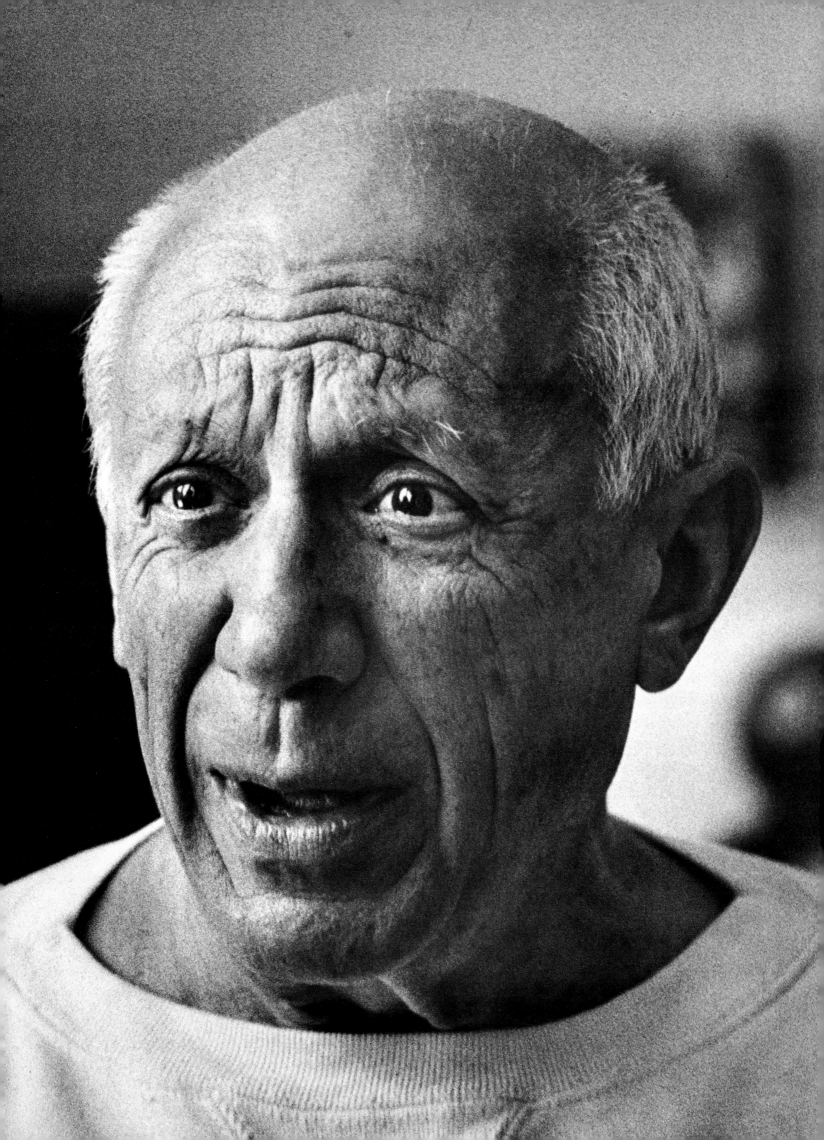

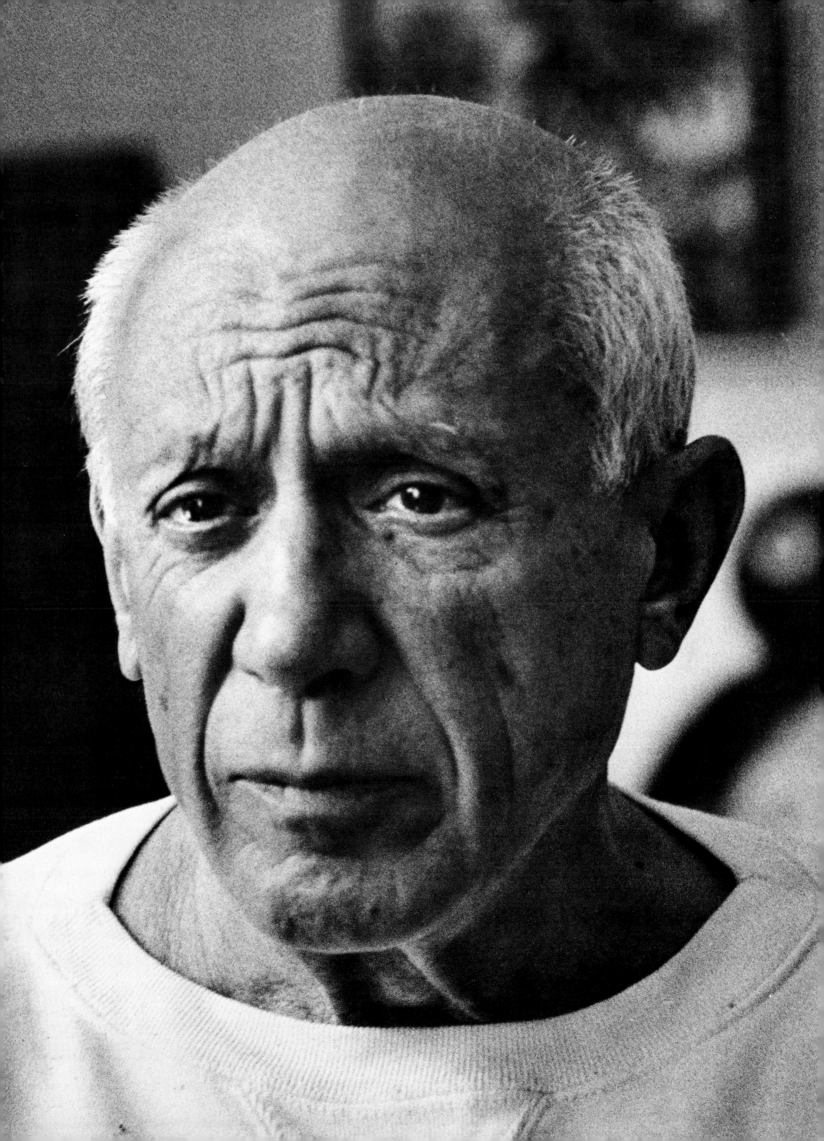

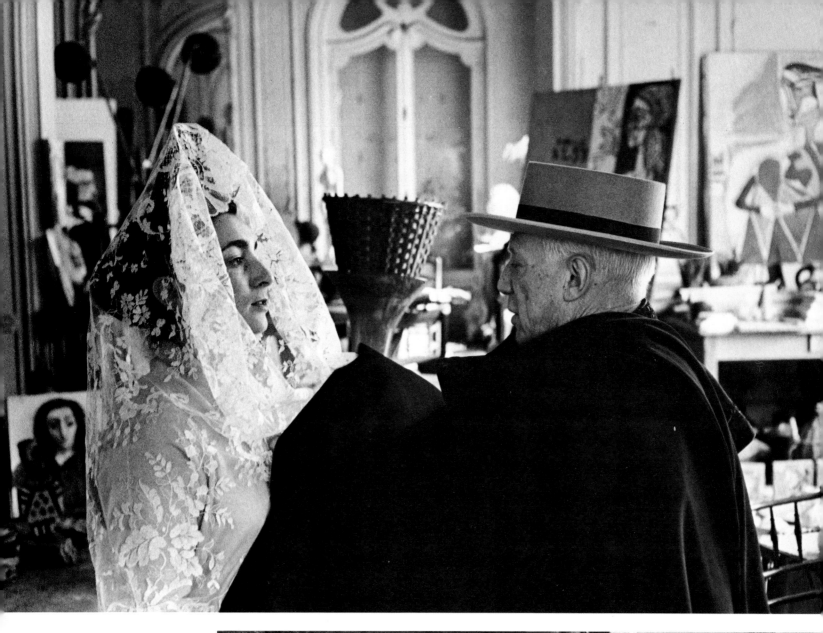

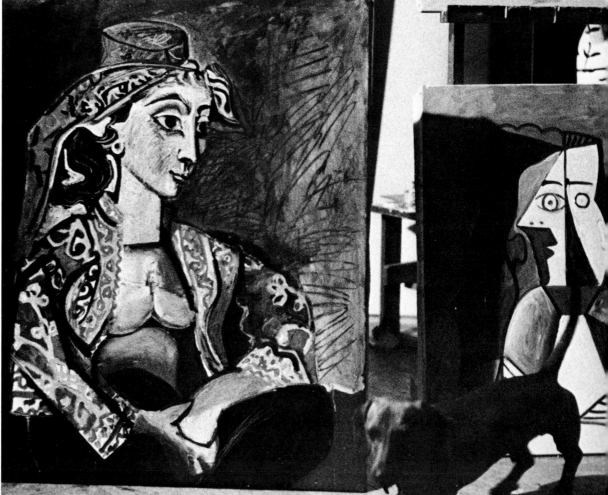

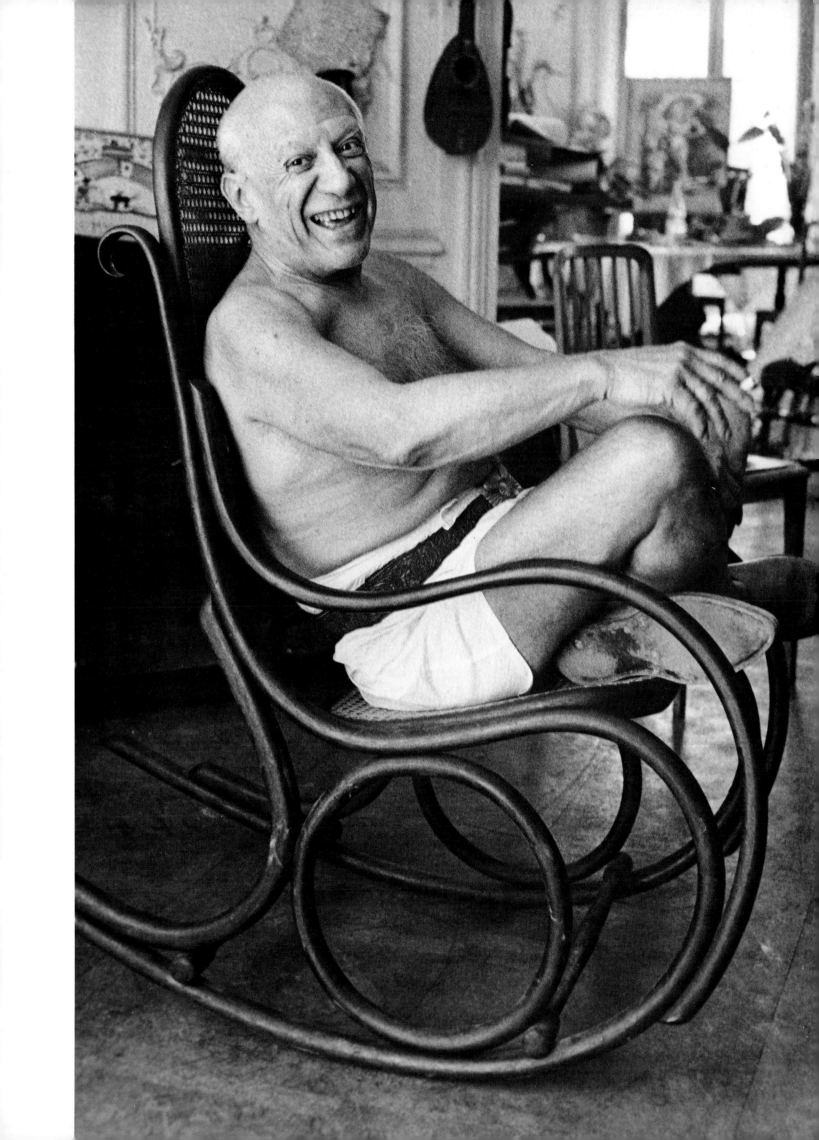

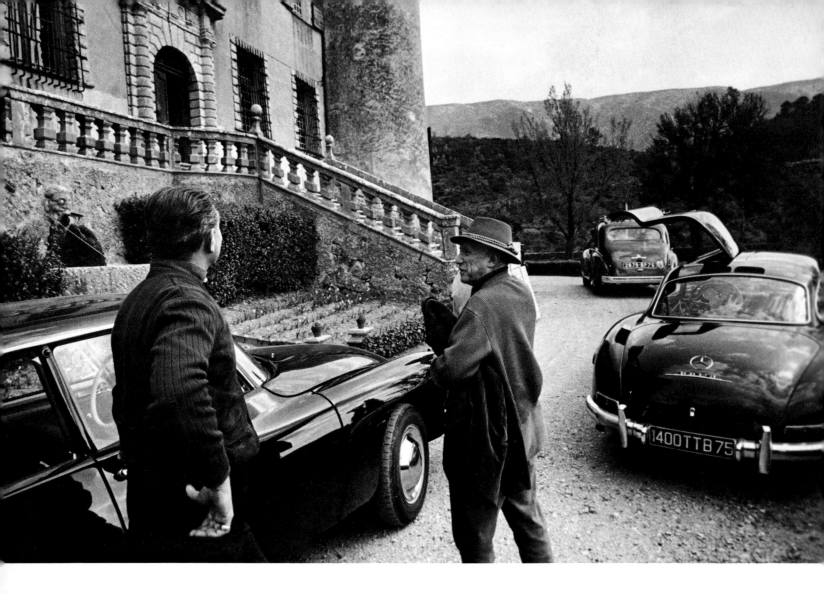

Château
de Vauvenargues

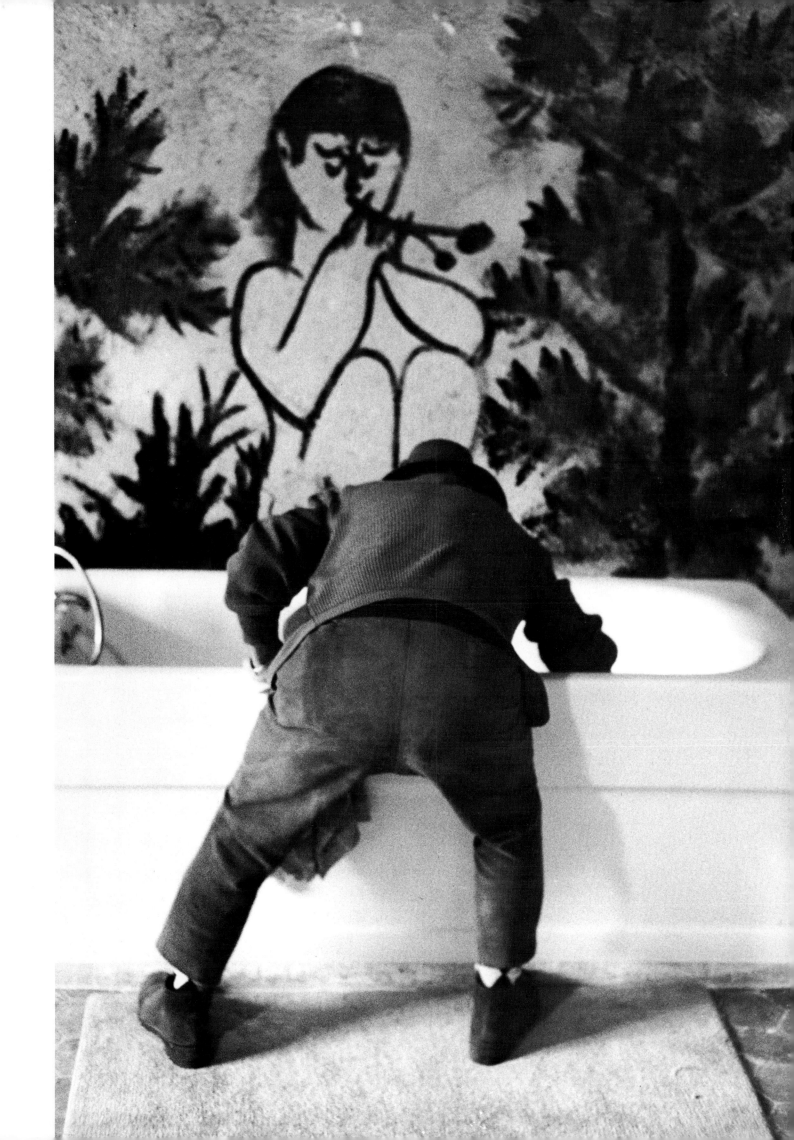

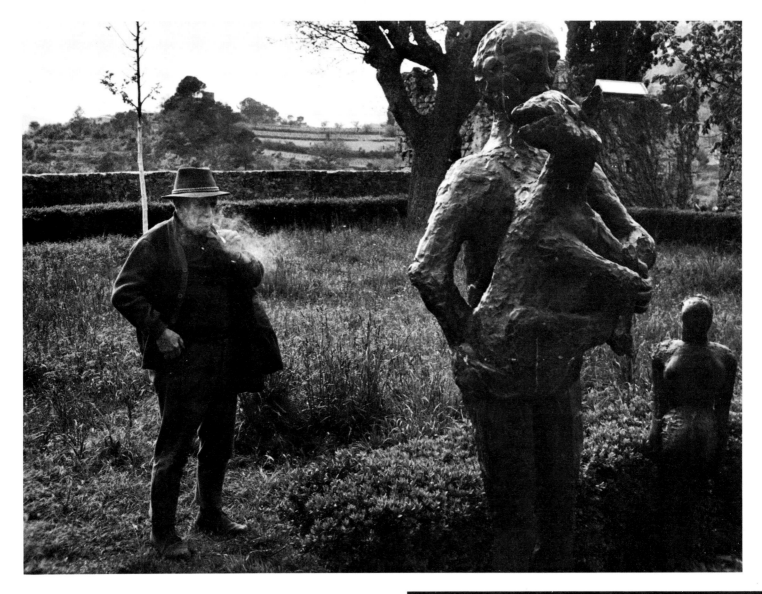

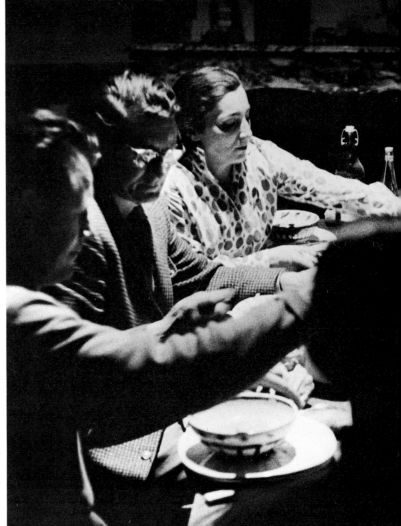

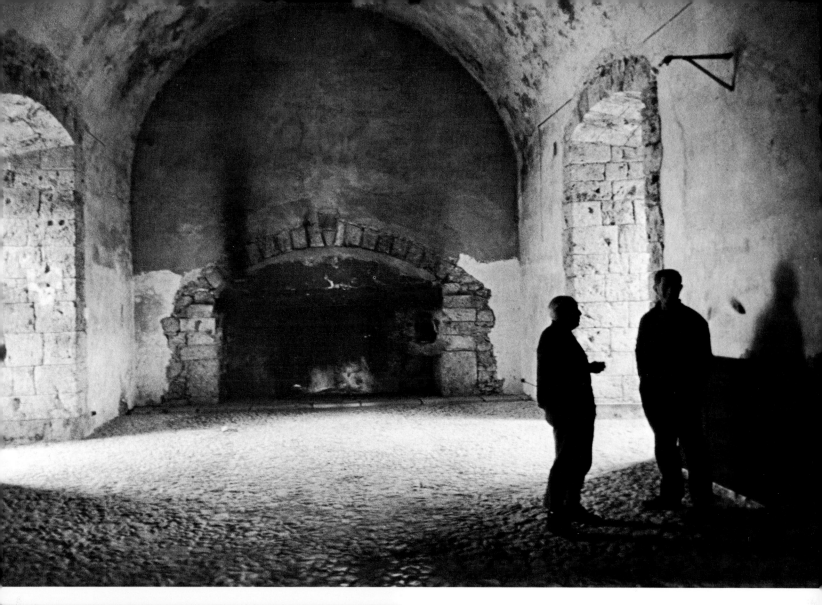

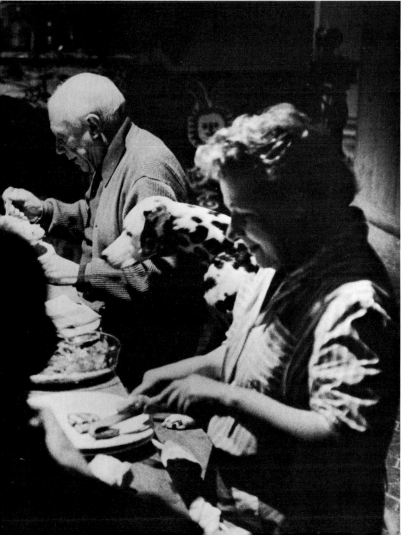

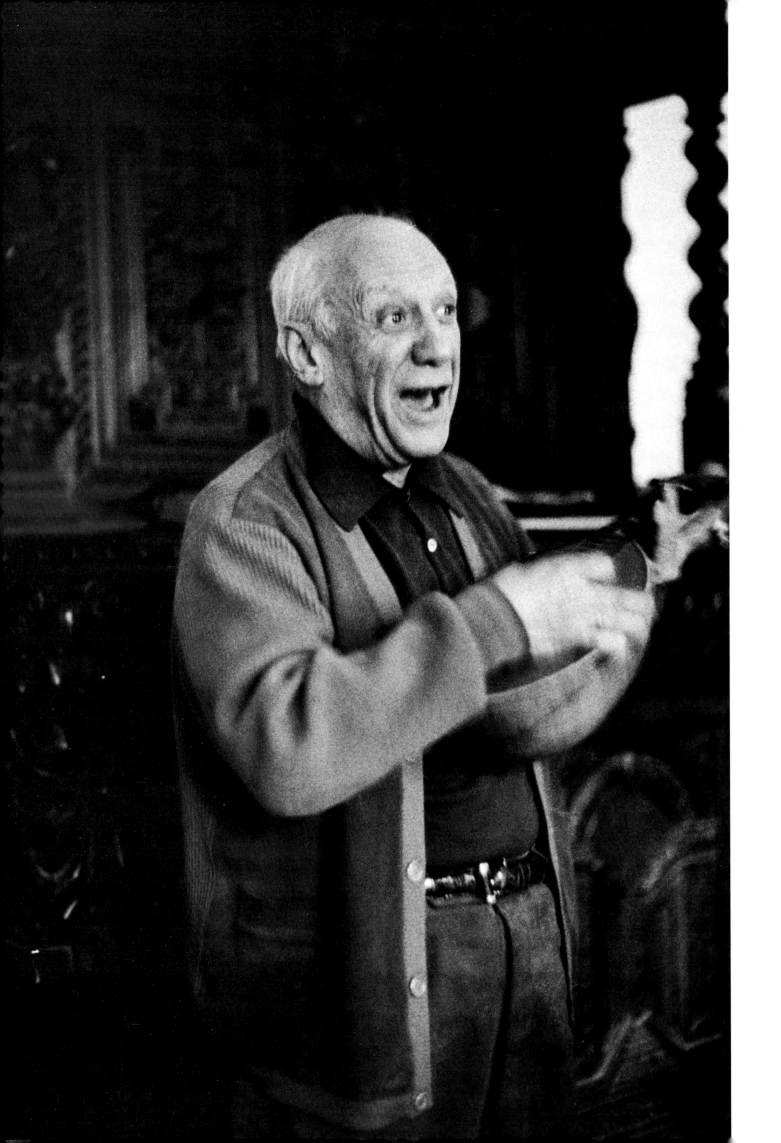

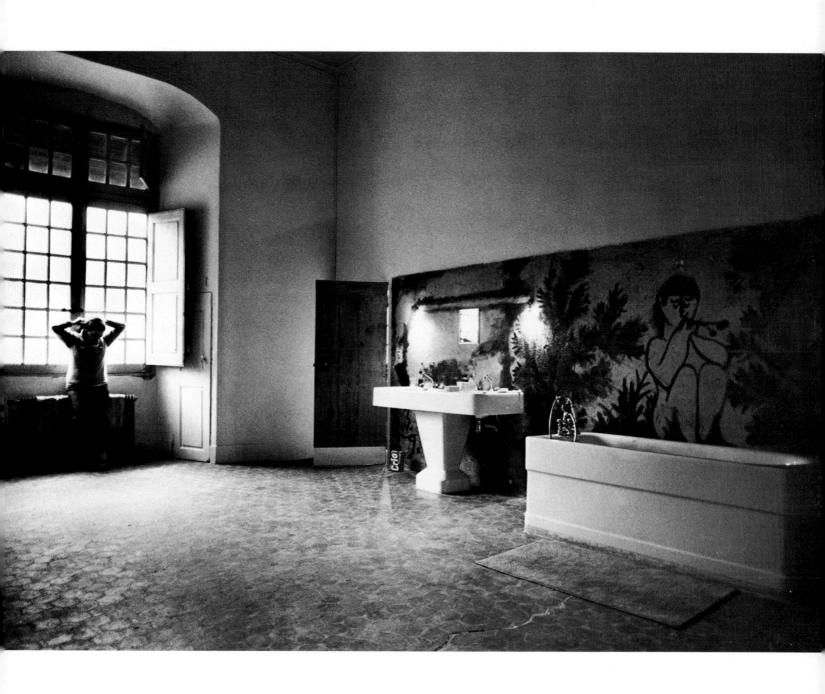

Notre Dame
de Vie

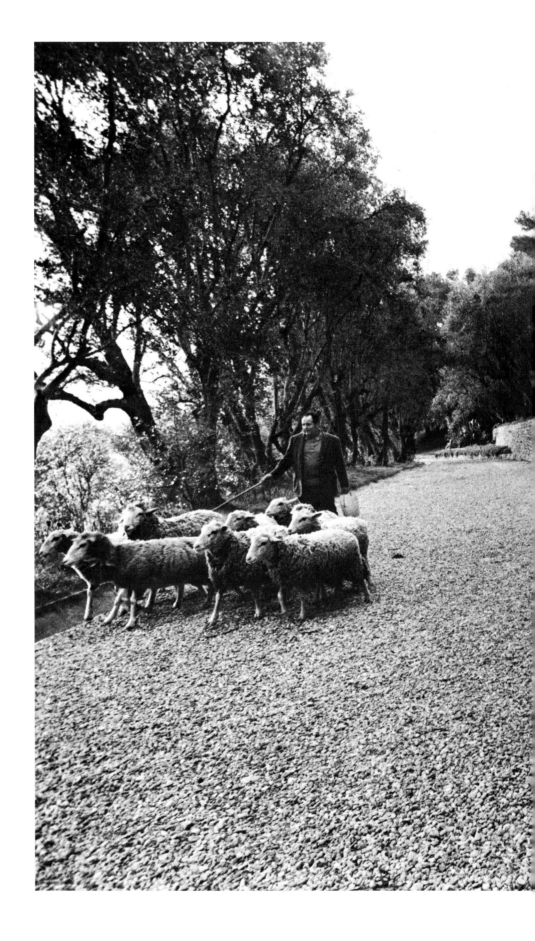

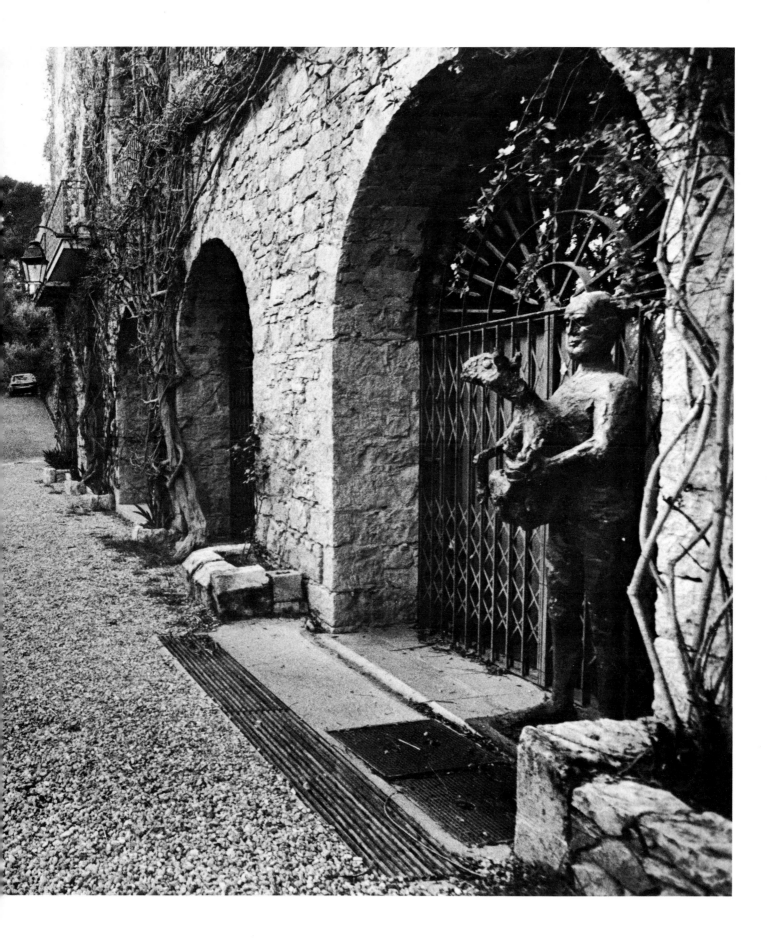

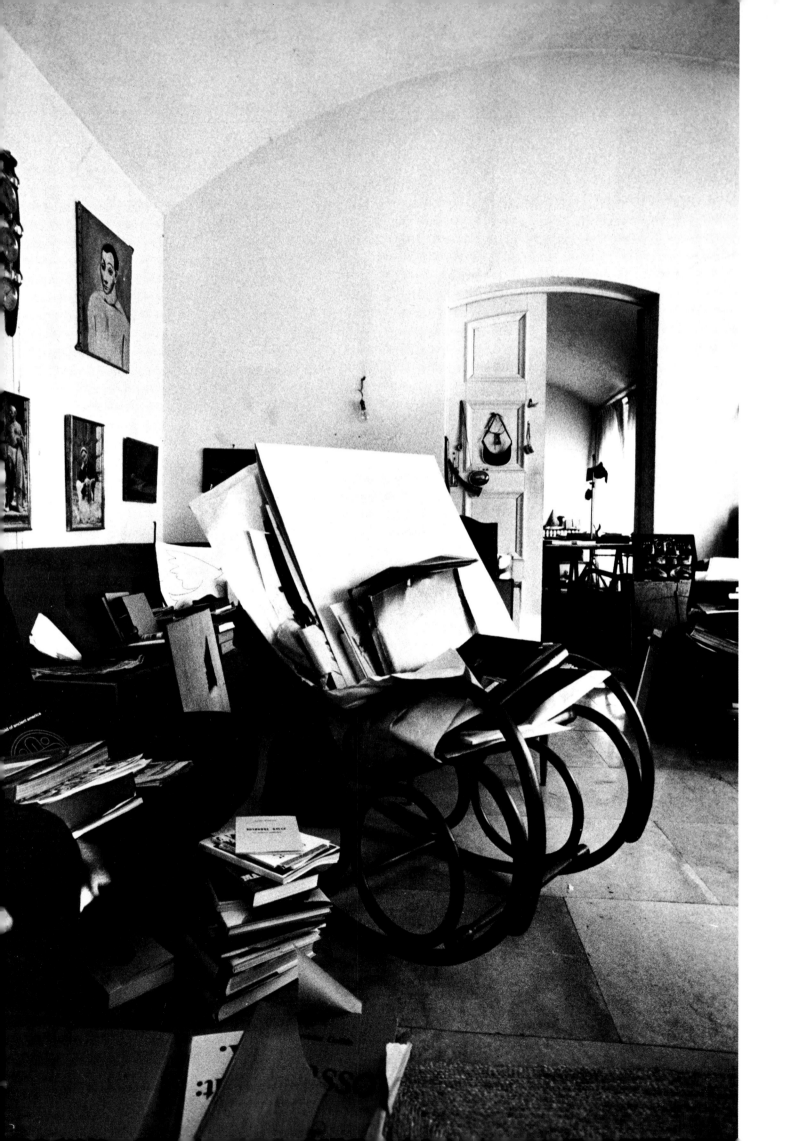

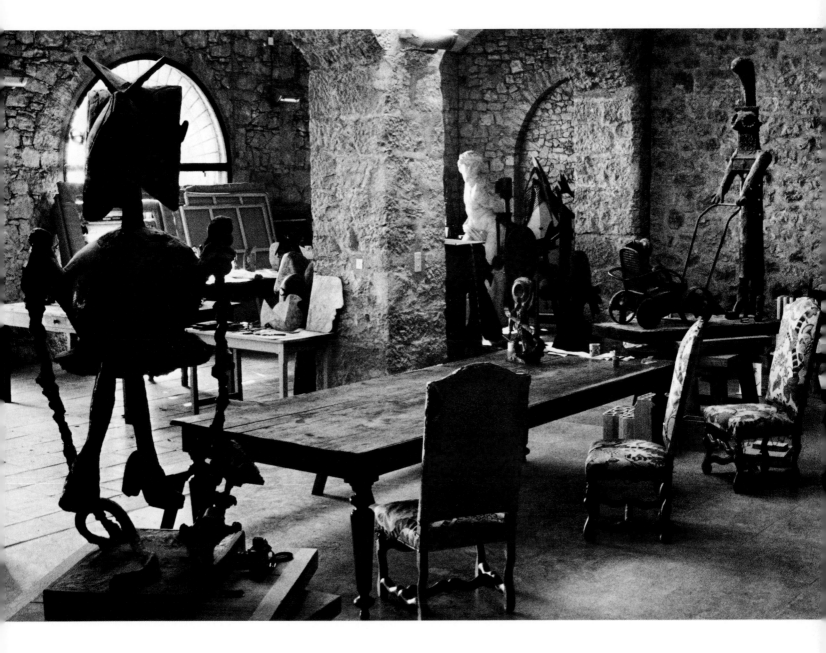

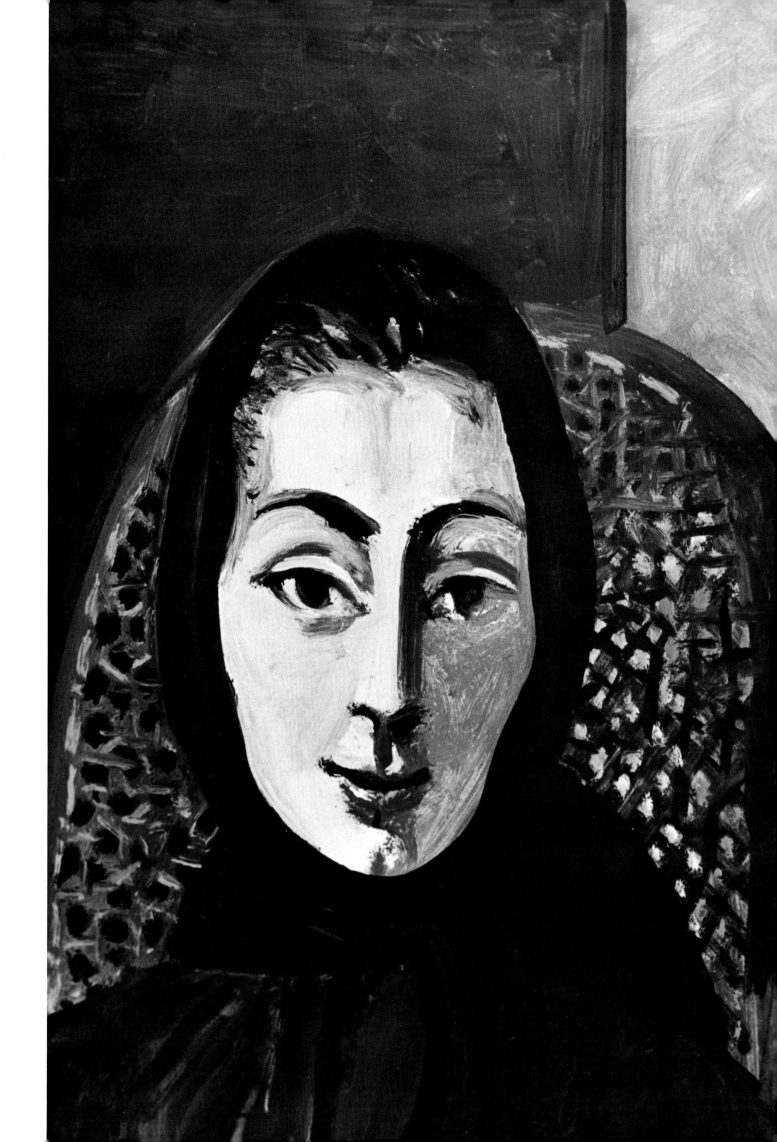

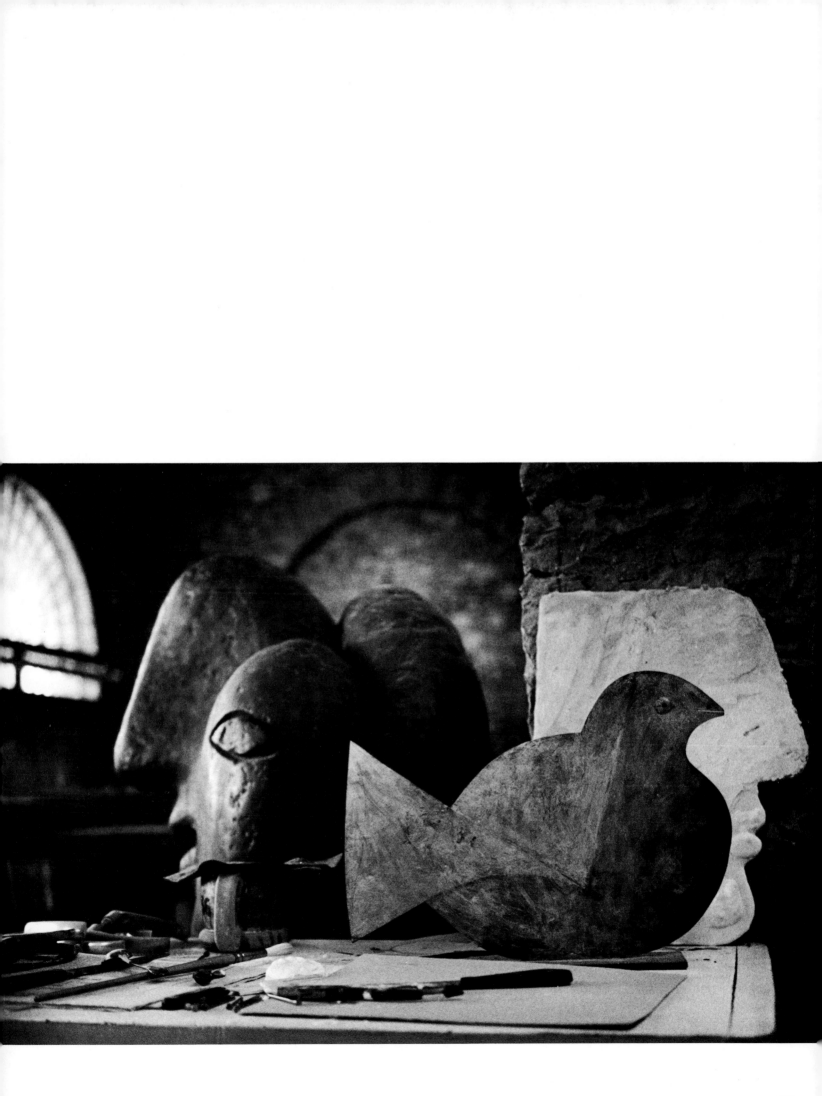

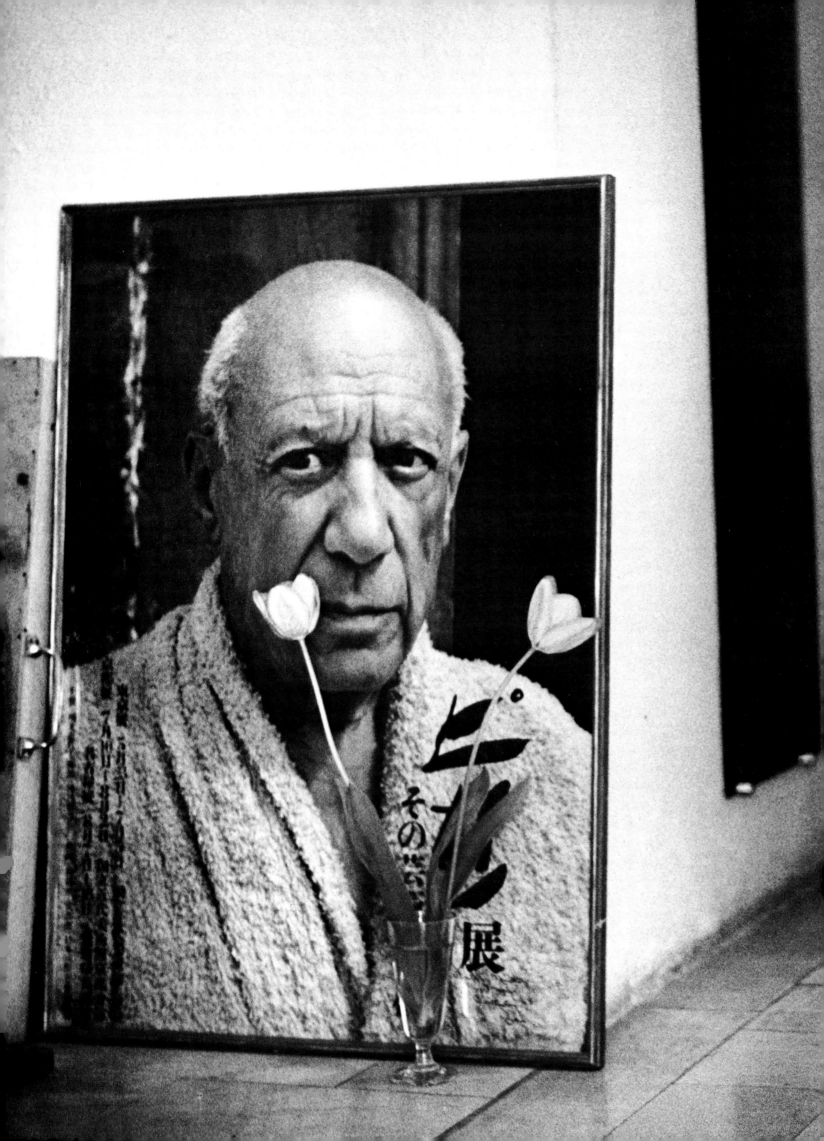

1881 - 1973

Viva Picasso

1881 - 1981

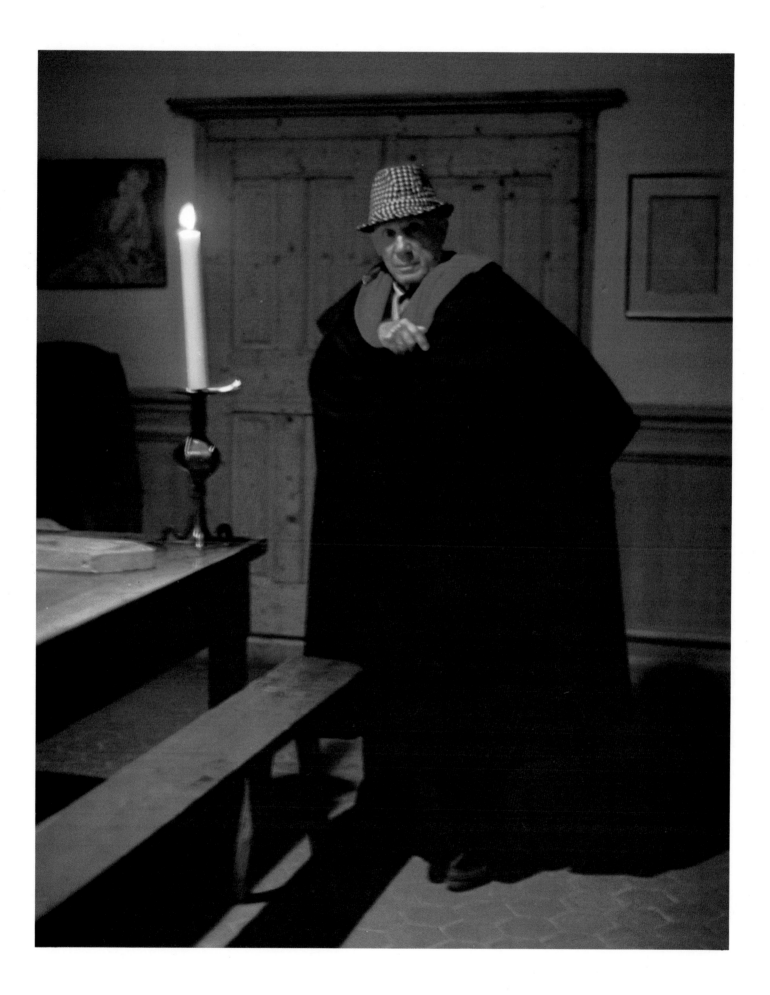

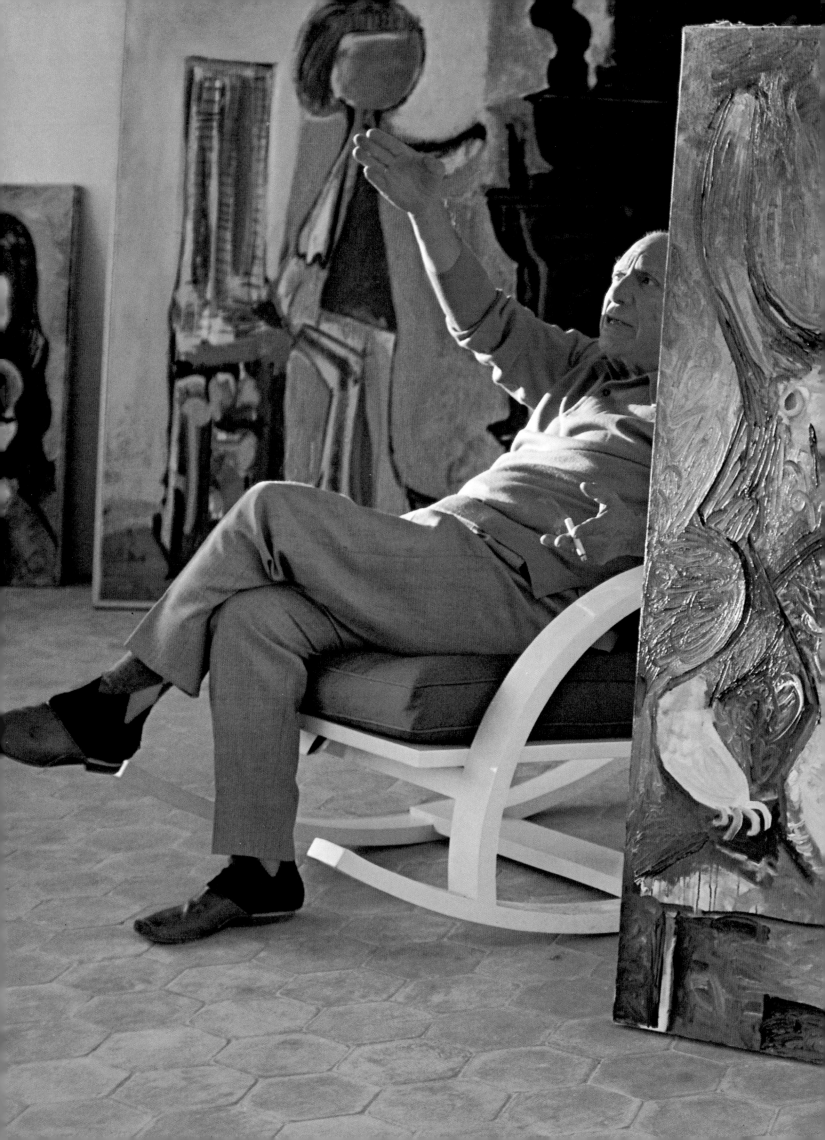

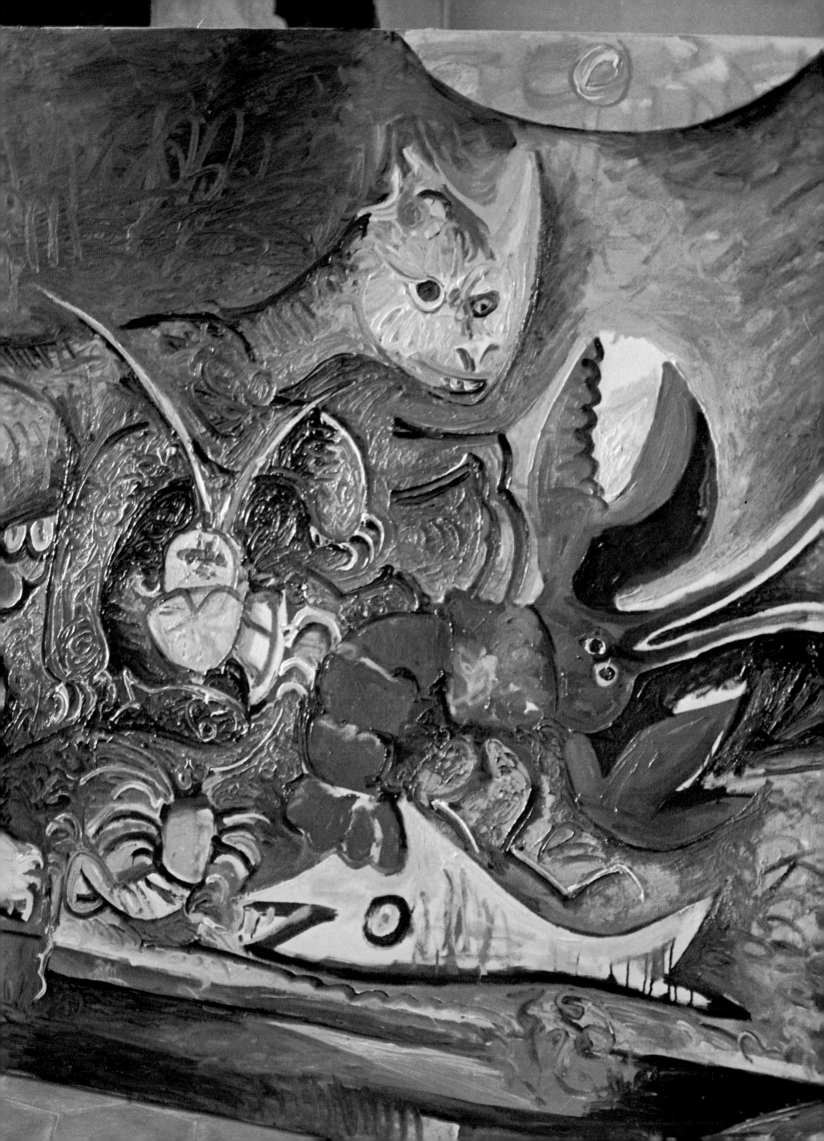

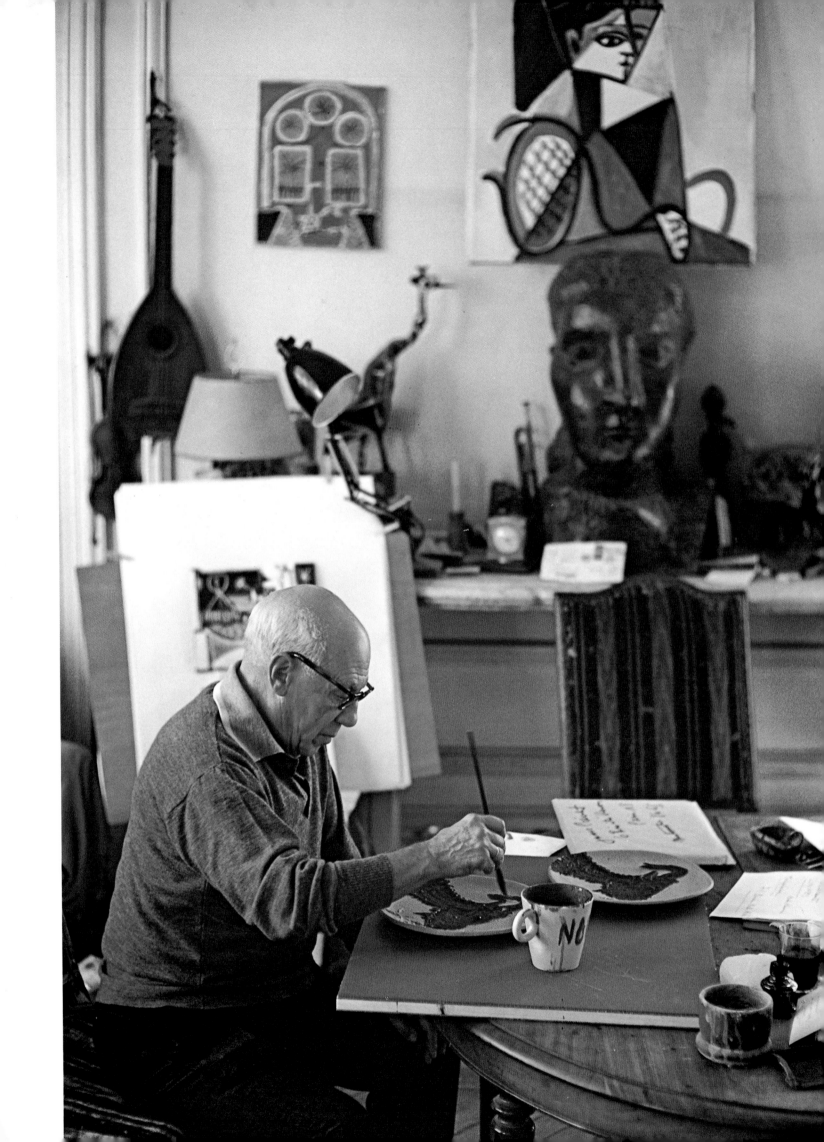

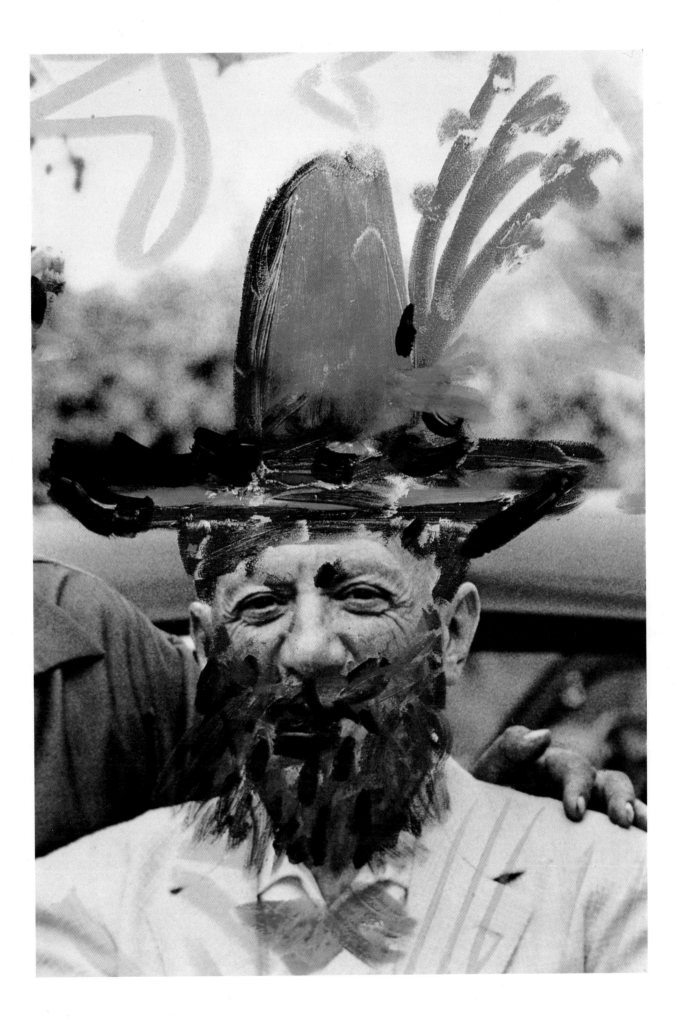

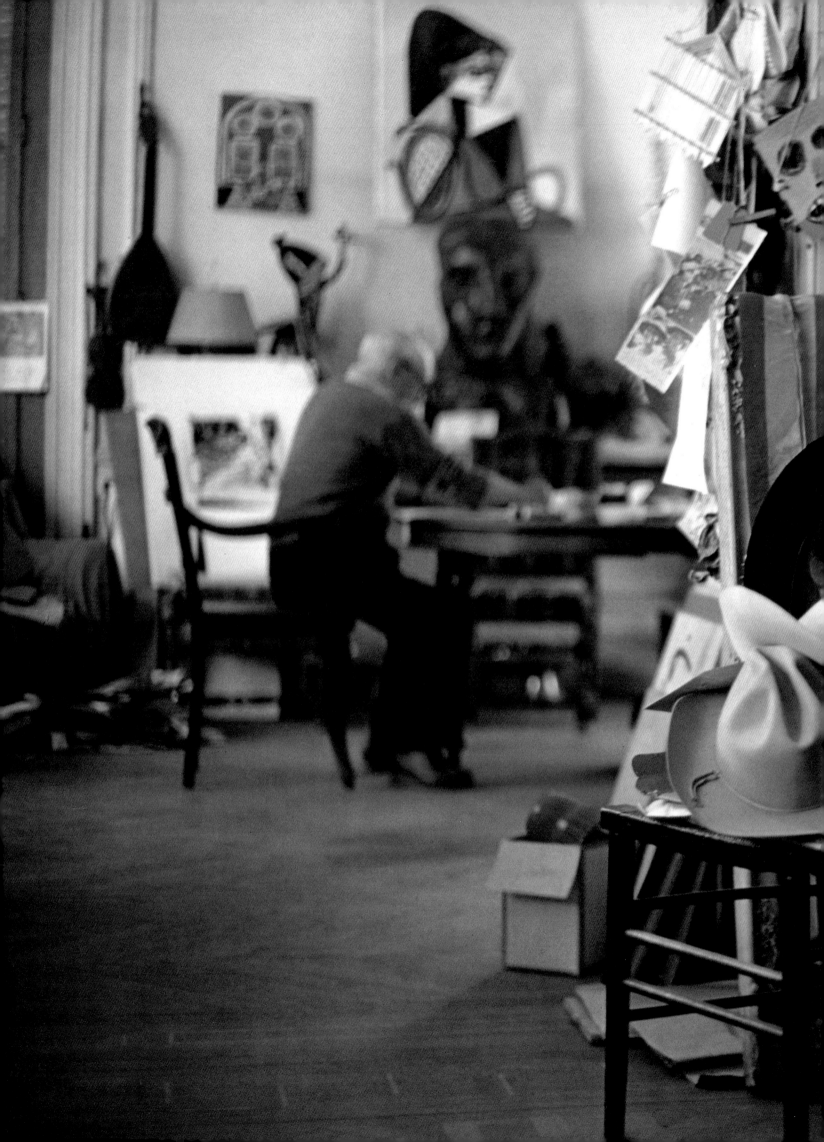

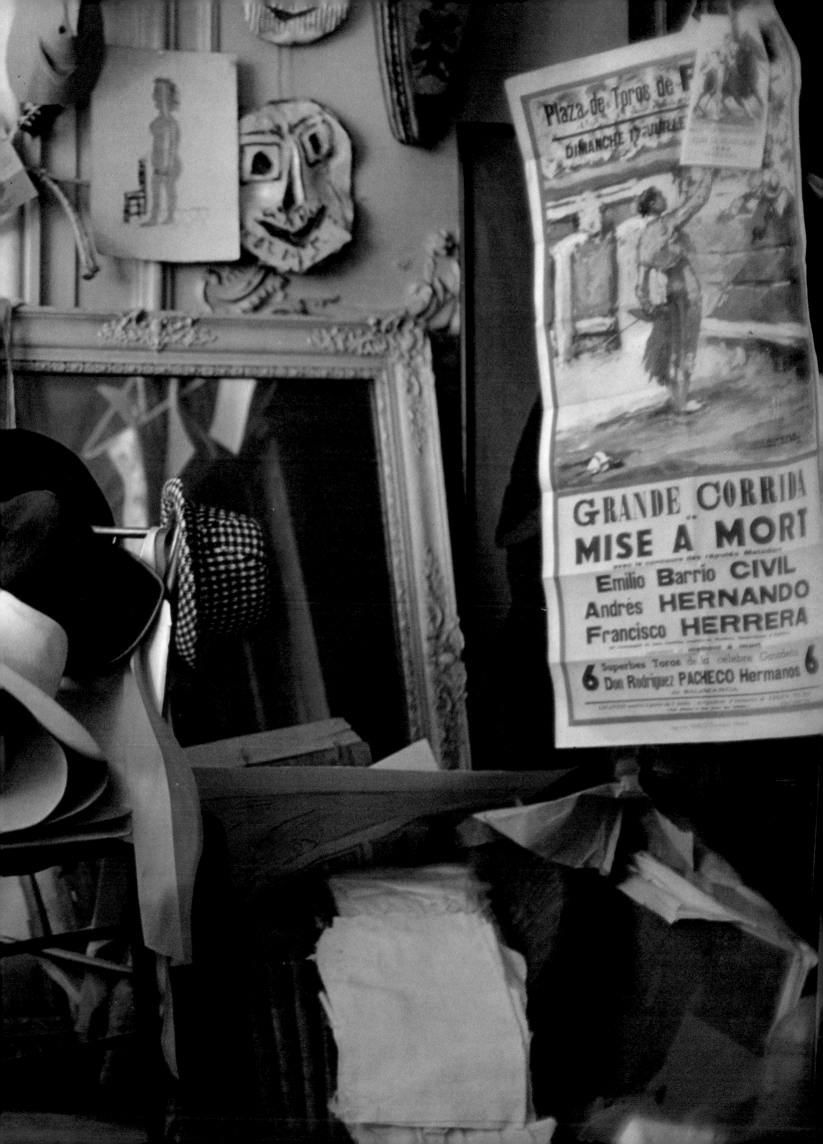

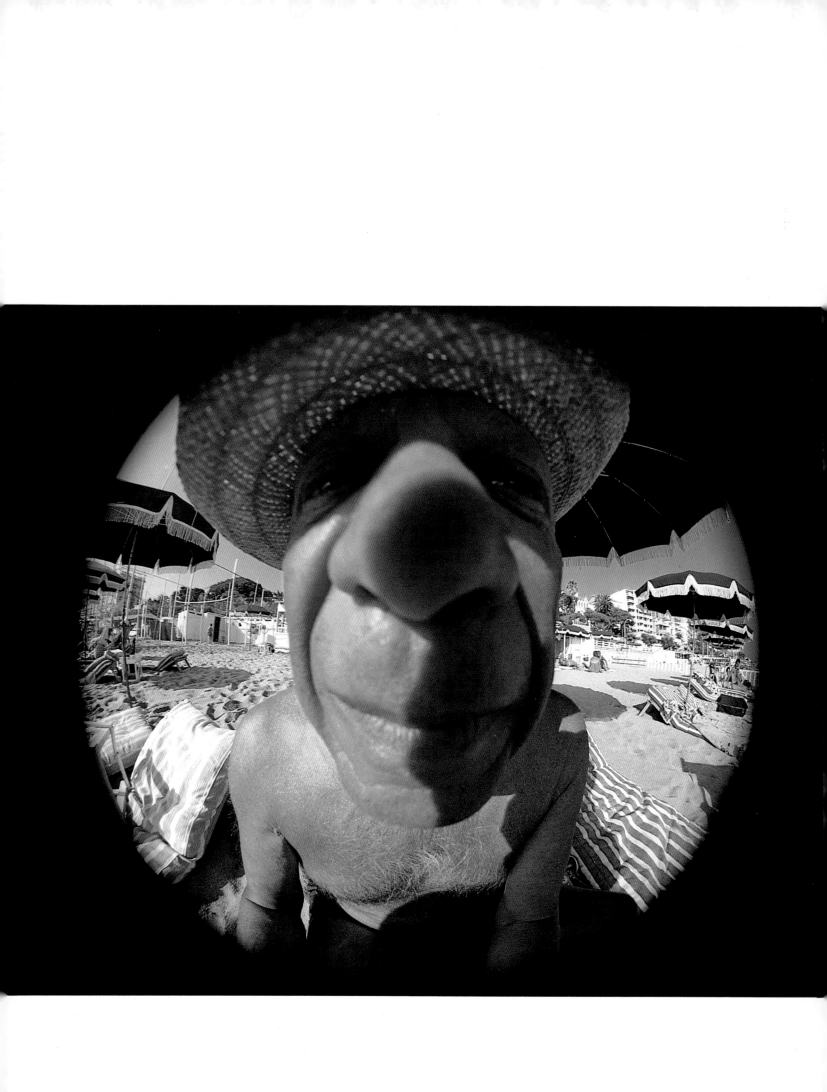

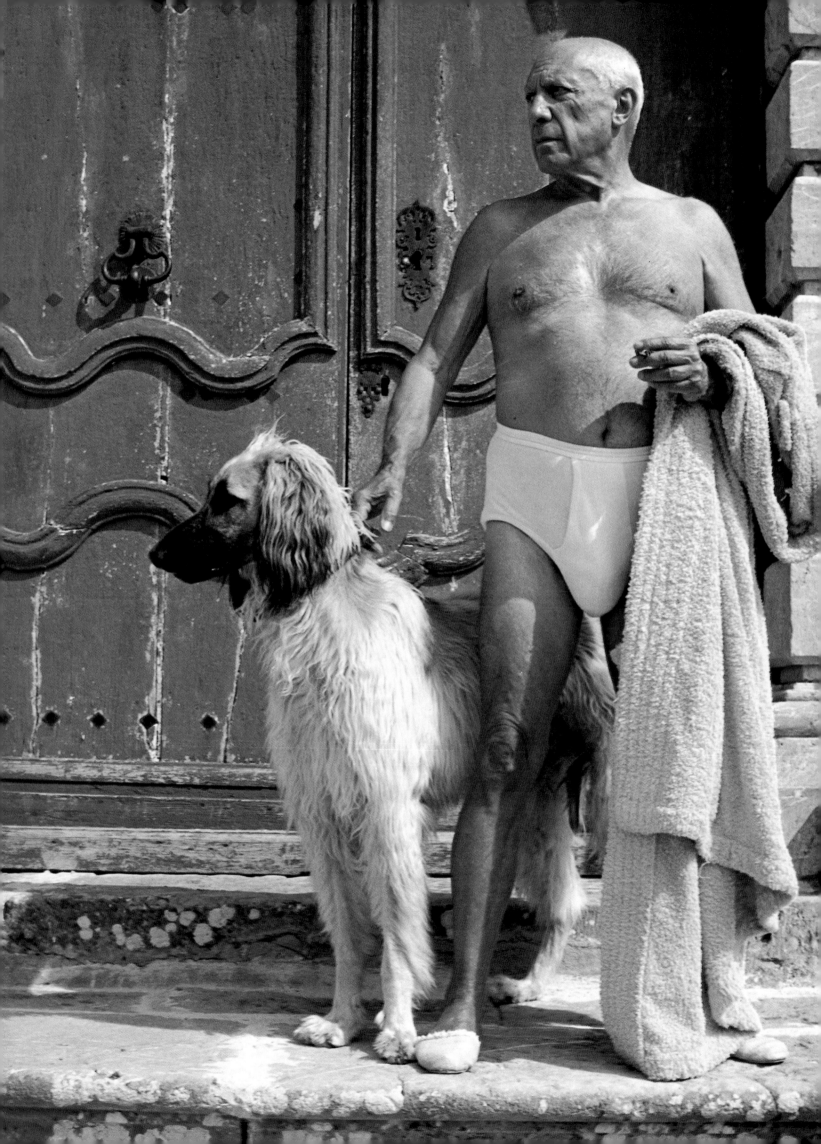

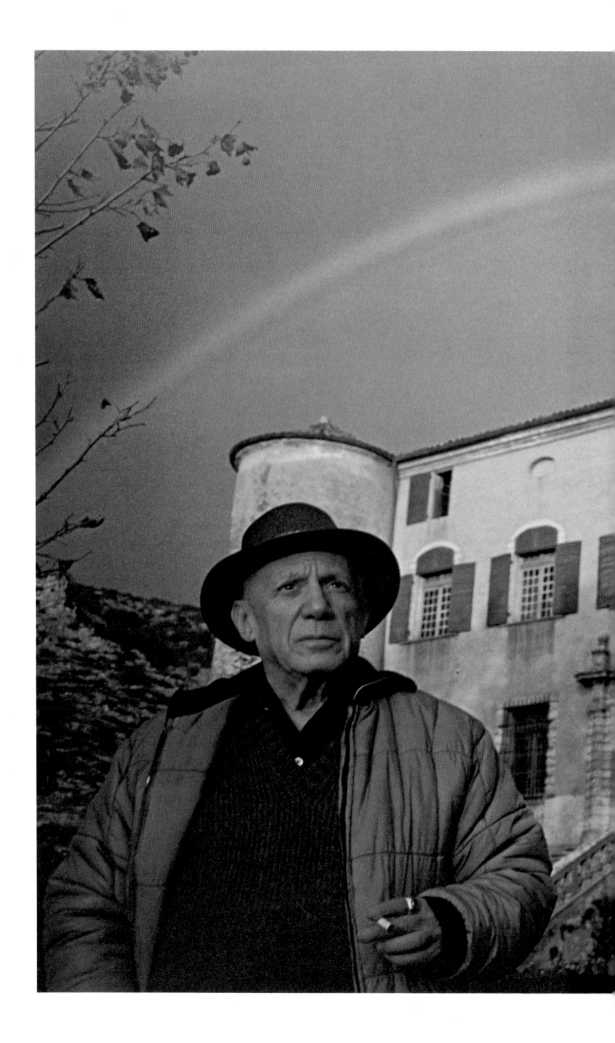

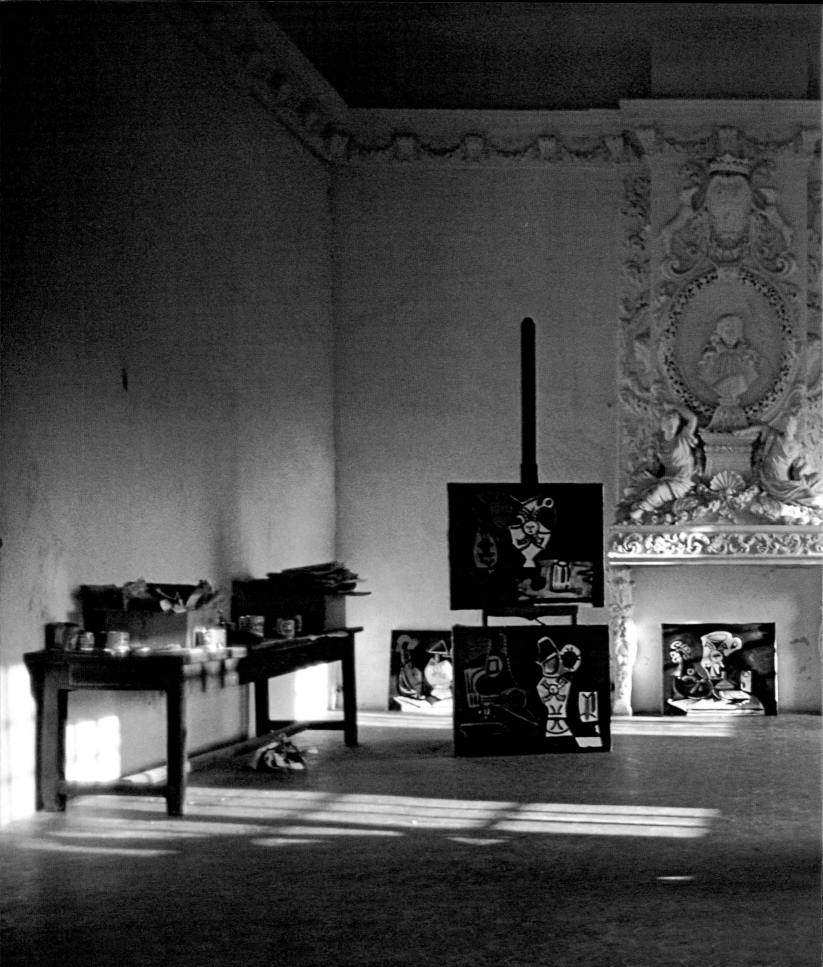

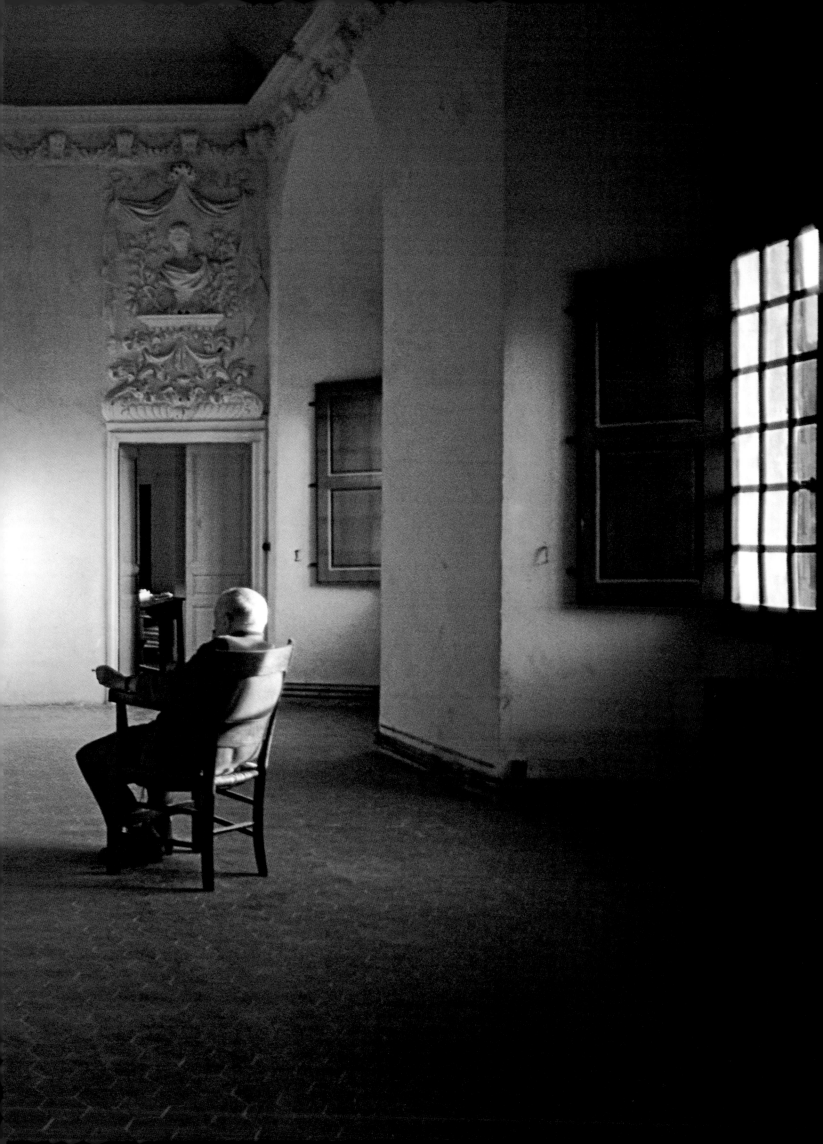

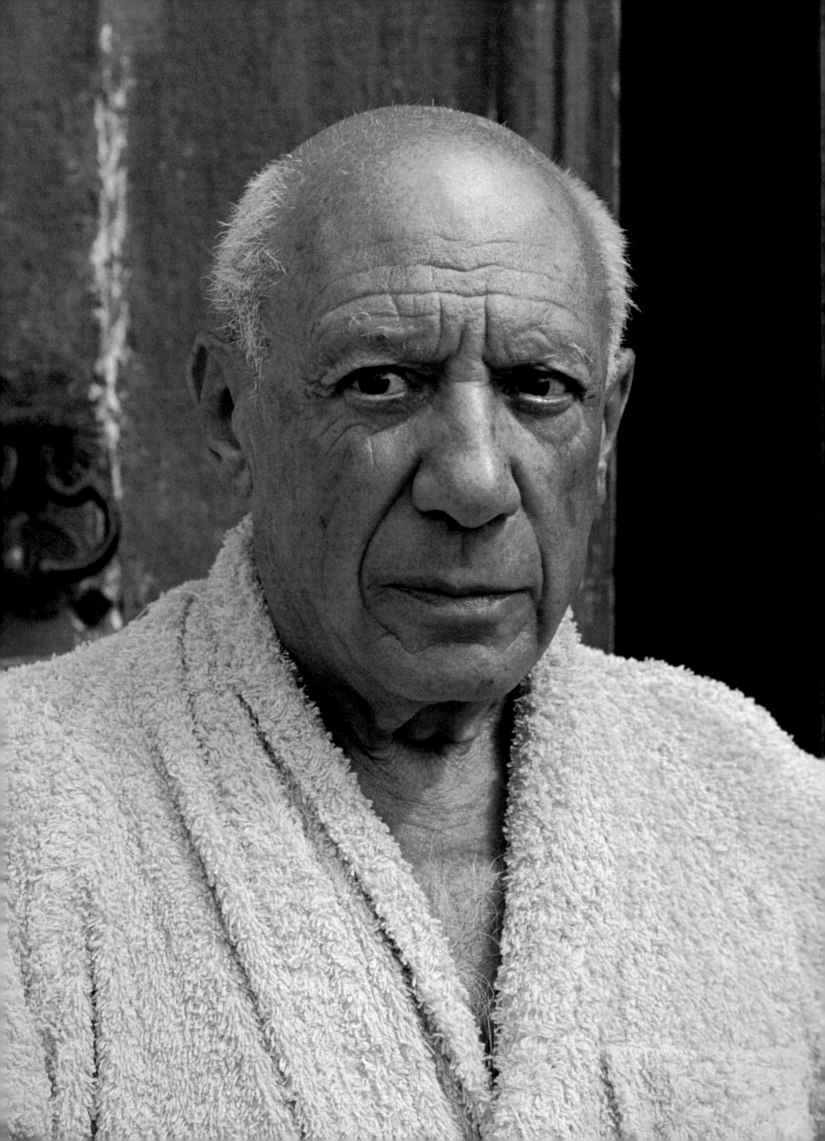

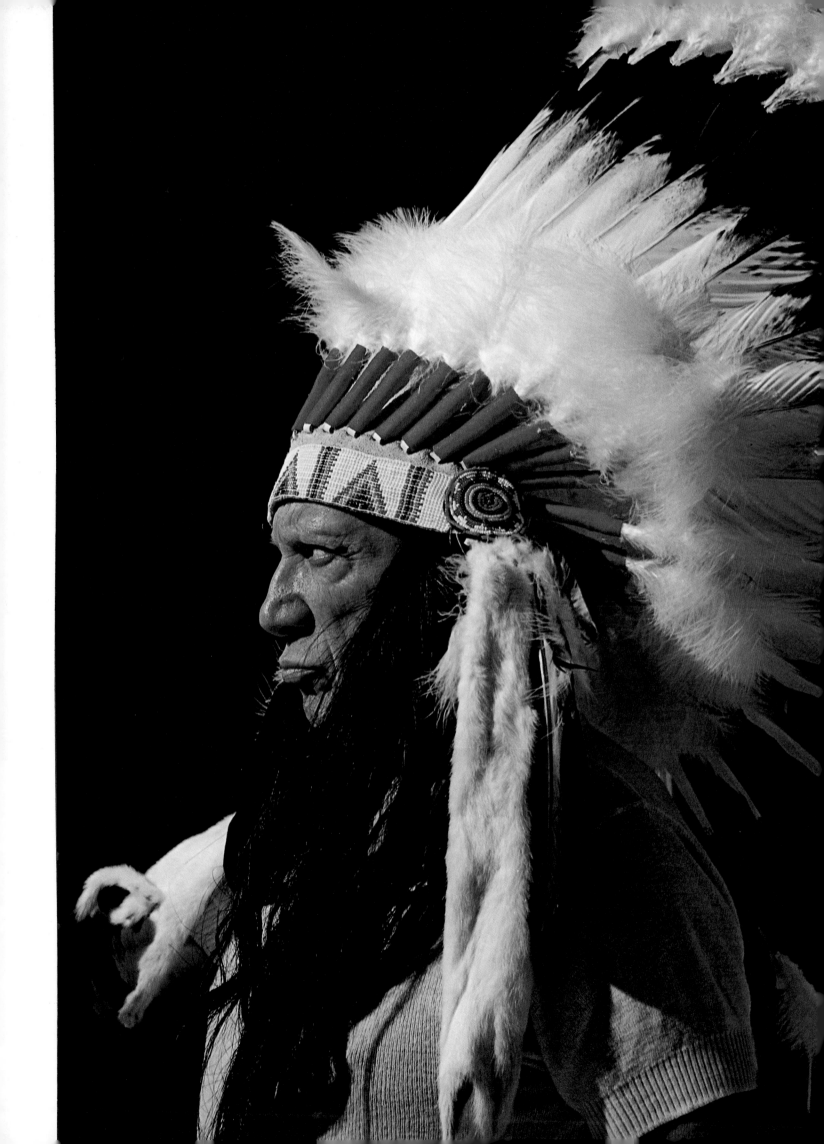

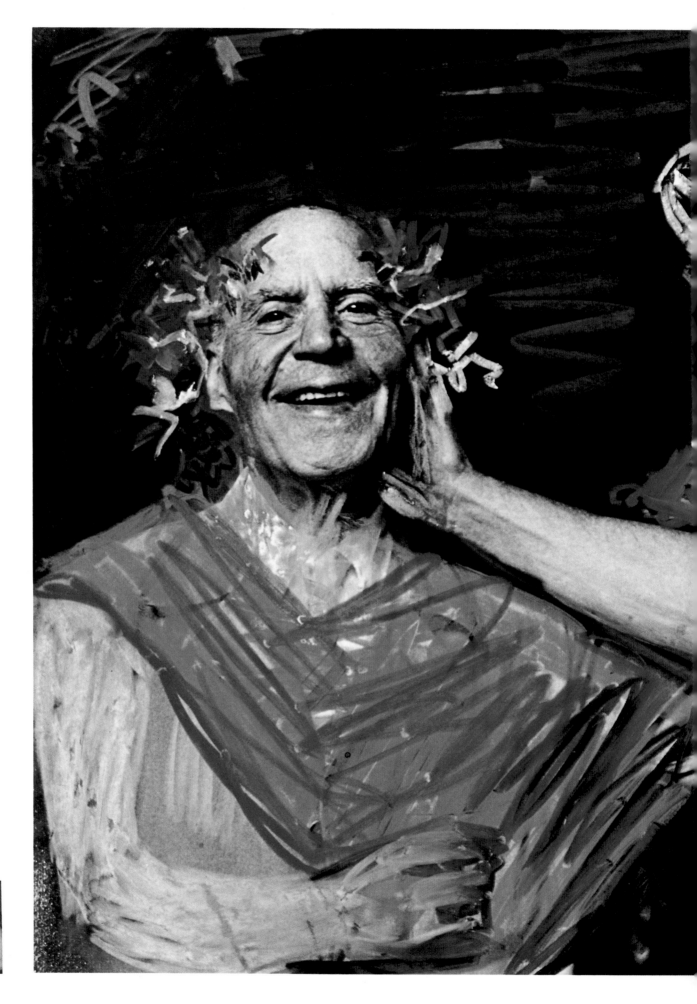

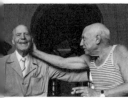

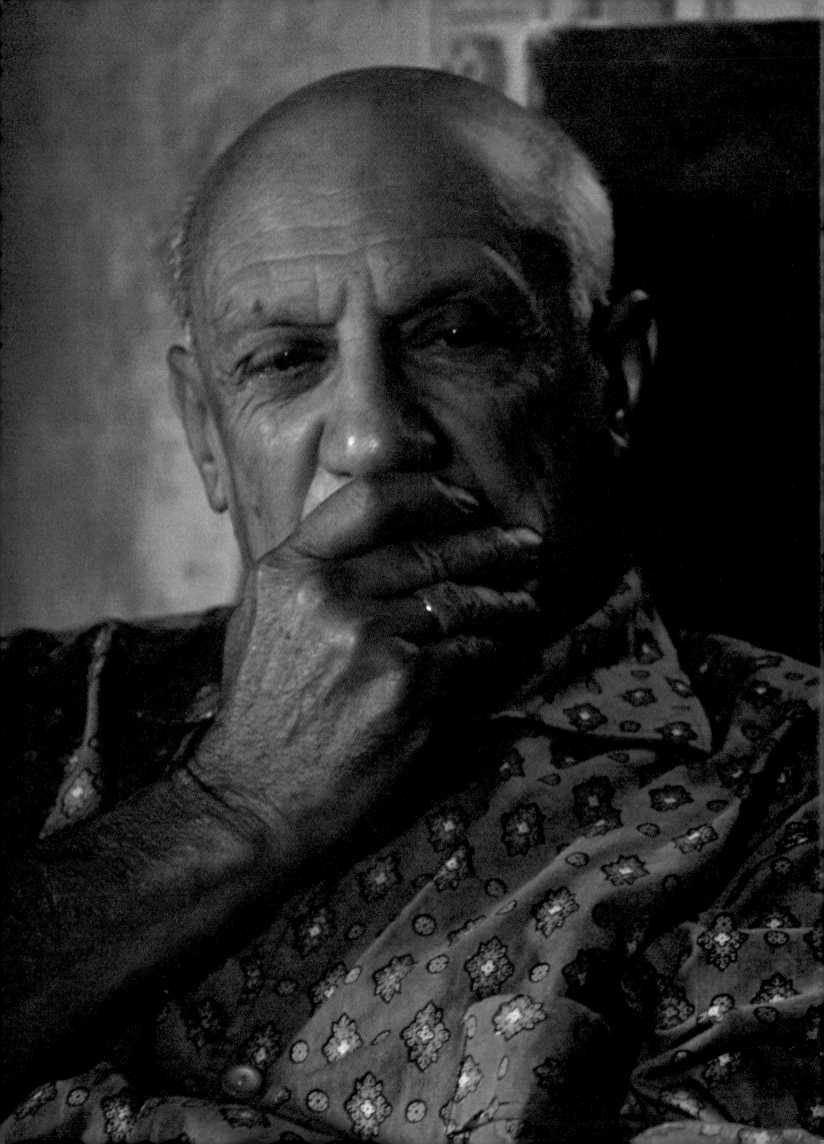

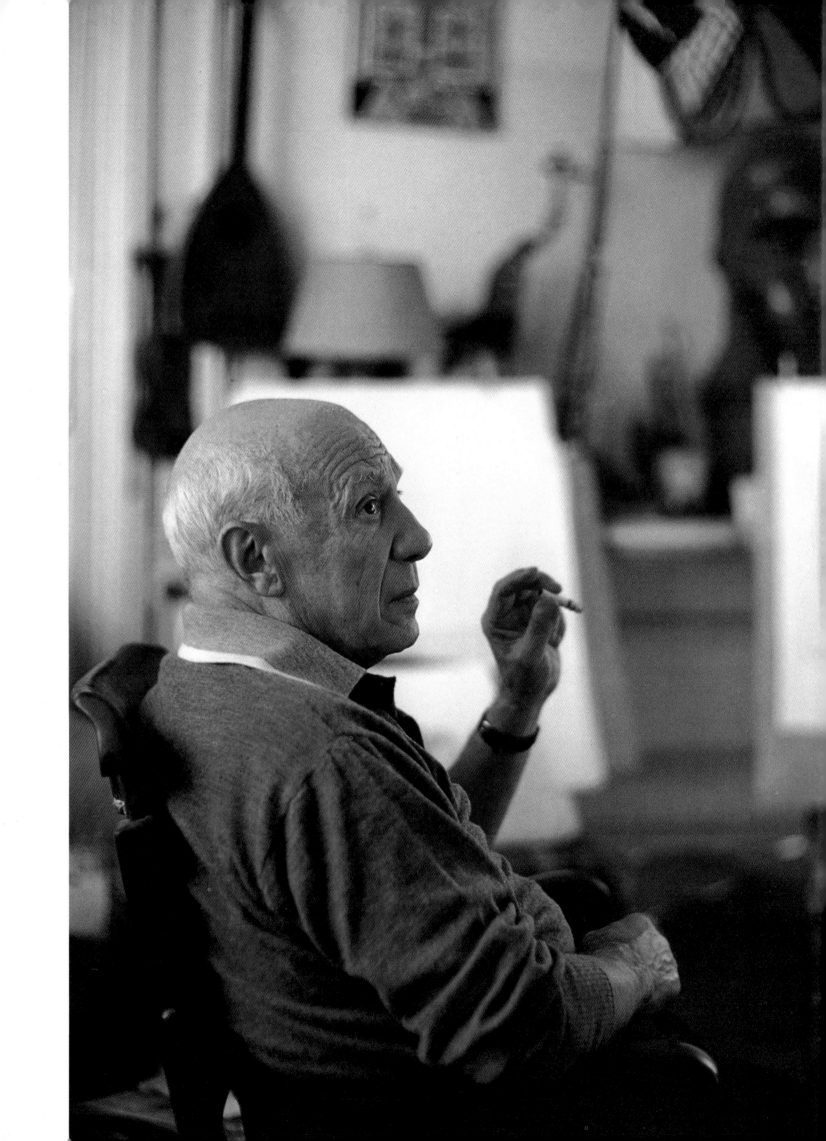

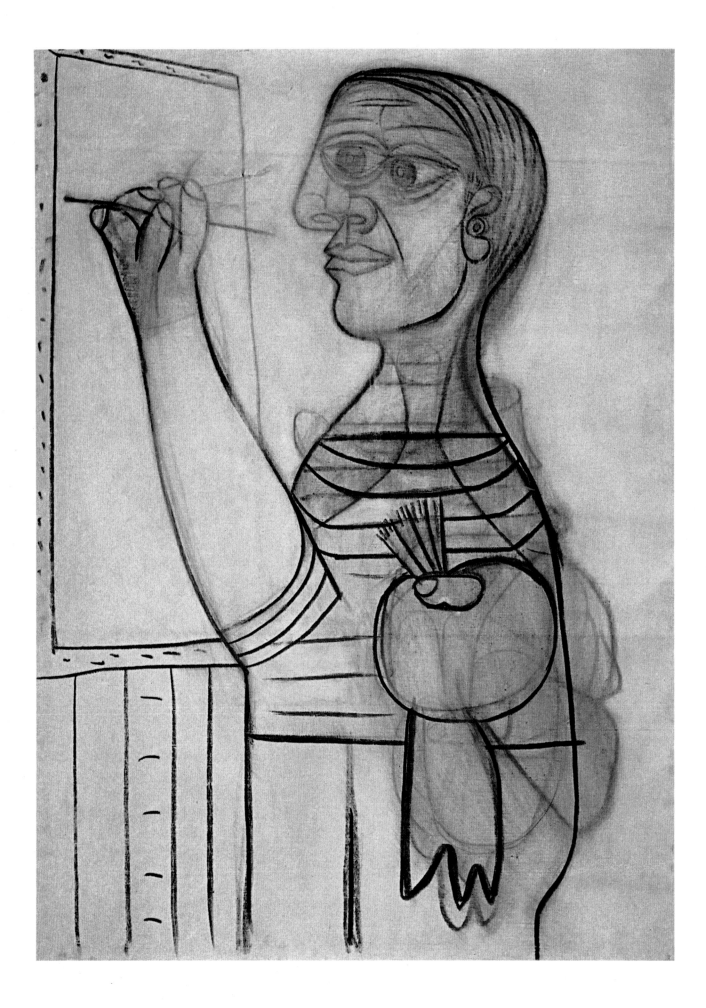

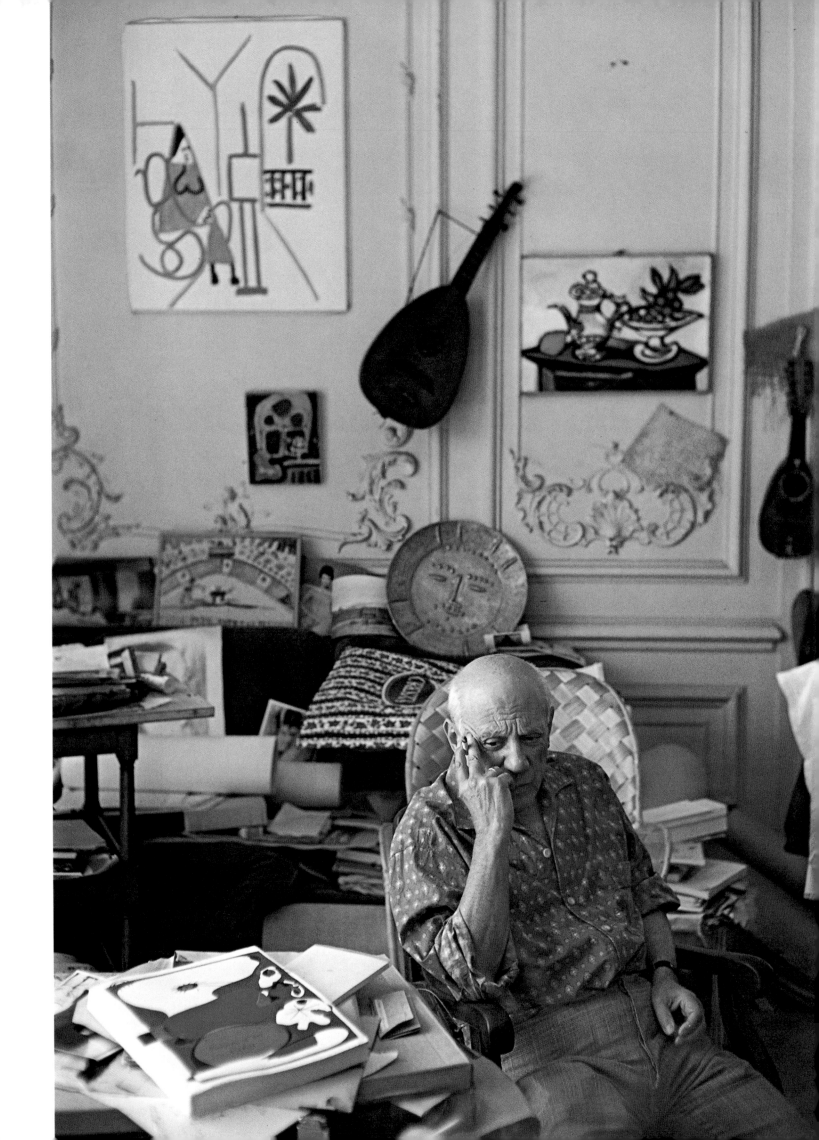

Photo Data

Front endpaper (a) Villa La Californie, Cannes, France; 1960. Pablo Picasso and Jacqueline in the great studio (formerly salon and dining room) of the late-Victorian mansion which was their home from 1954 to 1961, when they then moved to nearby Mougins. Bullfight posters, African ceremonial masks, Gary Cooper's cowboy hat, and Picasso's own cardboard masks intermingle at the right side. Picasso canvases from the '30s to '60s, mandolins acquired during his lifetime, solid silver Picasso trays (smithed by François Hugo, grandson of Victor Hugo), and a bullfight painting by 8-year-old Claude Picasso (behind Pablo's head) at the left side of the room, added to the seeming chaos, but everything had its special place. The dining room is beyond the arched doorway. It was even more cluttered than the salon. The dinner table served as Picasso's horizontal easel for graphics and ceramics. It was cleared for dining only on the most festive occasions, when guests like Artur Rubinstein or Jean Cocteau arrived at the villa.

Front endpaper (b) *Girl Reading at the Beach*. 18 II 1937. Oil, charcoal and crayon on canvas. 51⅛″ x 38⅛″ (130 x 97cm). Picasso often said he wished he had made sculptures 100 feet high, perhaps like this monolithic girl, and positioned them on Mediterranean cliffs.

page 1 Picasso in his bathtub, La Californie, 8 February, 1956. This shot, the first of thousands, reveals much of the artist's nature: indifference to the ancient fixtures and unpainted walls, a total lack of concern over his "image" when meeting a stranger, the self-assurance of a child, or monarch, who looks others straight in the eye—and his astonishing exuberance and physique. He was seventy-five years old.

page 2 Summertime, La Californie, 1957. Picasso wears a hand-tooled leather belt inscribed with his signature, a gift from an American admirer. The plaster cast of *Pregnant Woman*, 1950, was a permanent fixture on the worktable, where he cleaned his brushes, kept odd assortments of tools, tubes of paint, and a cageful of snails. As pets, not for the dinner table.

page 3 The artist, his easel, and a blank canvas on a typical summer afternoon at La Californie. Picasso's famed rocking chair (one of a pair) is in the foreground next to a finished painting. His work day usually began after lunch, then would continue through midnight.

page 4 Picasso's painting studio at La Californie, in 1957. He later moved to the third (top) floor, to a room with a balcony-terrace overlooking the garden, with the Mediterranean in the distance. Portraits of Jacqueline, oil on canvas and cut-out plywood, lined the room. All 1957, except for the charcoal-on-paper portrait of Jacqueline at extreme left, and the partially hidden Dora Maar portrait of the 1930s, behind chair.

page 5 180-degree reverse view from the painting studio, through the salon to the dining room (Jacqueline is almost lost, dusting the floor—Pablo was a firm believer in the merits of dust as a preservative). Two legendary portraits of Jacqueline are at right. Extreme right: *Portrait of Lady Z* (Pablo's first portrait of her), 3 VI 1954. Oil on canvas. 39⅜″x 31⅞″(100 x 81cm). Next to it is what many consider to be the greatest portrait of the 20th century, the almost never seen *Jacqueline in a Black Scarf*. 11 X 1954. Oil on canvas. 36¼″ x 28¾″ (92 x 73cm).

page 6 The back door of La Californie overlooked a vast, untended garden, where Pablo and Jacqueline often walked, many times watched by Cabra, the nanny goat who was usually tethered to the artist's famous *Pregnant Goat*, 1950, bronze.

page 7	Pablo and Jacqueline on the front steps of La Californie, the first day of our friendship. As I waved and drove away I made this single shot, struck by the obvious harmony between them—that the 47-year difference in their ages was irrelevant. It was like this until the end, when he was almost ninety-two.
page 8	Jacqueline watching Picasso, at work, across the studio. He was her life.
page 9	*Jacqueline with a Candy Box Blouse*, charcoal on paper, 13 II 1957. Picasso had just finished the portrait, when Swiss art experts Siegfried and Angela Rosengart arrived bearing a gift box of chocolates. Pablo immediately cut its wrapper—with tinsel cord—into a blouse for the picture. The artist's trousers, with horizontal stripes, were Pablo's favorites. He said he had seen a similar pair in a Courbet painting, so he ordered some from Sapone, his tailor in Nice. Sapone soon gave up sewing zebra cloth into pants and opened an art gallery, initially promoted with displays of hilariously ribald drawings of himself, given to "the bandit, Sapone" by Picasso.
page 10	The morning after bullfights in Arles, Picasso spun around with his bath towel, baiting Jacqueline across the room. A snapshot of Kathy, Jacqueline's daughter from an earlier marriage, is tacked to the wall of the nearly unfurnished second-floor sitting room where intimate friends sometimes gathered before lunch awaiting the artist, who was still in his adjacent bedroom reading mail or a book, or watching Lump, the tyrant dachshund, or weighing ways of how not to appear, or hoping that Jacqueline would send everyone away so that he might immediately start to work.
page 11	The second day after the Arles bullfights, Picasso painted a series of aquatints (known as *Pepe Illo*) of the drama of a classical *corrida*. His face appeared several times, reflected in the copper plate. Then one could look straight into his eyes during a time of absolute creative concentration.
page 12	Pablo Ruiz Picasso, Spaniard, in Sevillian hat and cape. 1957.
page 13	Picasso, international mime, in clown's mask and derby. 1957.
page 17 (top)	Villa La Californie. No one could have possibly imagined the world that existed behind that old wall and infrequently opened iron gate, on a quiet lane above Cannes.
page 17 (bottom)	Sculptures and canvases overflowed the studio, where Picasso appears to be walking into a wall of his own work, which began to fill La Californie after he moved there.
pages 18-19	White doves shared La Californie's third floor with Picasso, living on the terrace just outside his studio. Cannes and the Mediterranean fill the horizon beyond his garden. These doves, sitting on their tree-branch roost, inspired the artist to paint nearly a dozen canvases of exactly this scene, when he was creating his series of works based on Velázquez's masterpiece, *Las Meninas*, in the Prado. Picasso's *Las Meninas*, including the dove canvases, are now in the Picasso Museum of Barcelona.
page 20	La Californie, *Pregnant Goat*, and Cabra the nanny goat; midsummer, 1957. Picasso's second-floor bedroom is above Cabra's head. Below it, with closed windows, is the dining room; next to it is the salon. The second-floor sitting room is above the salon. Pablo was still asleep, Jacqueline marketing in Cannes.

The first stroke of a Picasso. The artist himself—except for the elegance of the extended right hand—reminded me of *The Scribe*, a XVth-century B.C. sculpture in the Cairo Museum.

The first day's, and night's, life cycle of a Picasso. It kept evolving until after midnight. Then the lights were turned off until the next night, when he continued painting, while Jacqueline watched silently from the shadows.

Picasso and *Lady Z*, titled by others. The artist never named paintings. That task was assumed by art historians and museum directors in an attempt to identify and record his prolific life's work. *Lady Z* is said to have been inspired by the thought that Jacqueline would be the last great love of his life, a prophecy that proved correct. Of the dozens of portraits of Jacqueline, she posed for him only once: *The Turkish Bride* (page 94). She posed, that time, because of the arabesque complexity of her costume. He knew her face from the first day.

Jacqueline in the dining room of La Californie. Behind her, the newly painted *Venus and Cupid*, gouache, 1957; after a work by Lucas Cranach. Despite distortions, *Lady Z* and Jacqueline are clearly the same girl.

Man Carrying a Sheep, 1943, bronze. 7' 2½". La Californie's garden, 1957. The sculpture is often viewed as an autobiographical work. Each time Picasso changed residences after the war, this towering figure would appear at the new studio a few days before the move.

Pablo Picasso: etcher. Not a sound could be heard in the studio while he worked on the *Pepe Illo* aquatints. His brush seemed to pulsate on the copper plate, similar to a phonograph stylus on a record.

Lump, the dachshund who had always lived in an apartment in Rome where he had never even seen a mouse, reacted with sheer horror when his curiosity led him into La Californie's garden—where he discovered Cabra, eyeball-to-eyeball.

Each day was different at La Californie when, in the 1950s, it was the center of Picasso's world. For a time, paintings filled the studio, then ceramics would take their place making it almost impossible to navigate from room to room. Perhaps one of the most extraordinary events in the life of the villa lasted only minutes. Picasso and Jacqueline had decided to leave Cannes, to live in an ancient château near Aix-en-Provence, in the Midi, many miles to the west. As they were preparing to leave La Californie, a squadron of pigeons soared straight through the open doors of the studio—then calmly walked through the villa, as though to say goodbye.

Only Lump dominated Picasso—which the artist apparently loved and calmly accepted. When Lump was eight weeks old, he peered up at me from a kennel garden in Stuttgart and decided that I offered escape and the promise of a gypsy life. He grew up in Rome, where he had to share everything with a regal Afghan hound, Kublai Khan—who couldn't be dominated by him, or anyone else. Lump stowed away in my car during a trip to La Californie. There, upon taking one look at the studio and the incredible clutter, with every foot of floorspace crowded with mysteries—enough to keep him poking into corners forever—he sat looking up at Pablo

Picasso (just as he did with me in Stuttgart) and shifted gears, to begin a new life. He dumped me for Picasso. La Californie was never the same again. He ran the place, barely permitting Pablo to paint there, Jacqueline to live there, or me to photograph there. Picasso would look at him with awe, shake his head, and smile: "Lump is not a dog, not a man—he *really* is someone else!" Naturally, Lump ate at the table. And, often first.

page 31 (bottom) One corner of the dining room in La Californie, where Picasso stored pots and cups of colors for painting ceramics. He just shrugged when visitors asked what he did for exercise; after they left he'd snort with indignation, looking around the studio: "Who do they think made everything here—alone! And I lean over to get something off the floor a thousand times a day."

pages 32-33 One afternoon, when he was painting a series of owl and fish plates, he asked whether Lump had ever had his own dinner plate. "Yes." . . . "With his name on it?" . . . "No." . . . "Why?" . . . "He can't read." . . . "How do you know?"

page 34 Picasso's place at the table, just after luncheon. His glasses, teacup and saucer (with snuffed-out cigarettes and ashes), a fly swatter, even a grape stem—and a tin of Craven A cigarettes for, obviously, a guest. He smoked only the popular, ordinary Gauloise *Gitanes*. A chain smoker until the last few years of his life—when he stopped overnight—he seemingly never inhaled, and, curiously, to a non-smoker, there was never the slightest trace of the smell of cigarettes in any of his studios. His was a unique world, in many ways.

page 35 The view straight ahead from Pablo's place at the dinner table, whether working, or, as sometimes happened, actually eating. (The kitchen table was the center of the villa, at mealtimes.) The artist's sculpture, *Bull's Skull*, bronze, 1943, was made from the discarded pieces (saddle and handlebars) of a bicycle. Above it, an aborigine's boomerang from Australia. At the right, a ceramic portrait of Cabra, the goat. A *corrida* poster, Jacqueline's tulips, and a sample color squiggle between the boomerang and sculpture, completed that visual fragment of the wall next to the kitchen door.

pages 36-37 For weeks, during the summer of 1957 when Picasso was creating a series of ceramic platters, Janot, his handyman-chauffeur, brought newly fired works from the Madoura kilns in neighboring Vallauris. Pablo's first stop of the day was at the bottom of the stairs, to examine all of the carefully assembled new members of his family—which is how he viewed them.

page 38 The floors of La Californie sometimes resembled mine fields during the various wars—awaiting just one false step! But nobody ever made one, least of all Lump who, with Jan (a giant boxer in residence long before Lump arrived at the villa), often fought and played all day long amid some of the most fragile ceramics and valuable paintings anywhere. They never touched a thing. Only I ruined a Picasso in that home—surely one of my bleakest days, ever.

page 39 Pablo and Jacqueline. He never seemed to be much of an advocate of physical contact when greeting anyone—not a cheek-kissing man. But when he embraced you with his eyes—which I have never seen in any photograph, including mine—the warmth lasted forever.

pages 40-41	Picasso and the fish skeleton that became a plate. He had just fileted a *sole meunière* with almost surgical precision, when he picked up the bones to finish off the last stray morsels. It looked as if he were playing a harmonica—and I grabbed this one shot, not aware of the distant look in his eyes. Lump, under his left elbow, also was riveting his attention on the skeleton, in case something fell his way. Picasso then put down the skeleton, disappeared into the front hallway of the villa, and returned with a slab of moist potter's clay. He'd eaten the sole, now its skeleton was to be immortalized.
pages 42-43	Pablo makes a plate. This 8-photo series follows each step involved in creating *The Fish-fossil Plate*, 1957. He pressed the skeleton into the soft clay, embedding it like a fossil. Next he cut out filets of each impression, which he placed over painted designs on the platter. The work was sent to Vallauris, and fired. A unique Picasso had been born. Then he had his coffee.
page 44	Pablo's hand, and Jacqueline behind a spray of field flowers. The dining room.
page 45	Sheet-metal portraits, which were painted. Jacqueline and mythological gods.
pages 46-47	The great studio of La Californie, 1957, itself resembled a cubist canvas.
pages 48-49	Whenever Picasso appeared in public, at his favorite restaurant in Cannes, or, even less frequently, at the beach with Jacqueline and Kahnweiler, tourists, photographers, and freelance portrait artists surged around the legend who suddenly appeared in their midst. He bore the ordeal with grace and good humor; in fact, it may even have pleased him to be treated as a superstar. The only time I *knew* he was touched by attention from strangers, was the day a gypsy woman spun her head, looked directly into his eyes as our car passed her horse-drawn wagon—and shouted "Picasso!"
pages 50-51	An unfinished canvas, *Bathers of La Garoupe* (a popular beach in nearby Antibes), had been leaning against the studio wall for many weeks during the summer of 1957. Late one night, Picasso took a piece of charcoal and completed the skeletal figures in about half an hour. He disappeared into the darkened villa, and returned in a black Spanish cloak, wearing a dead-white, toothy mask. One hand extended slowly across his chest, while he watched me with unblinking eyes.
pages 52-53	No one will ever know the total number of Picassos the artist gave away—scrawled doodles, paper scarves and neckties (like those that he made for Jacqueline), portraits that he made for friends: Artur Rubinstein, Kahnweiler, bullfighters, poets, and Sapone the tailor; or the total number of books he embellished with a swirling sweep of his hand. Then there were those great paintings that he gave away—to museums, everywhere, and when appeals were made to raise funds for special causes, even to cities, like Basel, Switzerland, when he learned that townspeople were in the streets soliciting contributions to buy several of his canvases. One afternoon, he and Jacqueline sat on the backsteps where a portrait of her leaned against the doorway, an inscription drying in the afternoon sun. Three years earlier, the day it was first painted (he modified it several years later), Jacqueline and I found this portrait on his easel a few hours after we had eased him out of a foul mood. This day, in the sunshine, he asked her if she was jealous: he had just given the painting to me.

pages 54-55	Picasso rarely used the telephone without good reason, like arranging a block of tickets for a *corrida*. Jacqueline, also on festive occasions, violated a rule of the studio and rearranged the sacred dust.
page 56 (top)	The nearest Picasso ever came to taking a vacation was when he escorted Jacqueline to the Arles' *corridas*, where they met a vast entourage of other *aficionados* chosen from family and friends. They rendezvoused for a sausage-and-wine lunch in a subterranean medieval bistro, before the bullfights began. Pablo was always their host.
page 56 (bottom)	Black suit, suede shoes, white shirt and silk necktie, effectively disguised the often more eccentrically clothed artist during his festive, but infrequent, trips to Arles. His conservative dress was not inspired by thoughts of being incognito, but rather as a gesture of respect for the men and beasts in the arena. His guests choked the ancient streets when walking through the town: (l-r) son Paulo, Jacqueline, daughter-in-law Christine, art expert John Richardson, poet-playwright (cape on shoulders) Jean Cocteau, and art historian Douglas Cooper, on sidewalk.
page 57	While heading for Arles' Roman arena, Pablo and his family passed in front of an image straight out of his Blue Period youth; a crippled guitarist with his dog, resting on the curbstone. Even though Picasso's head never turned, his eyes missed nothing. He did not stop his trailing *cuadrilla*, but sent money back later, in order not to humiliate the dejected musician.
pages 58-59	Picasso, Jacqueline at his shoulder, sat immobile during *corridas*, without visible emotion; without shouting, without gestures, without applause—nothing. But, seated directly behind him, I could almost see the invisible bond connecting those flashes of pageantry in the arena to the artist's eyes, and heart.
pages 60-61	A few days after returning to La Californie from Arles, after he had checked his most recently fired platters, Picasso sat at his dinner table and, in exactly three hours—the duration of a *corrida*—painted the entire bullfight drama on twenty-seven copper plates. He later etched each figure, using a difficult, almost forgotten technique: aquatint. And, as in all etching, every action, all details, had to be painted reversed. The series now is know as *La Tauromaquia de Pepe Illo*.
page 62	Two copper plates were etched simultaneously when Picasso applied acid to the figures in the *Pepe Illo* aquatints. A frame of translucent parchment diffused the daylight at his workbench, in the basement of La Californie.
page 63	Pablo and Jacqueline after midnight, at the end of a normal work day. Her profile mirrors the silhouette of the plywood cutout sculpture, across the studio.
pages 64-65	Jacqueline had gone to bed, Lump was asleep in a nearby chair, Cabra was in her box of straw on the second floor, and the villa was silent. It was 2 a.m. when Picasso settled into a chair in the dining room—his potter's wheel empty—to read the morning paper. Later, before going to bed, he again checked that day's newly painted platters waiting to be fired after daybreak, in the kilns at Vallauris.
page 66	During the creation of *Pepe Illo*, Jacqueline and Lump waited in the studio basement while Picasso silently etched. Daylight faded. Supper was delayed. They rarely ate before midnight, when Lump was already asleep. Then, after unseasoned vegetable soup, omelet, fruit and coffee, everyone returned to the basement, to *Pepe Illo*.

Picasso with *Jacqueline in a Black Scarf* (see page 5). This may be Picasso's masterpiece in portraiture. He gave it to Jacqueline. Except for a flush of rose in her left cheek, and points of golden light shining through the caning of the chair, this is a black-and-white painting. Paradoxically, Jacqueline often wore black prior to Pablo's death—almost never since. This great canvas today is with the dozen others, all portraits, that he gave her and are beside her, in Notre Dame de Vie.

At night and on rainy days, Cabra slept in her box of straw on the villa's second floor. When Pablo was painting, Lump and Jan supposedly stood sentry duty but often tried only to outstare each other. The white doves lived on the third-floor balcony, outside Picasso's "secret" studio—a simple, converted bedroom.

Claude and Paloma, Picasso's youngest children, passed summer vacations with the artist, coming from their home in Paris, where, while at school, they spent most of the year with their mother, Françoise Gilot. Daniel-Henry Kahnweiler, Picasso's veteran dealer, also appeared at the same time, when the rhythm of the studio changed completely to accommodate the joyous invasion. Claude found his father's mask collection challenging, discovering a clown's costume for every role. Paloma revealed an inherited compulsion to draw, even as a child—and to turn each day's tranquility upsidedown. Kahnweiler, younger than Picasso, seemed to be watching the turmoil from the sidelines of another century. Lump and Cabra, though hugged and petted and chased and ridden, quickly adjusted to the bedlam without changing their self-centered routines at all.

The Bathers of La Garoupe, long a fixture of the studio, formed the backdrop when the children skipped rope with their father, when Claude soared with the arms in the painting appearing like wings, to help him fly. Although he had bashed his toe against a painting, Picasso was waiting for his turn, too. Gorilla feet, a witch's mask, Gary Cooper's cowboy hat, and boxing with his father, formed a vacation to last, as a memory, all his life.

Claude, Paloma, Jacqueline, her daughter Kathy, and baby Meurice—son of the gateman-gardener—staged a private rodeo in the backyard, when Pablo tried to teach them how to ride a nanny goat. Cabra won every time. Another day, Picasso asked whether Lump had ever seen a rabbit. Never! He had lived in an apartment in Rome; he didn't even know what a cat looked like. But he *had* once tried to flirt with a chicken—a pet at a trattoria. No help! Picasso picked up an empty candy box and quickly scissored-out a white rabbit, crayoned-in pink eyes, and arced the drawing toward the floor—where Lump attacked. He snarled when Pablo attempted to retrieve his work, then backed out to the terrace steps to show his kill to Jacqueline—where he growled again at Picasso . . . and ate the rabbit. Probably the only time anyone ate a Picasso.

Luncheon in the kitchen was a family affair when Jaime Sabartés, one of Pablo's oldest friends—and subject for portraits—joined Jacques Frélaut—master printer—who was at the villa pulling proofs of *Pepe Illo*, when Picasso outworked everyone at night; often alone.

Picasso, having awaited Jean Cocteau, sprang from behind a stack of paintings when the poet arrived. Even after watching Pablo for years, I never ceased to be aston-

ished by his versatility. As a mime, his hands were always those of a professional; whether square dancing (page 81), playing an imaginary flute (page 80), acting the clown, as here with Cocteau, or blocking a fast right-hand punch (page 73), when boxing with Claude.

pages 80-81 Jacqueline gave up trying to teach Pablo a ballet routine, he seemed too flat-footed—hopeless. The moment she sat down, he twirled away in his own routine, playing the reed pipes of an imaginary Pan. Then he stomped and whirled, combination square dancer and dervish. He was nearly seventy-six. It was Jacqueline who freed the child in his heart.

page 82 The studio mirror served as a silent aide to Picasso, for he was sometimes apparently his own model. Late one afternoon, while photographing the wild assortment of hats stacked on a chair in the corner, a sinister form emerged from the darkening mirror before me—when I had thought I was alone in the room. There was no humor in the eye of the masked man who now stood directly behind me; I was never sure that he saw me at all.

page 83 During the summer of 1960, Picasso painted several unusually realistic landscapes (r) based on the view from his studio window (on the top floor of the villa), which included other aging mansions in the neighborhood similar to La Californie itself. He also painted an enormous Picassoesque canvas which is now in the Art Institute of Chicago (beside him in this photo, and on pages 88-89). The moment I saw it—a nude woman of Himalayan proportions and reclining on one elbow in the shade of a pine tree—I blurted out the first impression that struck me: "Ste. Victoire!" Picasso turned and said: "Who else?"—looking at me as though I'd identified the day as Saturday, which it was . . . and as though something was beginning to rub off, from the studio and all of its paintings, onto me. Ste. Victoire is the mountain that towers over Aix-en-Provence and was immortalized—if possible for barren rocks and scattered pines—by Cézanne, when *he* painted at Aix. Saturday or not, I was elated—thrilled by the glow in Picasso's eyes, too. That was the day he gave me the portrait of Jacqueline.

pages 84-85 The black-chestnut eyes of Pablo Picasso. In them, one can see the Victorian windows of La Californie. Astonishingly, he never seemed to blink. There is not one negative, in the thousands I shot of him, with eyes closed—a phenomenon, as every professional photographer knows.

pages 86-87 Several weeks after shooting the closeup of his eyes, I mounted two enlargements on canvases hoping he might sign them for me. He refused—then picked up his sketch pad, tore out two pages, reached for his scissors, then his charcoal, and in a couple minutes finished two self-portraits of Pablo Picasso as an owl. They went first on the wall, where they stared at us for several days. Then he took them down, signed each—and gave them to me.

pages 88-89 Jacqueline and Pablo and *Ste. Victoire*. The face of this gargantuan figure seems to be wearing a mask similar to that worn by Pablo in the studio mirror (page 82). This was one of those rare moments when they held hands—a moment that eliminated the forty-seven-year difference in their ages.

Signing day at La Californie. Picasso always dated each work when he painted it (day-month-year), but he never signed them until the final day before sending them to Kahnweiler, his agent in Paris. He is marking each painting to be shipped with "K," to separate the works to be sold from those he kept for himself, known as "Picasso's Picassos"—now, his estate.

Many people have looked at the photographs I made in the Korean war, but no one, in my presence, ever viewed them with such empathy as did Picasso. His friend Jaime Sabartés had just turned to the saddest pages of one of my war books, when Pablo looked over his shoulder. These, to me, are the eyes of the man who created *Guernica*.

Pablo engulfed Jacqueline in the mantilla of a Spanish bride, one summer afternoon when nostalgia for his homeland must have been acute, almost unbearable. He had worn the cape and hat most of the day. Lump prowled and played underfoot, never touching a canvas. One that he maneuvered around daily was *The Turkish Bride*. 20 XI 1955. Oil on canvas. 39⅜″ x 31⅞″ (100 x 81cm). This was the only portrait for which Jacqueline posed, due to the complexity of her costume: Hungarian hat, English hair scarf, and Turkish jacket. Today, this poignant masterpiece hangs opposite *Jacqueline in a Black Scarf* (page 67), in Notre Dame de Vie, Jacqueline's home in southern France.

Pablo Picasso, in the center of his studio, La Californie.

The changes in Picasso's world were mercurial, from day to day, even hour to hour, with the artist himself the least predictable element of all. And yet these same fluctuations in the atmosphere and activities within the studio were foreseeable; they became almost routine, structured by the character of Picasso himself. Contradictions and paradoxes were the norm. The greatest upheaval came in 1959, when Pablo and Jacqueline abruptly departed La Californie (temporarily, it turned out), where work and life at the villa had seemed to be rewarding. In fact, "experts" predicted that Picasso would never leave Cannes, or move again . . . he was too old! He was also too secretive for the same experts: a year earlier, he had quietly bought the remote and austere Château de Vauvenargues and most of the northern slopes of Ste. Victoire, "Cézanne's mountain" near Aix-en-Provence. After adding only central heating, modern plumbing, and a telephone, he moved in with easels and paint and blank canvases to start again. La Californie was overflowing with his work, Cannes was no longer a small town (even though he rarely visited it), and the harsh landscape surrounding the château probably reminded him of Spain, which he would never see again. His son Paulo arrived from Paris just as he walked toward the grand staircase to tour, once more, his new castle.

The château's stark walls immediately challenged Picasso: he painted a great mural in the bathroom soon after arrival so that Jacqueline would have music while in the tub, played by a faun with eyes discreetly closed. The day they moved in, I asked Picasso whether he had taken to housekeeping—his head was almost out of sight in the tub. His voice rumbled across the room: "I've got a *corrida* with a scorpion . . . and he may win!"

Picasso's almost heraldic sculpture, *Man Carrying a Sheep* (page 26), arrived at the château before the artist and was placed in the garden opposite the front door. The rolling hillside of Provence extended behind him. (Today, the artist's grave is almost exactly where he is standing in this photograph. Only a slightly raised arc of impeccably trimmed grass, with an unknown earth-mother sculpture in its center, marks the site.)

The vast ceremonial hall of the château dwarfed Picasso and his son Paulo, as the artist explained his daydream plans for the vaulted room—which, of course, he never touched.

The first supper at Vauvenargues. Art historian Sir Roland Penrose is next to Jacqueline, then Janot, the chauffeur, son Paulo (back to camera), a temporary housekeeper, Perro, a newly acquired Dalmatian puppy (eyeing my plate), and Pablo, who cooked the omelet.

The first night at Vauvenargues, after supper when a roaring fire warmed the "dining room" (the only room with chairs and a table), Picasso grabbed an ever-present mandolin from a wall and began singing a flamenco air remembered from his childhood. It was an eruption of volcanic enthusiasm, in no way to be confused with music. When working he sometimes whistled—a toneless, absentminded dirge that camouflaged total mental concentration—but he never hummed or listened to classical or other music. Yet Stravinsky, Rubinstein, Richter, and Rostropovich, even Manitas de Plata the gypsy guitarist, were all friends whose talents he admired and concerts he had attended. Even so, they were never heard in his studio—unless he passed Jacqueline's tiny hideout where she turned her phonograph low and listened to some of the world's finest musicians selected from a treasury of discs, all gifts of the artists.

Jacqueline often arranged her hair in the morning sunlight while seated on a newly installed radiator in the bathroom of the château. One night, several years later, these ancient tiles crashed into the kitchen below when even older wooden ceiling beams collapsed. No one was injured, and the flute-playing-faun mural survived undamaged on the wall. The earliest-discovered foundation stones of the château were said to date from the XVth century; the walls and turrets were raised in the XVIIth. Picasso had said it was only natural that there should be a few dents in the place; that is probably what appealed to him when he first walked through its abandoned rooms.

In 1961 the *Man Carrying a Sheep* moved again, from the Château de Vauvenargues to Notre Dame de Vie, an olive-framed sprawling villa near the village of Mougins, just north of Cannes. Pablo and Jacqueline had soon found Vauvenargues too isolated in case of accidents, and too remote for friends who had always gravitated to his studio, intrusions he pretended to deplore but loved. Friends were his antennae to the world. He was a gregarious man who at times seemed to lament, even resent, his self-inflicted discipline of solitude. So they moved back to La Californie, then to Notre Dame de Vie. There, he again walked through spacious rooms—which he soon filled to overflowing with paintings and etchings and ceramics and sculptures, and *life* . . . as was true, each time, when he started again. And he died there, the morning of April 8th, 1973, after working very late the night before. He would have been ninety-two on October 25th, his birthday.

Pablo Picasso. *Self-portrait*. 1938. Unfixed charcoal on canvas. Life-size. Face and right hand modified by David Douglas Duncan, 1960. I had been photographing Picasso's Picassos for months, cleaning them with a feather duster so that their colors would be as brilliant as possible. I came upon this stark canvas early one morning and, incredibly, did not check the charcoal to determine whether it had been fixed. One terrible sweep of the duster, and it was already too late. I spent the whole morning dabbing with spit-moistened Kleenex trying to reduce the damage, to clean away the smudges. At lunch I had to tell him—but he asked first what had happened, thinking I had crashed my 300 SL Mercedes racing car. My face was probably grey-green. I answered that I had just crashed a painting; his charcoal self-portrait. He asked at what time I had begun work, and had I had breakfast. Hearing only two words, "dawn" and "no," he turned and shouted to Jacqueline, who was preparing lunch in the kitchen: "You have two starving men on your hands! What time do we eat?" He never spoke of the picture. Years later, leaving for an assignment in Vietnam, I went over to Notre Dame de Vie to say goodbye. He took me up to his studio to show me a still unknown series of canvases inspired by Rembrandt's *Nightwatch*. As I climbed back into my old car, I said that I'd always felt at home in his home—that I'd always had luck there. His eyes began to glow with a luminosity I had seen only a few times before, and he answered: "Always . . . except once." He slammed a fist into my chest, hugged me, and stood watching as I drove away.

Pablo Picasso. Villa La Californie. 1960. A Miró exhibit catalogue on the table beside him. On the wall behind him, a painting of Jacqueline seated in one of the old rocking chairs beside an easel, with a palm tree seen through a studio window in the background. This canvas reduced many of the key elements of the villa to Pablo's own style of artistic shorthand—the same way he viewed everything else in life.

Jacqueline and Kabul in front of the great doors of the Château de Vauvenargues. 1962. Pablo was up in the studio, painting.

The Château de Vauvenargues, between the hamlet of Vauvenargues and the mountain range of Ste. Victoire. Today, Picasso's grave is at the bottom of the grand staircase. The view from the château, over the autumn-tinged fields and hillsides, is to the southwest—toward Spain.

Camera Notes An exact time can be pinpointed when most photo-journalists moved to Japanese cameras. It was midsummer, 1950, at the outbreak of the Korean War. Media photographers from everywhere poured into Japan for accreditation by General Douglas MacArthur's headquarters to cover the United Nations forces being rushed to South Korea. In Tokyo, magazine and newspaper photographers learned of another event that would affect their lives and work long after a cease-fire silenced the guns on the Korean peninsula.

Two weeks before the war started, Horace Bristol—a veteran of Edward Steichen's select cadre of photographers covering the U.S. Navy in the war with Japan, and later a resident of Tokyo—and I fitted some local, little-known lenses—Nikons—to

our cameras and continued working. He was shooting a general coverage of crafts of Asia, and I a *Life* story on Japanese art, which I finished June 24th. I have good reason to remember. The Korean War started the next day. I shifted from scrolls to combat, having been a Marine Corps photographer during the advance from the Solomon Islands to the surrender aboard the *U.S.S. Missouri* in Tokyo Bay. Now, pictures sent to New York were seen worldwide almost immediately—pictures made with Japanese cameras *and* lenses, which was considered revolutionary. The news-services photographers arrived with their faithful but cumbersome Speed Graphics, film holders, flashbulbs and all. A few *avant-garde* magazinemen (I recall not one woman photographer, other than the legendary Margaret Bourke-White) came with Rolleiflexes, which some of us had used during WWII. Veteran newspaper photographers, like Pulitzer Prize-winner Max Desfor of the Associated Press, faced instant firefights with equally veteran picture editors in New York when they tried to submit 35mm negatives from Korea. The editors wanted only "big negative" shots and fired back advice: "forget that mini stuff!" Desfor quietly added a Nikon to his gear, secretly souped and printed his films in the honored Speed Graphic format, then radiophotoed his pictures to New York—to rave responses. All of *Life's* arriving photographers—Carl Mydans, Hank Walker, Michael Rougier, Howard Sochurek— immediately fitted their 35mm cameras with Nikon lenses. The first victory for postwar-Japanese products had been won.

Most of the photographs in *Viva Picasso*, of the artist in his studio-homes, La Californie (pages 1-95), and the Château de Vauvenargues (pages 96-101), were made with M3D Leicas fitted with Nikon 50mm F1.5, and 28mm F2.8 lenses. A few were taken with a Leica M3D fitted with a Canon 50mm F1.2 lens, when the light was almost subminimal and a super-fast lens was needed. A Leicaflex SL, fitted with 20mm and 45-90mm zoom lenses, was used for the coverage of Notre Dame de Vie (pages 102-111). At La Californie, all black-and-white film stock was Kodak XX (rated at 200 ASA); later, at Notre Dame de Vie, the film was Kodak Tri-X (rated at 400 ASA). All film development was by inspection, in D-76, at the *Life* lab in Paris, under the direction of Jacques André. A Nikon-F, fitted with a variety of lenses, was used for the color chapter of this book, and also for the endpaper shots. (The only exception being the prismatic shot on pages 132-133, for which I used my "bazooka" apparatus attached to a Nikon-F, which itself was fitted with a 43-86 zoom lens, extended to 70mm). All color stock was Kodachrome I (rated at 25 ASA).

The photographs in this book were made under existing light conditions. Neither photoflash nor strobes were ever considered, since Picasso was working in a highly confined area where flash-gear of any kind would have violated his creative privacy, in addition to altering the mood within his studio.

In looking at these photographs, I find that I now smile. Today, I can view them almost as a stranger who never knew Picasso, never set foot in his studio, never held anything he created in my hands. And yet . . . in remembering, I rediscover all of those blank spots in my coverage, all of those shimmering facets of his character that I saw and never captured, or tried to shoot and lost. And that makes me smile even more, since this is a book about the freest spirit of my time—not a book on art or photography at all.

Acknowledgments

Book-and-Jacket Text Style
by Henry Wolf Productions—New York
with Special Gratitude expressed
to Henry Wolf
and David Blumenthal

Master Photographic Prints
by Life Magazine (1957-62)—Paris
Picto Photo Services—Paris
Park Madison Photo Lab—New York

Bodoni Book Text Computer-set
by Haber Supersystem—New York

Book Production Coordination
by Takeshi Fukunaga
Dai Nippon America—New York
and Teruo Nemoto
Dai Nippon—Tokyo

Editorial Director
Barbara Burn
Studio-Viking Books

Books by D.D.D.

This is War! - 1951
The Private World of Pablo Picasso - 1958
Treasures of The Kremlin - 1960
Picasso's Picassos - 1961
Yankee Nomad - 1966
I Protest! - 1968
Self-Portrait: USA - 1969
War Without Heroes - 1970
Prismatics - 1972
Goodbye Picasso - 1974
The Silent Studio - 1976
Magic Worlds of Fantasy - 1978
The Fragile Miracle of Martin Gray - 1979
Viva Picasso - 1980

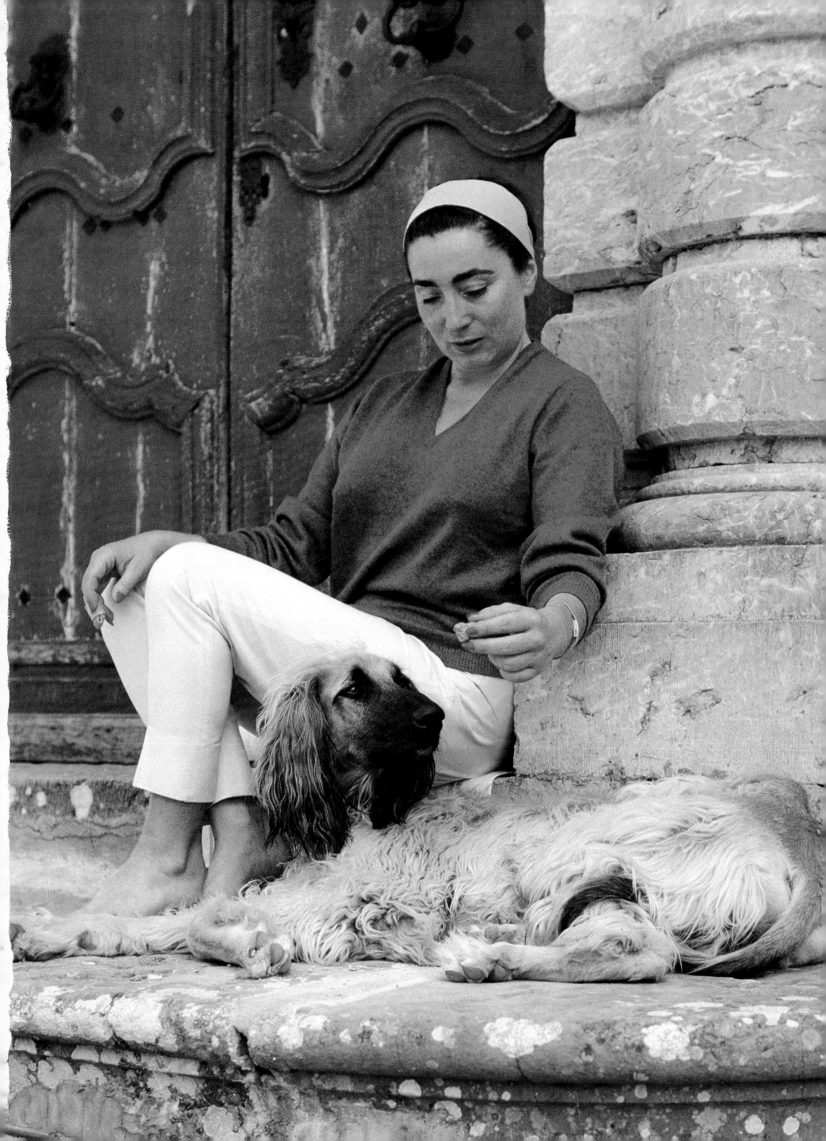